CHINESE LANDSCAPE WOODCUTS

FROM AN IMPERIAL COMMENTARY TO THE TENTH-CENTURY

PRINTED EDITION OF THE BUDDHIST CANON

CHINESE LANDSCAPE WOODCUTS

FROM AN IMPERIAL COMMENTARY

TO THE TENTH–CENTURY PRINTED

EDITION OF THE BUDDHIST CANON

Max Loehr

1968 / THE BELKNAP PRESS OF

HARVARD UNIVERSITY PRESS

CAMBRIDGE, MASSACHUSETTS

PREFACE

The matters discussed in the following pages concern two prominent Chinese achievements. One of them is the art of printing; the other, the conception of landscape painting.

What occasions our inquiry is a set of four woodblock prints in the Fogg Art Museum depicting landscapes of strange and involved design, in an unfamiliar, archaic style. They illuminate a text that is fully identified by a title and chapter number printed at the end: the *Yü-chih Pi-tsang-ch'üan*, "Imperially Composed Explanation of the Secret Treasure," Chapter XIII. This text is a commentary written by the second Sung emperor, T'ai-tsung (r. 976–997), for the first printed edition of the Buddhist scriptures, the *Tripiṭaka*, in Chinese translation, published in his reign. A printed cartouche placed next to the title gives the year the prints were made; it is the year Ta-kuan 2, in the reign of Emperor Hui-tsung, corresponding to A.D. 1108.

This is all that we learn from the evidence supplied by the fragmentary scroll. There is no indication as to the edition to which these prints belong, or when and where the blocks were carved. The blocks might be considerably older. The landscape pictures suggest an earlier date; they are quite incompatible with works of landscape painting around 1100. But because these four woodcuts are unique, they defy dating by the simple method of comparison. Conceivably they originate from the time when the text of the Imperial commentary was readied for publication, sometime in T'ai-tsung's reign. Yet while the archaic character of the landscapes favors a tenth-century date, it is very difficult to arrive at a stylistic equation of woodblock designs with painted landscapes. The obstacle caused by discrepancies between the two techniques cannot quite be overcome by the imagination. The difficulty is compounded by the scarcity of tenth-century painting in general. Too little is left today to enable us to reconstruct the historical sequence of styles. Yet if we can define the chronological position of the four woodcuts within reasonably close limits, they would go some way to make up for what is lost and shed some light where now there is darkness. Such is the promise which they hold out to us.

There is one analogue that must be mentioned. It is the fragment of a landscape woodcut forming the frontispiece of a Buddhist *sūtra* found by Sir Aurel Stein at the Central Asian site of Kara-Khoto. Listed without illustration as item KK II.0285a in Stein's *Innermost Asia*, I, 496, it was erroneously described as a fragment of a Hsi-hsia (or, Tangut) text. Actually the text is a Chinese translation of a Ma-hāyāna text, the *Ta-pei-hsin t'o-lo-ni-ching*, "Dhāraṇī-sūtra of the Heart of Great Compassion," No. 320 in B. Nanjio's *Catalogue*. All that is left of the print, of which I was permitted to take a photograph at the Museum of Central Asian Antiquities in New Delhi in 1958 (Pl. 40), is the left edge of the picture, the title, the name of the translator, and the first column of the text. The picture shows a densely fissured, jagged wall of rock which rises over a small stream with a stalactitic overhang, a few trees with patterned foliage, and a sky filled with undulating lines radiating from a center to the right of the narrow strip now left. The Kara-Khoto finds are assigned roughly to the eleventh and twelfth centuries: the Mongol conquest of A.D. 1226 was taken by Stein as the *terminus post quem non*. The *sūtra* fragment in New Delhi cannot be dated any more precisely. Still, while it does little for the chronology of landscape styles, it remains an important instance of the use of landscape motifs in a *sūtra* frontispiece executed in woodcut during the Sung Dynasty.

The safest way to establish the age and authenticity of the Fogg Museum prints is to determine the edition to which they belong. From Chinese Buddhist chronicles, the *Sung Annals*, extant prints, and from researches carried out in this century by Eastern and Western scholars, it is possible to obtain information on the dates and the typographic appearance of the various editions, official or monasterial, achieved in Sung times (960–1278) in Sung and Tatar territories and in Korea. This information, which enables us to identify the prints as fragments of the Northern Sung Imperial edition, is given in Chapter II.

To furnish the reader with the essential information on the development of printing in China up to the time when the gigantic project of publishing the Buddhist *Canon* became feasible, I have provided an outline of earlier events in Chapter I.

Chapter III describes the landscape woodcuts and their stylistic properties. In comparing the woodcuts with paintings — a procedure beset with the difficulties hinted at above — I have given attention to the features least affected either by technique or by style, that is, to specific motifs, especially those which define the terrain.

Final proof of the late tenth-century date of the woodcut designs, however, came unforeseen. It was toward the end of a journey to Europe

and Japan in the fall of 1964 in search of Sung Buddhist prints that I learned, while in Tōkyō, that two chapters of an illustrated Korean edition of the *Pi-tsang-ch'üan* from the Nanzenji had been shown for two days, November 7 and 8, at the Fiftieth Annual Exhibition of the Daizō-e, or "Tripiṭaka Society," held at the Ryūkoku University Library in Kyōto. Through the kind offices of Mr. Jirō Enjōji of the Nihon Keizai Shimbunsha in Tōkyō, of Miss Rei Sasaguchi in Tōkyō, and of Professor T. Makita of the Jimbun Kagaku Kenkyūjo in Kyōto, I was received by Mr. Sakurai Kageo at the Nanzenji on November 23, and was allowed to examinine several chapters of their Korean edition and to take photographs of the woodcuts of *chüan* XIII. I wish to express my gratitude to Mr. Sakurai and to those who introduced me to him, for the privilege of perusing this unique Korean copy that has never been published. A discussion of the evidence concerning the origin and date of the Nanzenji prints and a description of four woodcut landscapes in *chüan* XIII are found in Chapter IV.

It was during my visit at Nanzenji that I had the further privilege of meeting Professor Ogawa Kanichi, whose admirable account of the Chinese and Japanese *Tripiṭaka* editions, entitled *Daizōkyō*, proved to be a major source for Chapter II.

I thankfully remember the help received from Mme. Marie-Roberte Guignard, Conservateur au Cabinet des Manuscrits de la Bibliothèque Nationale, Paris; from my friend Soame Jenyns of the British Museum; from Mr. E. D. Grinstead, of the British Museum; from Dr. Gösta Montell, Director of the Statens Etnografiska Museet, and Dr. Bo Gyllensvärd, Director of the Museum of Far Eastern Antiquities and Keeper of the Collection of H.M. King Gustaf VI Adolf of Sweden, in Stockholm.

My obligations to academic circles in Japan are many, and can never be adequately acknowledged. Through the kindness of my friend Dr. Tokugawa Yoshihiro of the Kunai-chō (Imperial Household Office), I was given permission to inspect the *Pi-tsang-ch'üan* chapters of the Fu-chou K'ai-yüan-ssu twelfth-century edition and of the Korean thirteenth-century edition (in a recent impression) in the Imperial Palace Library in Tōkyō. Professor Mori Katsumi sacrificed a whole day for an excursion to the Kanazawa Bunko near Yokohama, where I could see Fukien prints of Northern and Southern Sung date, amiably made accessible to me by the Director, Mr. Kumahara Masao. The Director of the Seikadō Bunko, Mr. T. Yoneyama, showed me a collection of fragments from Chinese printed books found in Turfan. Thanks to Professor Tsukamoto Zenryū, Director of the Kyōto National Museum, Mr. Nagazawa, head priest of the Seiryōji at Saga, Kyōto, al-

lowed me to study the magnificent single-leaf prints discovered in the interior of the famous Shaka image brought from China by Chōnen in A.D. 987. Rewarding and pleasant were my visits to several temples in the Kyōto area known to possess collections of ancient *sūtras*, chiefly Fukien editions of Sung date. I gratefully recall the reception at the Chion-in, seat of the Jōdo Sect; at the Daigoji, seat of the Shingon Sect, where I was shown by a priest, Mr. Saitō Meitō, a copy of the *Ta-chih-tu-lun* printed at Fu-chou in A.D. 1091; and at the Tōji, another of the great Shingon centers, where on November 25, 1964, I was able to study a complete set of the Sung Imperial commentaries in Fu-chou impressions of A.D. 1109 — one year later than the Fogg Museum prints. For this rare opportunity, provided with the additional amenity of a blazing stove, I am beholden to Mr. Sawamura Kakushin, Head of the Department of Education at the Tōji. For the opportunity of seeing diverse samples in the rare book rooms of the Buddhist Universities in Kyōto and of Tenri University, I wish to thank in particular Mr. Taira Haruo of Ryūkoku Daigaku; Mr. Takahashi Shōryū and Miss Yokogawa Kōchiko at Ōtani; and, for his gracious hospitality, Professor M. Tominaga of Tenri Central Library. Shortly before my departure from Japan in early December, Mr. Mayuyama Junkichi presented me with a set of photographs of a rare illustrated book of Sung date in the collection of Mr. Aimi Kōu, thoughtfully estimating its interest to the studies he knew I was pursuing; this book, *Hua-yen Ju-fa-chieh-p'in Shan-ts'ai ts'an-wen pien-hsiang-ching*, "Illustrated sūtra of Shan-ts'ai's pilgrimage [according to] the Chapter on Entering the Dharmadhātu of the Hua-yen [or Avataṃsakasūtra]," more than a century later in date than the *Pi-tsang-ch'üan*, was recently discussed in Jan Fontein's *The Pilgrimage of Sudhana* (The Hague, 1966, pp. 40–52) and therefore need not occupy us in the present publication.

Visiting a few days later Professor Richard C. Rudolph in Los Angeles, a collector and student of early prints and former owner of the *Pi-tsang-ch'üan* fragment, I was surprised to see, once more, printed *sūtras* of Sung and Yüan times assembled, including Ssu-ch'i, Chi-sha, and Hang-chou editions. For this unexpected recapitulation as well as for bibliographic information given me by Professor Rudolph I am grateful to him.

To Professor Edward Wagner of the Harvard-Yenching Institute I am indebted for having supplied the transliteration of the Korean names. To Professor Yang Lien-sheng, also of the Harvard-Yenching Institute, I owe thanks for having read, and improved on, my translation of the text of the cartouche of 1108. Miss Celia Carrington Riely, graduate student at Harvard, who read and polished the style of my draft — a task as arduous, no doubt, as that performed at the Jun-wen-t'ang, Hall

of Polishing the Style, in the Sung Court of Translations — I cannot thank sufficiently.

Finally, I express my gratitude for the generous support that enabled me to travel abroad, support received through Harvard University from the Abby Aldrich Rockefeller Fund, and through the kindness of Mr. Porter McCray, New York, from the JDR IIIrd Fund.

For the courteous permission given him to reproduce the prints or paintings in their collections, the author is much obliged to the following institutions and persons: Fogg Art Museum, Harvard University (Pls. 1–17, Daly, Higginson and Hyatt Funds purchase); Nanzenji, Kyōto (Pls. 18–27); National Palace Museum, Taipei, Taiwan, Republic of China (Pls. 28, 29, 30, 31, 33, 34, 36, 38); Smithsonian Institution, Freer Gallery of Art, Washington, D.C. (Pl. 32); Mr. Chang Ta-ch'ien, Sao Paolo (Pl. 35, photograph by Mr. O. E. Nelson, New York); Museum of Central Asian Antiquities, New Delhi (Pl. 40). The sources for the remaining few illustrations are duly acknowledged in the list of illustrations.

M.L.

CONTENTS

ILLUSTRATIONS

CHINESE LANDSCAPE WOODCUTS

FROM AN IMPERIAL COMMENTARY TO THE TENTH-CENTURY

PRINTED EDITION OF THE BUDDHIST CANON

CHAPTER I / THE BEGINNINGS OF PRINTING

IN THE FAR EAST

By the time they could undertake the printing of bodies of texts as large as the *Nine Classics* (A.D. 932) or the Buddhist *Canon*, the *Tripiṭaka* (A.D. 971), the Chinese had several centuries of experience behind them. But where and when the first print was made is not known.

The oldest extant item from China dates from A.D. 757 at the earliest. It is a charm printed on a single sheet, showing a six-armed Bodhisattva figure in the center of concentrically laid out Sanskrit words written in Lantsa letters, that was excavated in 1944 from a T'ang Dynasty grave in the city of Ch'eng-tu, Szechwan.[1] This charm is the first find from China to rival in age the 1,000,000 small *dhāraṇī* scrolls printed between 762 and 770 in Japan; these were Sanskrit spells transcribed in Chinese characters, which were deposited in the great temples of the realm, the earliest known texts printed in Chinese.[2] That similar prints must have existed before 770 in China, whence the Chinese versions of those *dhāraṇī* texts came, cannot seriously be doubted.

Literary evidence of a still earlier date, however, points to India as the possible source of printing techniques. What appears to be the oldest statement in the world about printing is contained in I-ching's (635–713) *Nan-hai chi-kuei nei-fa-chuan*, "A Record of the Inner Law Transmitted from the Southern Seas," one of two memoirs written by the renowned monk in the years 689–692 at Palembang, Sumatra, after many years of travel and study in India. It is but a short passage which says, "[in India] they make clay *caitya* and moulded clay images, or they print [images] on silk or paper for worship wherever it be."[3] Pelliot, who admitted that in this late seventh-century text we have the first explicit statement concerning prints on paper or silk, was not convinced that the technique originated in India, but assumed for it a Far Eastern origin, for reasons to be given presently.[4]

About thirty years before I-ching's account, in A.D. 660, one Wang Hsüan-ts'e returned to China from his third ambassadorial mission to India, bringing among other things "Buddhist prints, four *k'o*," which has been taken to mean printed leaves. But the classifier *k'o* suggests

something like the stamped clay or terra cotta images which had been current in India for a long time; we cannot be certain about his *"Fo yin"* having been in the nature of prints.[5]

As early as about A.D. 600, on the other hand, there is some evidence of primitive printing in connection with Taoist practices in China. In a passage noticed by Pelliot in the Annals of the Sui Dynasty (581–617), *Sui-shu* (*ch.* 35), we read of Taoist priests who "make 'seals' [*yin*] of wood upon which are carved the constellations, the sun, and the moon. Holding their breath, they take them with their hands and make impressions [*yin*]. There are many whose ailments are cured thereby." [6] Nothing is said here about the material used for the impressions. Nevertheless, in his cautious evaluation of this passage Pelliot came to the conclusion that in all probability we have to do with prints made on paper, from blocks with designs in reverse position and in relief rather than in intaglio.

Other instances, whether archaeological or philological, which were taken by some scholars as proof of the existence of Sui Dynasty prints, are a decree by the First Sui emperor, Wen-ti, of A.D. 593, ordering the conservation of deteriorated statues and the publication "in print" of stray *sūtras;* Buddhist images bearing the date Ta-yeh 3 (A.D. 607), alleged to have been found at Tun-huang; and a printed *dhāraṇī* from Tun-huang whose title, *Ta sui-ch'iu t'o-lo-ni*, was misunderstood as referring to the Ta Sui (Dynasty) although its actual, inscribed date corresponds to A.D. 980. All these have to be discarded. Wen-ti's decree speaks only of the collecting of stray texts. The Ta-yeh 3 images, which, moreover, are not printed but painted, appear to be forgeries of the nineteen-twenties. The *dhāraṇī* gave rise to the misinterpretation only because the character *sui* was printed in the form it has in the name, Sui, of the dynasty, a form which was merely substituted for the similar, correct character.[7]

If, under the circumstances, the evidence of pre-T'ang times is limited to the one *Sui-shu* passage quoted above — suggesting the existence of archaic printed charms or image seals around A.D. 600 — the question of Chinese priority in matters of printing might be considered as not conclusively settled. In fact, it has been asked whether the more or less simultaneous appearance of print-making in India, China, and, perhaps, also in Central Asia might not be accounted for by the assumption of a common source, that is, whether it was not from Tibet that the art spread. Of course, it is not impossible that the Tibetans did practice printing at an early date, but there are neither records to suggest it nor datable remains to prove it. Moreover, the Tibetans possessed no script until as late as the seventh century, when Thon-mi Saṃbhoṭa, by adapt-

ing the Nāgarī letters of the Gupta style, first created a Tibetan alphabet, "... a far cry from China's experience of two millennia of writing (before A.D. 600)," in the words of L. C. Goodrich, who, in his answer to a hypothesis that was based mainly on the observation that the Tibetan word for printing block, *dpar*, appears to be indigenous, stressed the aspect of Tibet's late literacy.[8] In any case, none of the conditions which favored the development of printing in China obtained in Tibet.

Evidence still points to China as the place where in all likelihood the written word was first printed. Here there was a long tradition of handing down texts in manuscript or epigraphic form, and an abiding concern for scriptorial matters quite generally, that led the Chinese to search for, and invent, the perfect medium of brush, ink, and paper. They also knew how to reproduce texts by a method other than either copying or printing, namely, by rubbings or inked squeezes (*t'a-pen,* Japanese *takuhon*) taken from engraved stone tablets. The engraved stones, permanent and complete in themselves, were not conceived as printing tools but as monuments to which to turn for the authentic wording of scripture or, more often perhaps, for guidance in calligraphy. Nor was the rubbing conceived of as a means of distribution as are books. A rubbing was a likeness of the monument, a prized possession, even though it was a "negative" reproduction inasmuch as the characters appear white on blackened paper. The printing block, by contrast, serves as a tool, functioning like a seal with its reversed characters carved or cast in relief to produce the "positive" impression. Seals of this kind, in Pelliot's estimate, became common about the middle of the first millennium.

What little of eighth-century printing has survived was mentioned before. The following century did see a wider application of the new technique, but extant prints are rare. It is recorded that printed paper money was issued in the Pao-li era (825–826).[9] Dictionaries of such renown as *Kuang-yün* and *Yü-p'ien* were first printed in the time of Wen-tsung (r. 827–840).[10] That poems of Po Chü-i (772–846) were made available in printed editions in the markets of Chekiang by an enterprising admirer, Yüan Chen (779–831), as upheld by Chinese and Japanese scholars, was, however, doubted by Pelliot.[11] What may be the first incontrovertible reference to printing in China is a petition of December 29, 835, by one Feng Su, Regional Commandant (*chieh-tu-shih*) of Tung-ch'uan, Szechwan: he petitioned the throne to prohibit the sale of privately printed calendars which flooded the market [before the appearance of the official calendars].[12] About 847–850, several thousand copies of a biography of Liu Hung (156–189) were circulated in Kiangsi Province by one Ho-kan Chi.[13] Around 868, there were six hundred

chapters of *sūtras* of the *Prajñāpāramitā* class and seven chapters of the *Lotus-Sūtra* printed.[14]

From that year, 868, dates "the world's oldest printed book," the *Diamond-Sūtra* (*Vajracchedikā-Prajñāpāramitā-Sūtra*), which Sir Aurel Stein purchased for the British Museum when he visited Tun-huang in 1907. It is in the form of a scroll, printed from large blocks (two and a half feet in length and nearly a foot wide) on a paper stained yellow but grayish at the beginning where it was often exposed. The text is preceded by a frontispiece showing the Buddha surrounded by a host and addressing the aged Monk Subhūti, who is kneeling on the ground. A small cartouche in the upper left corner tells us that the scene takes place at the Jetavana Monastery. A colophon that gives a date corresponding to May 11, 868, says that the print was made by [order of] Wang Chieh for [the welfare of] his parents. It is not known where the *sūtra* was printed.[15]

The Stein collection in the British Museum further contains a single-leaf calendar for the year *ting-yu* (A.D. 877) on grayish white paper with minute drawings, and the fragment of a calendar of the year 882 from Ch'eng-tu Fu, Szechwan, that may have been printed from a clay block.[16] The paper of the fragment is very thin and of yellowish color, reminiscent of the paper of the Sung prints in the Fogg Museum described in Chapter III.

The city of Ch'eng-tu remains conspicuous, for it is mentioned again in an important note that was singled out by Carter as the first clear reference to block-printing in Chinese literature. This brief account from the preface of a lost work, *Chia-hsün*, "Family Admonitions," written by Liu P'ien, an official under the Emperors Hsi-tsung (r. 874–888) and Chao-tsung (r. 889–904), has survived in quotations only, the fullest of which was found by Pelliot in the thirteenth-century *Ai-jih-chai ts'ung-ch'ao* by Yeh Chih:

In the third year of Chung-ho, *kuei-mao*, in the summer, which was the third year that the imperial chariot was stationed in Shu, I, being a Secretary in the Imperial Secretariat [*chung-shu she-jen*], on my days of rest used to examine the books [on sale] in the southeast of the second city-wall. Most of these books were Yin-Yang items, about oneiromancy, geomancy, the nine palaces [of the astrologers], the five planets, and the like. There were also dictionaries and lexicographic [*hsiao-hsüeh*] items. As a rule, they were printed with carved blocks on paper, but so blotted that they were not always legible.[17]

Obviously these were cheap books, unattractive in appearance, hardly appealing to the educated, and unlikely to have entered into libraries. It is not surprising, therefore, that of such inferior prints nothing seems to have survived. The few ninth-century specimens which did survive

are, by contrast, of a quality that forecasts the perfection of the Five Dynasties and Sung editions.

It was left to the politically unsettled period of the Five Dynasties (907–960) to recognize the importance of block-printing for the cause of literary learning as well as for prestige, and to undertake — with all the resources of government and officialdom — the work of editing, printing, and distributing texts of such magnitude as the Chinese *Classics*. That work was begun in the tenth year of the Later T'ang, under Ming-tsung (r. 926–933), when in the second month of that year (March 10–April 8, 932) the ministers Feng Tao (882–954) and Li Yü (d. 934) presented a memorial which, according to the *Ts'e-fu yüan-kuei* encyclopedia (of 1005–1013), was worded as follows:

> In the time of the Han, when Confucian learning was held in respect, the *Classics* were engraved in stone in three scripts. Under the T'ang Dynasty, too, they were carved in stone at the National College. Our Dynasty, not knowing a day of leisure, cannot possibly erect a new set of stone inscriptions. But we have seen people from Wu [Lower Yangtse] and Shu [Szechwan] who sold books made with printing blocks [of wood] which, though greatly diverse in kind and content, fail to include any of the *Classics*. If the *Classics* were revised, carved in wood, and distributed, it would be of profound benefit to literary education.[18]

The emperor assented and forthwith ordered T'ien Min, Division Chief in the Department of Ministries, and others, to edit both the texts (on the basis of the T'ang *Stone Classics* of 830–837) and the commentaries (from then current manuscripts).

An imperial decree of the same year (932), recorded in *Ts'e-fu yüan-kuei* and, in a variant version, in *Wu-tai hui-yao* (961), gives some insight into the organization of the project, carried out under the auspices of the National College, the Kuo-tzu-chien. According to the latter source,

> the National College will assemble expert Confucian scholars and their disciples who, working from the edition of the [T'ang] *Stone Classics* of the Western Capital [Ch'ang-an] in accordance with each man's speciality shall punctuate the original texts, copy the commentaries, and read them with the minutest care; whereupon the College will engage workmen skilled in the carving of characters who shall carve the blocks for each title in the order of the wrappers [*chih*, Japanese *chitsu*], and distribute the prints over the empire. Whosoever in the future intends to write a copy of a canonical text shall do so relying on this printed edition; it must not again happen that sundry versions are allowed to perpetuate errors.[19]

The concern for the textual accuracy of the new edition was matched by the concern for exemplary calligraphy. In a decree of the fourth month of A.D. 932, the College was ordered to appoint an outstanding calligrapher who was to supply the *k'ai-shu* models to the carvers. Chosen was Li O,

an executive assistant in the College (*Kuo-tzu-ch'eng*) and a professor (*t'ai-hsüeh po-shih*).

Despite the almost uninterrupted civil wars, the work entrusted to the Kuo-tzu-chien progressed steadily. A report submitted by the College in A.D. 948 (Ch'ien-yu 1) during the rule of the Later Han Dynasty (947–950), indicating that four books, the *Chou-li, I-li, Kung-yang,* and *Ku-liang Commentaries* (to Confucius' *Spring and Autumn Annals*), had not yet been printed and that a commission for the editing and printing of these four books ought to be appointed, makes it likely that all the other texts had by then been printed. In fact, two glossaries, *Wu-ching wen-tzu* and *Chiu-ching tzu-yang* (that were included in the T'ang *Stone Classics*) would, on account of the date of their prefaces written by T'ien Min, *viz.* A.D. 946, suggest that the bulk of the canonical texts was printed by 946. However that may be, after twenty-one years of labor, in 953 (Kuang-shun 3, of the Later Chou, the last of the Five Dynasties), T'ien Min, now titled Supervisor of the Affairs of the National College and Left Executive Assistant of the Department of Ministries, presented the completed edition of the *Nine Classics* in 130 volumes (*ts'e*) to the court.[20]

That one of the men who initiated the undertaking, Feng Tao, advisor to ten rulers of four dynasties, was later credited with the invention of block-printing is understandable. Yet he himself had acknowledged, in his and Li Yü's petition of 932, the existence of prints in Wu and Shu. Carter assumed that Feng Tao's indebtedness was even greater. He assumed that the Kuo-tzu-chien printed edition of the *Classics* was preceded by, and dependent on, a new set of stone-engraved texts executed at Ch'eng-tu in Shu (Szechwan), and possibly also by a printed edition done under the direction of Wu Chao-i in close connection with the stone texts, achievements that would have come to Feng Tao's knowledge at the time when Shu was brought under the suzerainty of the Later T'ang, from 929 to 933.[21] This view hinges on the belief that the Shu stone texts were cut under the first ruler of Shu, Wang Chien (r. 908–919). But the known dates of the Ch'eng-tu *Stone Classics* show that their engraving was begun only under the second sovereign of the Meng family, in 938 — six years after Feng Tao's memorial of 932. By 944, the *Hsiao-ching, Lun-yü,* and *Erh-ya* were completed; by 951, the *I-ching;* by 965, when Shu ceased to exist as an independent state, the *Mao Shih, Shang-shu, I-li, Li-chi,* and *Tso-chuan* I–XVII had been added. The work was continued during the Sung period: the *Tso* XVIII–XXX, *Kung-yang,* and *Ku-liang* were completed by 1049, the *Meng-tzu* by 1124, and a work of Sung criticism, *Shih-ching k'ao-i,* "An investigation of textual variants in the *Stone Classics*," was cut as late as 1170.[22]

As for the block-printed edition, Wang Kuo-wei had collected and critically evaluated the pertinent passages in his *Wu-tai Chien-pen-k'ao*, from which it is clear that most of the titles in the National College edition were printed before 950. Wu Chao-i, the driving spirit behind the Ch'eng-tu edition, became prime minister in Shu only under Meng Ch'ang (r. 934–965), a position he held from 935 to 954. According to K'ung P'ing-chung (who received his doctoral degree in 1065), it was no earlier than 951–953 that Wu Chao-i asked his sovereign for permission to have the *Classics* printed — by which time the National College had completed its work.[23]

Questions of priority aside, the fact that Shu did create the stone engravings as well as its own printed edition proves that the western province was determined to maintain its position of eminence in matters of printing and publishing.

The extant dated Chinese tenth-century prints, largely single-sheet items and Buddhist in subject matter throughout, are, with the exception of the leaves of 984 from the Shaka image of the Seiryōji, Kyōto, provincial products which do not measure up to the standard of the official editions of the Confucian *Canon*. They originate from Tun-huang (Kansu), Hang-chou (Chekiang), and, probably, Pien-ching (Honan), the northern capital, and are linked to three historical personages.

Earliest are several prints from Tun-huang, three image prints and one text, made for the same patron, Ts'ao Yüan-chung, Governor (*chieh-tu-shih*) of Kuei-i Military District, by the same woodcutter, Lei Yen-mei. Two leaves represent *Chiu-k'u Kuan-yin,* "Avalokiteśvara, Savior from Hardships," and they are dated in correspondence with August 4, 947 (K'ai-yüan 4, seventh month, fifteenth day). Underneath the image of the Bodhisattva appear thirteen columns of text, a prayer spoken by the donor whose every title is given. Carved in a slightly clumsy manner, these leaves were printed

to the end that the city god may enjoy peace and prosperity, that the whole prefecture may be tranquil, that the highways leading east and west may remain open, that evil-doers north and south may be reformed, that diseases may disappear, that the sound of the war-gong may no longer be heard, that pleasure may attend both eye and ear, and that all may be steeped in happiness and good fortune. . . .[24]

One of the sheets came with Sir Aurel Stein's collection to the British Museum; the second was given by Pelliot to the Pierpont Morgan Library and is now kept in the Metropolitan Museum in New York.[25] The third of the image prints, again in the British Museum, bears the same date, August 4, 947. It is a leaf of coarse buff paper which shows "Vaiśravaṇa, Guardian King of the Northern Quarter." The Devarāja, in armor, is

surrounded by three figures facing toward him, who are representatives of "the various classes of demons and spirits under Heaven." [26] Like the main figure they are rendered with sureness and grace, in contrast to the text, which shows the same undistinguished hand seen in the preceding prints. The fourth item is a fragment of the *Vajracchedikā* of very small size, printed in rather rudely cut characters on whitish paper with large brown stains. Its date, T'ien-fu 15, *chi-yu*, fifth month, fifteenth day, is ambiguous; if the reign year is correct, it corresponds to June 3, 950, while the cyclical year corresponds to June 14, 949.[27] Since there was never a fifteenth year of the T'ien-fu era (of the Posterior Han), the twelfth having been the last (A.D. 947), we have to conclude that it is safer to rely on the cyclical date, *chi-yu*, and to regard the equation with June 14, 949 as correct. A colophon at the end of the text again refers to Ts'ao Yüan-chung as the donor. The Fonds Pelliot in the Bibliothèque Nationale, Paris, lists two other incomplete copies of the same print. These fragments are the oldest known Buddhist fold-books from China.

Next in age are the remaining specimens of 84,000 small *sūtra* scrolls printed at Lin-an Fu (Hang-chou, Chekiang) for a patron of high station, Ch'ien Hung-shu (929–988), Generalissimo and King of Wu-Yüeh, who later changed his name to Ch'ien Shu. They were discovered in the pagoda of T'ien-ning-ssu at Hu-chou in Wu-hsing Hsien (Chekiang), where they had been deposited as an offering. The 84,000 copies of the *sūtra* in question, *I-ch'ieh ju-lai-hsin pi-mi ch'üan-shen she-li pao-ch'ieh-yin t'o-lo-ni ching* (Sanskrit, "Sarvatathāgata-adhiṣṭāna-hṛdaya-guhya-dhātu-karaṇḍamudrā-dhāraṇī-sūtra," Nanjio, No. 957), were printed by the Yin family bookshop on T'ai-miao Front Avenue at Lin-an Fu in the third year of Hsien-te, *ping-ch'en* (A.D. 956) for Ch'ien Hung-shu, Generalissimo of the Empire (*T'ien-hsia Tu-yüan-shuai*) and King of Wu-Yüeh. They were embellished with frontispieces showing people worshipping a *stūpa*. Apropos of this motif, Wang Kuo-wei, who described these *sūtras* as the oldest prints ever found in his home province, Chekiang, mentions the fact that one year earlier (*i-mao*, A.D. 955) the same prince had a set of small bronze *stūpas* cast and gilded, which also numbered 84,000 — like those built by the Maurya king Aśoka to house the 84,000 relics (or "atoms") of the Buddha's body. Possibly the small scrolls of 956 were made to be enshrined in those bronze *she-li-t'a*, "relic stūpa" (Japanese, *sharitō*), of 955, one of which can be studied at the Yūrinkan Museum in Kyōto.[28]

Nineteen years later, in A.D. 975 (*i-hai*), the same text was printed once more for the same donor, whose name now reads Ch'ien Shu ("Hung" having been dropped in deference to a Sung taboo: Hung-yin was the

name, *hui*, of the father of the first Sung emperor, Chao K'uang-yin)
and whose title is changed to *T'ien-hsia ping-ma ta-yüan-shuai;* he is
still King of the Country of Wu and Yüeh. But the colophon of this
edition explicitly says that the 84,000 scrolls (*chüan*) are to be given as
an offering for the brick pagoda of Hsi-kuan, later known as Lei-feng-t'a,
"Thunder Hill Pagoda." They came to light again when the pagoda,
which had stood for nearly a thousand years, collapsed on September 25,
1924.[29] It was found that there was a hole in each of the bricks used
to build the pagoda, and that a *sūtra* was inserted in each hole. Un-
avoidably we are led to assume that the structure was calculated so
that its main body would consist of exactly 84,000 bricks, as if to simulate
or symbolize the very body of the Buddha.

Of this scroll of A.D. 975, the year that saw the surrender of the last
lord of Nan-T'ang, Li hou-chu, as well as of the prince of Wu and Yüeh
to Sung, many specimens may still be in existence. One was seen by
Wang Kuo-wei; another one, in Hang-chou, was reproduced in the recent
sumptuous publication, *Chung-kuo pan-k'o t'u-lu*.[30] The British Museum
owns one print.[31] Three came into Japanese collections, those of the late
Naitō Torajirō, the Tenri University Library, and the Yūrinkan Museum
in Kyōto.[32] The last two specimens are provided with short modern
prefaces accompanied by sketches of the Lei-feng Pagoda in the evening
sun. The printed scroll opens with the colophon and a small frontispiece
of unpretentious character. In the right half we see a worshipper kneeling
in front of the Buddha, who is seated on a lotus seat and flanked by
two standing monks. The left half is occupied by the figures of a standing
Buddha approached by a supplicant in humble pose, with a roofed gate
and wall rising behind him. The foreground is marked by a rudimentary
hillock or mountain, the design of which is derived from late T'ang
conventions. The characters of the text are hardly superior to those of
the Kansu prints mentioned above. But they are printed in very fine
strokes, suggestive — in the view of Fujii Shuichi, Curator of the
Yūrinkan Museum — of metal rather than of wooden blocks. Bronze
blocks were an innovation which in fact goes back to the Sung Dynasty.
An edition of 84,000 impressions undoubtedly required the repeated re-
placement of worn blocks, even if they were of bronze. This accounts
for the minute variations we are able to observe, for instance, in the
three frontispieces of the scrolls in Japan. No two of them are identical.
These scrolls were printed on long, narrow strips of paper, which in the
case of the specimen in the Fujii collection (Yūrinkan) is of a yellowish
gray tone and in perfect condition.

Of course, these staggering numbers of impressions were not meant to
be read or distributed, and neither were they copied by hand. If the act

of copying scripture was considered meritorious in itself, it had certainly degenerated into empty piety in the case of prints which were mass-produced. Nevertheless the manuscript copy was not in the tenth century wholly displaced by prints as yet. Several decades ago the collector Yeh Kung-ch'o (born in 1880 in Canton) acquired in Shanghai a set of seven chapters of the *Lotus-Sūtra* written in gold characters on purplish blue paper embellished with gold painted illustrations at the beginning and end of the chapters. Apparently originally in the form of scrolls, they had been converted into folded books, each chapter (*chüan*) forming a book (*ts'e*). The donor's title and name were prefixed to all of them: *ti-tzu* Chang-i-chün *chieh-tu-shih* Ch'ien Hsin *ching she*, "reverently given by the disciple Ch'ien Hsin, Governor of Chang-i Military District."[33] This Ch'ien Hsin was a son of Ch'ien Yüan-kuan (886–941), second prince of Wu-Yüeh, and a younger brother of Ch'ien Shu, the fifth prince, who had the *sūtras* of 956 and 975 printed. *Sūtras* written in gold and silver or palladium on dark blue paper are now rare in China. In Japan there still exist magnificent examples, possibly entire sets of the *Canon*, from the Fujiwara period (897–1185), in the form of scrolls (Japanese, *makimono*) provided with frontispieces (Japanese, *tobira-e*) that are countless variations of Buddhist and landscape themes.

August 8, 980 (T'ai-p'ing hsing-kuo 5, sixth month, twenty-fifth day) is the date of a large Sanskrit charm printed on light gray paper from a carefully carved block from the Stein collection in the British Museum, representing the *Ta-sui-ch'iu t'o-lo-ni* (Sanskrit, *Mahāpratisarā-dhāraṇī*), "Spell of [the Bodhisattva] Great Response to Prayer." The Sanskrit text is arranged in nineteen concentric circles around a diminutive figure of the ten-armed, seated Bodhisattva, who is related to Avalokiteśvara. Text and figure form a large disk, which is placed upright on a lotus pedestal supported by two warrior-like Nāgarāja figures emerging from billowing waters. The water reaches up to the middle of the disk. The upper half of the disk is surrounded by curling clouds symbolizing the sky. Between the two Nāga kings and cutting across them is a rectangular cartouche with a Chinese text. It gives the title of the spell and explains its powers. The last three columns indicate the date when the carver finished his work. The carver's name, Wang Wen-chao, appears in a narrow cartouche to the left of the disk. On the right side we find the name of the donor, Li Chih-shun. The four corners are occupied by small disks with Sanskrit syllables in Siddham script over fully open lotus flowers; they are the *bīja* or sound seeds (*chung-tzu*, Japanese *shuji*) of four deities. This configuration is enclosed by a border consisting of three bands with medallions placed across them. Eight of the medallions hold *bīja* syllables; they alternate with image medallions, also eight in number.

The central band is filled with sixteen five-pronged *vajra* or "thunder-bolt" symbols. The inner bands, where they run vertically, contain eight Sanskrit words transliterated into Chinese. They designate the eight esoteric attributes held by the Bodhisattva in the center of the *maṇḍala*. I will attempt no further interpretation of the iconographic details; they are hard to read and have no bearing on the issues in hand. The importance of this woodcut lies in the fact that it is contemporaneous with the printing of the Sung *Tripiṭaka*. The curling clouds of its design closely resemble those in the landscapes of the *Pi-tsang-ch'üan* chapter in the Fogg Museum.[34]

The last of the dated tenth-century prints to be mentioned are four leaves which until recently were enshrined in the interior of the Shaka statue in the Shakadō of the Seiryōji at Saga, Kyōto, a statue brought from China to Kyōto (then Heian-kyō) by Chōnen, a priest of the Tōdaiji in Nara, in A.D. 987. Since the statue was carved for Chōnen after the model of an allegedly Indian statue in the K'ai-yüan-ssu at T'ai-chou (in Kuei-chi, Chekiang) by two brothers Chang from T'ai-chou in the twenty-eight days from August 9 to September 5, 985, and Chōnen left China some time in 986, the image must have been consecrated late in 985 or in 986. None of the prints and other objects placed in the figure, which is listed among Japan's national treasures, is likely to be later than the consecration ceremony. In fact, one of the four image prints bears a date corresponding to November 10, 984 (*chia-shen*, tenth month, fifteenth day), which agrees perfectly with the tradition linking the image to Chōnen's voyage.[35]

One of the prints is very large ($30\frac{6}{8}$ in. high, $15\frac{3}{8}$ in. wide), an image of Śākyamuni (Japanese, Shaka), printed without the slightest blur on white paper that does not reveal its age. The other three form a set and are of smaller size ($21\frac{1}{4}$ by $11\frac{1}{4}$ in.) but of equal technical perfection. They represent, respectively, the three Bodhisattvas Mañjuśrī, Samantabhadra, and Maitreya, Buddha of the Future. It is the last leaf that bears the date 984. The Maitreya print also gives the names of both the designer and the printer: *Tai-chao* Kao Wen-chin *hua* ("painter-in-ordinary Kao Wen-chin *delineavit*"), Yüeh-chou *seng* Chih-li *tiao* ("priest Chih-li from Yüeh-chou *sculpsit*"). Kao Wen-chin's name is recorded. He was born in Shu (Szechwan), where his father and grandfather were court painters. When Shu surrendered to Sung in 965, Kao joined the Academy circle in the capital, Pien-liang. Of his work, nothing else is known today.[36] This is the first case of a painter's name being recorded on a printing block. That the carver of the block was a priest deserves to be noted, as does the fact that he came from, or worked at, a place in Chekiang. But whether the print originated there, in the province

where the Shaka statue was carved, or in the Northern Sung capital in Honan, where the painter lived and where Chōnen stayed in 984, remains an open question.

The quality of the Seiryōji prints, at any rate, is such that the items from Tun-huang and Hang-chou are relegated, by comparison, to the level of provincial folk art.

Chōnen, the learned Buddhist priest and scion of the Fujiwara clan, brought yet another treasure from China, the first printed Chinese *Tri-pitaka*, of which the second Sung emperor, T'ai-tsung (r. 976–997), favorably impressed by his Japanese visitor, had given him an entire set. Of this monumental late tenth-century work, just then completed, we shall read in the next chapter.

CHAPTER II / SUNG PRINTED EDITIONS

OF THE CHINESE TRIPITAKA

The *Sung Annals* might have gloried in an achievement of the printer's art which, even if measured in volume only, far surpassed that of the edition of the *Nine Classics* of 953. They did not. A few passages casually reveal the fact that by 985 the Sung were in possession of a printed Buddhist *Canon*, but nothing is said about its origin, its compass, or its appearance. Perhaps the Confucian historiographers succeeded in eliminating, as suggested by Tokiwa Daijō, some of the documents that would have lastingly testified to the importance conceded to Buddhism by the founders of the Sung Dynasty.[1] That first edition of the *Tripiṭaka*, the *K'ai-pao Tsang* of the 970's, is long since lost. Even later prints made from the original blocks are exceedingly rare. Thus we cannot turn to that edition to reconstruct part of its history. Fortunately, however, there are some sources, Chinese, Japanese, and Korean, on which we can rely.

A Buddhist chronicle compiled by Chih-p'an in 1269, the *Fo-tsu t'ung-chi*, has the following entry:

In the fourth year of the K'ai-pao era [971] in the reign of Sung T'ai-tsu [960–975], Chang Ts'ung-hsin, [eunuch] of elevated rank, received an imperial order to proceed to I-chou [i.e., Ch'eng-tu, Szechwan] to [supervise] the carving of printing blocks of the *Ta Tsang Ching*. In the eighth year of the T'ai-p'ing hsing-kuo era [983] in the reign of T'ai-tsung [976–997] of the same dynasty, the *Ta Tsang Ching* blocks previously ordered from Ch'eng-tu by T'ai-tsu were completed and delivered at the court.[2]

A slightly different account is given in Nien-ch'ang's *Fo-tsu t'ung-tsai*, the preface to which was written by the eminent Yüan Dynasty scholar Yü Chi (1272–1348) in 1341:

In the year *hsin-wei* [971] an imperial order was issued to the authorities of Ch'eng-tu to produce two sets of the Buddhist scriptures written in gold and silver characters. . . . In the sixth moon of this year, an imperial command [was issued] for another set written in gold characters. In the year *jen-shen* [972], an imperial order [was issued] to carve one set of the Buddhist scriptures, to amount to 130,000 blocks.[3]

A third record, Chüeh-an's *Shih-shih chi-ku-lüeh,* which dates from about 1341, may be quoted for its fuller detail:

In the first year of the K'ai-pao era, *mou-ch'en* [968], in the ninth moon, an imperial order [was issued] to the authorities of Ch'eng-tu Fu to produce two sets of the Buddhist scriptures written [respectively] in gold and silver characters under the supervision of the Executive of the Ministry of War, Liu Hsi-ku. In the fourth year of K'ai-pao, *hsin-wei* [971], in the sixth moon, an imperial command for another set written in gold characters [was issued]. In the fifth year of K'ai-pao, *jen-shen* [972], [the emperor] having succeeded in pacifying the various states by his use of military might, had several Canons written in gold and silver characters. In the fifth year of K'ai-pao [972], an imperial order [commanded that] the Buddhist sūtras be cut in woodblocks and the entire Canon be printed. The blocks numbered 130,000.[4]

None of these texts explains why the execution of both the luxurious manuscripts and the more economic prints was entrusted to some institution in the former capital of Shu. But presumably there were trained scribes and superior facilities available there. The great local projects of engraving the *Stone Classics* (begun in 938) and printing the woodblock edition of the *Classics* (begun after 951–953), which were still in progress, could not have been carried on without organized expert labor. Admittedly the editors and scribes employed for the *Classics* were hardly familiar with Buddhist texts, but there may have existed Buddhist scriptoria in the Shu monasteries which could be relied on for both textual accuracy and calligraphic excellence — commensurate with the expectations of an imperial patron. As for the xylographers, who were artisans, there were no ideological obstacles involved. They reproduced whatever texts were given them, and their services may have been available for the Sung emperor even if it interfered with the work of printing the Confucian books.

That comparable or higher standards could be met in Nanking, capital of the Southern T'ang, cannot be doubted. But at the time in question (971/72), the Chiang-nan kingdom was still independent, and remained so until 975 — while Shu had surrendered to Sung as early as 965. Surely the Sung emperor would not have honored the Southern T'ang with his prestigious requests.

The Sung emperor's decision to have the enormous body of Buddhist texts in Chinese translation carved and printed was in keeping with his concern, shared by his successor, for a revival of Buddhism, which had suffered severely from persecution in the mid-ninth century. Demiéville has gathered the records of the emperor's efforts.[5] As early as A.D. 966 he had sent a mission of one hundred and fifty-seven Chinese monks to India to collect Buddhist Sanskrit texts for translation. (One member of the group is known to have returned in 978.) He invited Indian monks

to the Sung capital; arrivals at Pien-liang are noted for the years 971, 973, and 980, when monks came from Central India, Nālandā University (in Bihār), and Northwest-India. These foreigners assisted in the interpretation and translation of Sanskrit texts not as yet incorporated in the Chinese *Tripiṭaka*. They were assigned to a newly established Court of Translations (*I-ching-yüan*) which by an imperial decree of July 9, 982, was set up at the T'ai-p'ing-hsing-kuo-ssu in Pien-liang, a temple previously called Lung-hsing-ssu that had been renamed in 977. This court was organized in the following way: in the center was a Hall of Translations (*I-ching-t'ang*); on the east side, a Hall of Polishing the Style (*Jun-wen-t'ang*); on the west side, a Hall of Verification of Meaning (*Cheng-i-t'ang*). When the shipment of the 130,000 blocks from Shu arrived in 983, another group of buildings was added to the west of the Court of Translations, namely, the Court of Printing the Sūtras (*Yin-ching-yüan*). Here the blocks were stored and impressions made until 1071, when the blocks were transferred to another temple in Pien-liang, the Hsien-sheng-ssu. The two courts, the Court of Translations (consisting of the three halls mentioned) and the Court of Printing, were known as the Court of Propagation of the Law (*Ch'uan-fa-yüan*).[6]

The first foreigner to receive a complete set of the printed edition of the *Canon* was the Japanese priest Chōnen of the Tōdaiji in Nara, who arrived at the Sung capital early in 984 and on April 8 was received in audience by T'ai-tsung (r. 976–997). Returning after a pilgrimage to the sanctuaries of Wu-t'ai-shan (N.E. Shansi), he asked for permission to purchase and take back to Japan one set of the *Ta Tsang Ching*. The emperor granted his request and presented him with a set. Sailing home from T'ai-chou (Chekiang), where he acquired the Shaka statue mentioned above, he was in possession of a cargo consisting, in the main, of 1124 works (*pu*) in 5048 chapters (*chüan*) in 480 wrappers (*han* or *chih*; Japanese, *kan* or *chitsu*), of the following composition:

Divisions	Works	Chapters	Wrappers
Mahāyāna Sūtra (*Ching*)	563	2173	203
Mahāyāna Vinaya (*Lü*)	26	54	5
Mahāyāna Abhidharma (*Lun*)	97	518	50
Hīnayāna Sūtra	240	618	48
Hīnayāna Vinaya	54	446	45
Hīnayāna Abhidharma	36	698	72
Works of Saints and Sages	108	541	57
Totals	1124	5048	480

In addition to these works — which agree with those listed in the Chinese *Tripiṭaka* catalogue of A.D. 730 called *K'ai-yüan-lu*[7] (after the K'ai-yüan

era, 713–741) — Chōnen was given copies of newly translated texts [8] as well as a copy of the *Yü-chih hui-wen chi-sung* (Japanese, *Gyosei emon geju*), "Imperial palindromic hymns of praise," illuminated with pictures of good portent.[9]

Chōnen's collection was ultimately stored at the Hōjōji in Kyōto, a temple built in the 1020's by Fujiwara Michinaga (966–1027), the most powerful of the Fujiwara lords, and it was lost in the fires which occurred in 1140, 1219, 1254, and 1331.[10] Only manuscript copies of that first Sung edition are said to exist (at Hōryūji in Nara and at Ishiyamadera in Ōmi).[11] Chōnen, who rose to the position of chief abbot of Tōdaiji, died in 1016.

Before long, other countries, aware of the existence of a printed *Tripiṭaka* at the Sung capital, submitted requests for the purchase of copies; Korea in 991, Annam in 1010, the Khitan (Liao) in 1019, and the Tangut (Hsi-Hsia) in 1035. The Sung emperors granted those requests, considering, we may suppose, that it was a meritorious act to do so, having the added advantage of increasing political goodwill and enhancing China's cultural prestige. All of these nations — with the exception of Annam — soon produced their own editions.

It is through the record of another Japanese visitor to the Sung capital, the priest Jōjin (1011–1081), who came to Pien-ching in 1073, that there can be traced something of the output of new translations and prints made up to the time of the transfer of the blocks to the Sheng-shou Ch'an-yüan of Hsien-sheng-ssu in 1071. In his *San-Tendai-Godaisan-ki*, "Record of a Pilgrimage to T'ien-t'ai and Wu-t'ai Mountains," the priest has left notes about the texts added to the *Canon* since Chōnen's visit in 984, additions which he was anxious to acquire. Of the 530 *chüan* added he obtained no more than 413 *chüan*, which he was able to ship from the port of Ning-po to his homeland. Jōjin himself did not return; he stayed on in China and died at the K'ai-pao-ssu monastery in the Sung capital in 1081.[12] One single print believed to be a remnant of his acquisitions still exists today, namely, *Fo pen-hsing-chi ching*, or *Buddhacarita*, *chüan* XIX, printed in 1071 from a block carved in 974, which is in the possession of the Nanzenji in Kyōto; it happens to be an old translation (Nanjio, No. 680). It bears a cartouche of the Hsien-sheng-ssu that gives a date corresponding to 1071 — the first decade of the mid-autumn moon, that is, August 28 to September 6, to be precise — as well as the name of the superior of that monastery, Huai-chin (1011–1085),[13] with whom Jōjin had to deal when negotiating his purchase.[14]

A few months earlier, between April 3 and May 2, 1071, according to Demiéville, the Court of Translations was eliminated from the framework of the imperial administration. It was a measure which, advocated

by an opponent of Buddhism such as Ch'en Shu (944–1002) as early as the beginning of Chen-tsung's reign (998–1022), ended the state monopoly of Buddhist printing.[15] Only nine years later, in 1080, the first "private" or nonofficial printing of the Chinese Buddhist *Canon* began at a monastery in Fukien. Even so, reprints continued to be made and new titles incorporated, with imperial authorization, by the printing office at Hsien-sheng-ssu in Pien-liang as late as the reigns of Che-tsung (1086–1100) and Hui-tsung (1101–1125). When Pien-liang was sacked by the Chin Tatars (or, Jurchen) in 1127, the blocks of the Sung *Tripiṭaka* were carried off to the north and lost, and the buildings which housed them were destroyed by fire.

Very few prints from this edition have survived. None of them is older than the *Buddhacarita* Chapter at Nanzenji, mentioned above, printed in 1071 from a block of 974. Another specimen in Japanese possession is a Vinaya text, *Shih-sung-ni-lü (ch. 46)*, printed in 1108 from a block of 974, formerly in the Nakamura Fusetsu collection, now in the Shodō Hakubutsukan or Calligraphy Museum, in Tōkyō.[16] Two specimens of the same year, A.D. 1108, are in China. One of them is Chapter 2 of the *Chung-lun*, that is, Nāgārjuna's *Madhyamaka-Śāstra*, in the collection of Yeh Kung-ch'o; it was printed in 1108 from a block dated K'ai-pao 7 (974) and bears the same cartouche as the Vinaya chapter from the Nakamura collection.[17] The other one, which only recently came to light at Ch'ung-shan-ssu in T'ai-yüan, Shansi Province, is of particular interest because it bears three consecutive dates, namely, K'ai-pao 6 (973), Hsi-ning *hsin-hai* (1071, like the Nanzenji print), and Ta-kuan 2 (1108).[18]

Invariably these prints show the text arranged in fourteen-character columns which are neither separated vertically nor framed horizontally. Under the title of each chapter appears the character — from the *Thousand-Character Classic* — which functions as the number of the wrapper or box where the text belongs. At the right edge of each sheet, preceding the text, the following designations are printed in small characters:

 1. title of the work, sometimes abbreviated;
 2. chapter number (where applicable);
 3. sheet or folio number;
 4. wrapper symbol (in the fixed order of the Thousand Characters). These designations, which completely identify the sheet, were bound to disappear in part or in entirety when the sheet was glued to the (overlapping) preceding sheet to form a *chüan* or scroll; it would seem, therefore, that they served the needs of the repository, the printing shop, and the mounter of the scroll or folded book rather than the reader's convenience. We may assume that the sets sold by the Sūtra Printing Court were delivered in the original wrappers containing loose sheets,

and that the mounting in whatever form desired was a matter left for the purchaser to decide and effect by using outside labor. The scroll form, however, seems then to have been most common. Of the T'ai-yüan specimen it is stated that it was printed on yellow paper, *ying-huang chih*, or paper treated with yellow dye from the inner bark of Phellodendron amurense, and was in the form of a handscroll. It remains to be mentioned that at the end of a chapter the title and chapter number were repeated, while the date, in characters of the same size, was placed after them. The carver's name followed the date but was written in smaller characters.

The cartouche of 1071 is of modest size, about half the length of a text column; the cartouche of 1108, by contrast, occupies the full height of a *sūtra* column of fourteen characters. Impressions of these colophons could certainly be made from small, separate blocks, applied like stamps or large seals. That the T'ai-yüan print shows the colophons of both 1071 and 1108 is rather puzzling. Was it a left-over print of 1071, carefully preserved and finally sold with fresh 1108 impressions? Or was the 1071 cartouche actually inserted into the old woodblock so that it could not but register with each subsequent printing? However it may be, the examples mentioned do offer definite proof of the continuous use of the same blocks throughout the period from 972 to 1127.

A further example of a print bearing the cartouche of 1108 remains to be described in detail, namely, the nearly complete Chapter XIII of the *Yü-chih pi-tsang-ch'üan*, one of the imperial commentaries written for the *Tripiṭaka* edition of A.D. 983. This print, which was acquired by the Fogg Art Museum of Harvard University in 1962, will be discussed in Chapter III. It is of exceptional interest because of its illuminations, four landscape woodcuts dating in all likelihood back to the late tenth century, older than any other landscape woodcut known today.

It is in view of the rather difficult task of properly judging these unparalleled landscape prints that it would seem desirable first to ascertain whether or not they belong to the Sung Imperial edition, and to enquire into the nature and history of the various Buddhist *Canons* published in China or abroad during the Sung period. The following pages are devoted to this enquiry.

THE FIRST KOREAN EDITION: KOREAN A
(1020/21–1099)

This edition consisted of three successive parts:
I. The texts of the *K'ai-yüan-lu* of 730, printed 1020/21–1031;
II. New translations and Imperial prefaces, printed about 1048–1087;
III. A supplement of commentaries, printed about 1091–1099.[19]

When an embassy from Korea (Korean, Koryŏ; Chinese, Kao-li) ar-
rived at the Sung capital in 991, the ambassador Han Ŏn-gong (Chinese,
Han Yen-kung), an executive in the Ministry of War, submitted his
sovereign's request for a printed edition of the Buddhist *Canon*. The
Sung emperor, T'ai-tsung (r. 976–997), complied and presented the am-
bassador with a set of the *Canon* as well as the Imperial commentaries
entitled *Pi-tsang-ch'üan*, "Explanation of the Secret Treasure," *Hsiao-
yao-yung*, "Verses of Leisurely Wanderings," and *Lien-hua-hsin-lun*,
"Wheel with the Lotus Heart." [20] When Han delivered the set, which
according to his biography in *Kao-li ming-ch'en-chuan* consisted of 481
wrappers (*han*), he was received by the king, Sŏngjong (Ch., Ch'eng-
tsung; r. 981–996), who immediately invited Buddhist monks for readings
in the royal palace.[21] Two years later (993) the gift from China was
formally acknowledged by the Korean king.

Soon afterward the prosperous kingdom was forced into an alliance
with the neighboring empire of the Khitan (Ch., Ch'i-tan), a Mongol-
speaking people that had risen to power after the fall of T'ang (A.D.
906). To boost the prestige of his nation, Hyŏnjong (Ch., Hsien-tsung;
r. 1010–1031), in the second year of his reign (1011), decided to emulate
the Sung and bring out a Korean edition of the *Tripiṭaka* in Chinese.
This edition (Korean A–I), which — exactly like the Sung *Canon* on
which it was modeled — comprised the 5048 chapters of the *K'ai-yüan-lu*,
appeared during the reign of Hyŏnjong, thus before 1031.[22] During the
following three reigns, those of Tŏkchong (Ch., Te-tsung; 1032–1034),
Chŏngjong (Ch., Ching-tsung; 1035–1047), and Munjong (Ch., Wen-
tsung; 1048–1083), additional blocks were carved to cover translations
of more recent date.[23] By A.D. 1087, in Sŏnjong's (Ch., Hsüan-tsung)
fourth year, the work was completed, according to the *Annals* of Koryŏ.[24]

In 1086, Ŭich'ŏn (Ch., I-t'ien; Jap., Giten), Munjong's fourth son,
who had become a Buddhist priest very early in his life (1055–1101),
headed a Korean mission across the sea to China. Having been received
by the Sung emperor, Che-tsung (r. 1086–1100), and having traveled for
fourteen months, he returned to Korea with a veritable library of Chinese
Buddhist texts and commentaries, as well as secular works. He compiled
a catalogue of these works, *Hsin-pien chu-tsung chiao-tsang tsung-lu*,
which is still in existence.[25] His acquisitions were the basis of a Korean
Supplement to the *Tripiṭaka*, the blocks of which were carved and stored
at a monastery called Taehŭngwangsa (Ch., Ta-hsing-wang-ssu). Ap-
parently this *Supplement* was brought out in Ŭich'ŏn's lifetime, during
the years 1091–1099. A copy of it came to Japan as early as 1105, and
a few prints from this copy have survived there. H. Ikeuchi mentions a
set of forty scrolls, part of a commentary to the *Hua-yen-ching* (Jap.,

Kegon-kyō; Sk., *Avataṃsakasūtra*), in the library of the Tōdaiji in Nara, three of which are dated with Khitan era years: Ta-an 10, Shou-ch'ang 2, and Shou-ch'ang 3, which correspond to A.D. 1094, 1096, and 1097.[26] At the Shinpukuji in Nagoya is a print of A.D. 1099 which carries two handwritten notes with Japanese *nengō* dates, Chōji 2 (A.D. 1105) and Kōan 5 (A.D. 1282), the earlier of which provides both the date of the copy's arrival in Japan and a safe *terminus ante quem* for the edition.[27] Two chapters of a commentary to the *Nieh-p'an-ching* (Sk., *Nirvāṇasūtra*) collated by Ŭich'ŏn himself and printed in 1099 were discovered accidentally by a Japanese official in a Korean monastery, Songgwangsa (Ch., Sung-kuang-ssu), in 1922.[28]

The Korean prints had fourteen characters to the column; they were done on yellow paper, and are said to have been mounted as scrolls with red roller ends (*chu;* Jap., *jiku*). They were provided with frontispieces (Jap., *tobira-e*) and occasionally with illuminations. The blocks of the first and second parts (I, II) were kept at the Puinsa (Ch., Fu-jen-ssu) in the capital, Kaesŏng (Ch., K'ai-ch'eng),[29] while those of the *Supplement* (III), as mentioned above, remained at the Taehŭngwangsa (Ch., Ta-hsing-wang-ssu).

THE SECOND KOREAN EDITION: KOREAN B (1236–1251)

The printing blocks of the first Korean edition were lost when, in Kojong's (Ch., Kao-tsung) nineteenth year (A.D. 1232), a Mongol army invaded the country and the two monasteries, Puinsa and Taehŭngwangsa, went up in flames. Only four years later, however, in 1236, Kojong, whose court had found a safe refuge on the island of Kanghwa (Ch., Chiang-hua) off the west coast, issued orders to Prime Minister Yi Kyu-bo (Ch., Li Kuei-pao) to arrange a new edition of the *Canon*. It was expected that the efficacy of a new edition would be such as to bring about the downfall of the Mongols. After fifteen years of work, in 1251, still within Kojong's reign (1214–1259), the task was completed.[30]

The new *Canon* contained the texts of all the previous issues. The prints were again mounted as scrolls, every sheet having 23 columns of 14 characters. On the right margin of each sheet were printed the title of the text, the chapter number, the sheet number, and the character from the *Thousand-Character Classic* designating the number of the wrapper. Mr. Ogawa notes that in this edition the word "sheet" was rendered by the character *chang* (Japanese, *chō*, "stretch"), whereas in the older edition the characters *fu* (Japanese, *fuku* "hanging picture") or *chang* (Japanese, *jō* "ten feet") were used. The set consisted of 1524 works in 6558 *chüan*, divided into 628 wrappers.[31]

A Korean priest, Sugi (Ch., Shou-ch'i), painstakingly collated these texts with those of the Northern Sung Imperial edition, of the earlier Korean edition, of the Khitan edition, and of ancient *sūtra* manuscripts as well, for which the *Canon* of 1236 is renowned among the editions in existence. Sugi's labor resulted in a publication of 30 *chüan*, the *Hsin-tiao Ta-Tsang chiao-cheng pieh-lu*, "Special catalogue of revisions in the newly edited *Canon*." Of the original blocks, no less than 81,258 are said to be still in existence today at the Haeinsa (Ch., Hai-yin-ssu) Monastery; engraved on both sides, they form the equivalent of 162,516 printing plates. Weighing about 3.5 to 3.75 kilograms apiece, these blocks, which are protected against insects by a coating of varnish and whose corners are reinforced by iron bands to prevent warping, measure about 66 cms in width, 24.2 cms in height, and 6.4 cms in thickness; their total weight exceeds 285 metric tons.[32]

This edition, according to Tokushi Yūshō, has no illustrations.[33]

THE KHITAN OR LIAO EDITION
(1031–1059)

The Khitan people, founders of the Liao Dynasty (907?–1124), who had risen in Eastern Mongolia to overrun the territories to the north of the Sung empire, had received a copy of the Sung *Tripiṭaka* in A.D. 1019. A statement concerning this copy in the *Fo-tsu t'ung-chi* names, it is true, the Eastern Jurchen as receivers — erroneously so, because, as has been pointed out by Tokiwa Daijō, the Jurchen counted for little on the political scene until they overthrew the Khitan in 1124.[34] At any rate the Khitan, illiterate before their contact with the Chinese, none-theless soon contributed a printed *Canon* of their own, which with respect to accuracy and completeness appears to have surpassed the Sung and Korean editions then current. It was begun and largely carried out in the reign of Hsing-tsung (1031–1054), but completed only under Tao-tsung, in the fifth year of the Ch'ing-ning era (1059).[35] Of course, the task of collating the texts and supervising the engraving of the blocks was left to learned Chinese monks; they acted, however, under orders of the Khitan rulers. Copies were distributed within the country and abroad. The Koreans received one in Ch'ing-ning 8 (1062); several other copies followed — well before Prince Ŭich'ŏn's *Supplement*, which prof-ited from this extensive and, in Pelliot's evaluation, truly critical edition.[36] The texts incorporated in it were those of the *K'ai-yüan-lu* (480 wrap-pers), of the *Hsü K'ai-yüan-lu* (25 wrappers), of various exegetic books and commentaries, as well as the Sung translations (74 wrappers), their wrappers numbering 579 in all, according to Ogawa Kanichi's computa-tion.[37] The numbering of these wrappers, which differed from the system

devised for the Sung and Yüan editions, followed the order adopted by the priest K'o-hung of Later Chin (936–946) in his catalogue entitled *Hsin-chi Tsang-ching yin-i sui-han-lu,* "Catalogue of a new compilation of Buddhist scriptures and phonetic and semantic [commentaries] in the order of wrappers." [38]

The Khitan prints are believed to have been executed on thin paper and, as Nogami Shunsei informs us in his article on the *Kittan Daizōkyō,* to have differed from the Sung and Korean editions in the smaller size of the sheets and the accordingly smaller size and denser placement of the characters.[39]

Of that important edition, of which a complete set was stored at the Ta Hua-yen-ssu monastery of the "Western Capital" of the Liao (Ta-t'ung in Shansi Province), nothing seems to have survived except a few fragments excavated in Turfan; these would date from, or possibly antedate, the time of the Western Liao (1125–1211) in East Turkestan, where by 1141 they had succeeded in establishing, together with the Uigur Turks, an empire that was known as Kara-Khitai, "Black Khitan." [40]

THE CHIN EDITION
(SHANSI, 1141–1189)

Far better fared the edition which the people of Shansi Province undertook fourteen years after the loss of the Northern Sung *Tripiṭaka* blocks. These were confiscated, it will be remembered, by the successors of the Liao in North China, the Tungusic Jurchen (who chose the dynastic name of Chin, "Gold"), when they occupied Pien-liang in 1127. The inscription of a stele set up at the Hung-fa-ssu monastery in Yen-ching (Peking) in 1193 tells us that a printed *Canon* was submitted to the Chin court in 1178 by the nun Fa-chen from Lu-chou, Shansi. According to that inscription, the *Canon* in question consisted of 682 wrappers (about 7000 *chüan*) and had been printed over a period of thirty years at the T'ien-ning-ssu in Chieh-chou, S.W. Shansi. Soon after 1178, however, the printing blocks were brought from there to the just mentioned Hung-fa-ssu in Peking, where printing was continued from 1189 onward. They were still there in the Mongol period, and their number must have increased somewhat, as the total number of scrolls amounted to no less than 7082 by Chih-yüan 22 (A.D. 1285).[41]

In 1934, a large part of this edition was discovered at a monastery named Kuang-sheng-ssu in Chao-ch'eng, Shansi. These texts comprised the core of the *Canon,* with Yüan additions printed at the Hung-fa-ssu in the reign of Ogodai (1229–1241) and Ming and Ch'ing supplements as well, 4957 *chüan* all told, in the form of handscrolls of yellow paper,

with red axle-caps like the scrolls of the first Korean edition. The Chin prints were embellished with frontispieces showing the Buddha discoursing. A general account of this find was given by Chiang Wei-hsin, in *Chin Tsang tiao-yin shih-mo k'ao*, "Investigation into the history of the Chin Tripiṭaka block-prints," in 1935. Many of the scrolls had suffered from moisture, but the majority, about 4000 scrolls now in the Peking National Library, are still in good condition, as is a smaller number (about 152 scrolls) in the Shansi Provincial Museum.[42]

A well-preserved specimen of the year Cheng-lung 2 (1157) is in the possession of the Tenri University Library at Tenri, Nara-ken, namely, Chapter 9 of the *A-p'i-ta-mo fa-chih-lun* (Sk. *Abhidharma-jñānaprasthāna-śāstra;* Nanjio, No. 1275) in Hsüan-tsang's translation. It is in the form of a scroll, printed on yellow paper sheets with 23 columns of 14 characters each, and is provided with the typical frontispiece. The layout is obviously modeled on that of the Imperial Sung edition, though in addition the text has lines framing it above and below. A colophon gives the names of the contributors from Hsia-hsien in Chieh-chou who together donated thirty ounces of gold, and, following a formula of benediction, a date which corresponds to April 25, 1157.[43]

On the basis of the "thirty years" mentioned in the inscription of the Peking stele as having passed since the inception of the Shansi edition, it has been assumed that its printing was begun in 1149, thirty years before delivery in 1178. The earliest date encountered, however, among the prints recovered in Shansi corresponds to A.D. 1141.[44]

A detail worthy of note in connection with the similarity observed above of the Chin *Canon* to the Imperial Sung edition is the fact that in at least one instance, mentioned in Hsiang Ta's "Notes on some extant versions of Hsüan-chuang's *Ta T'ang Hsi Yü Chi*," the date of K'ai-pao 6 (A.D. 973) is repeated in the Chin print; it proves the close dependence of the present edition on the *K'ai-pao-Tsang* and explains its similarity with the Korean A.[45]

THE TUNG-CH'AN-SSU EDITION
(FU-CHOU A; 1080–1112 AND LATER)

After the Sung government by a decree of Hsi-ning 4, third month, seventeenth day (April 19, 1071) discontinued support of the Sūtra Printing Court (that was converted into the official residence of the Finance Commissioner), a monastery in Fukien, Tung-ch'an Teng-chüeh Yüan, "Court of Absolute Enlightenment of Eastern Ch'an," on the White Horse Mountain at I-su-li in Min-hsien, Fu-chou, was the first to undertake a new edition of the Buddhist scriptures. The earliest date found in the prints of this edition corresponds to A.D. 1080. It is possible,

however, that printing actually began before that year because, as related by Ogawa, the colophons to the 600 chapters of *Prajñāpāramitā* texts, while giving no date, acknowledge Yüan Chiang as sponsor. Yüan Chiang, whose biography is found in the *Sung Annals* (*ch.* 343), was the very official who took the former Printing Court as his residence, having been promoted to Finance Commissioner by the governor of the Sung capital. As he retired in 1079 and died in 1080, his promotion must have taken place well before 1079. The colophons in question must in turn antedate his promotion because they indicate his rank as Ts'an-chih-cheng-shih, "Assistant Executive of the Secretariat-Chancellery," which is the lower rank. Be that as it may, the *Prajñāpāramitā* prints in all likelihood antedate the year of Yüan Chiang's death, which no doubt dealt a serious blow to the monastery.[46]

Private donations enabled the monastery to complete the printing of its *Canon*. By 1103 the 480 wrappers containing the *K'ai-yüan-lu* titles had been published. In the same year a building was constructed to house the blocks and a printing shop. Above its portal was displayed a tablet with the two characters TA TSANG, "The Great Canon," carved after the handwriting of Mi Fei (1051–1107). On December 24, 1103, the Emperor Hui-tsung (r. 1101–1125) bestowed the name of the era on the new edition, which then became known as the *Ch'ung-ning Wan-shou Ta-Tsang*, "Great Canon of the Emperor's Birthday of the Ch'ung-ning [era, 1102–1106]," while the Tung-ch'an Monastery itself was given the official designation Ch'ung-ning-ssu.[47]

In 1107 work on the edition of the new Sung translations was begun. Five years later, in 1112, the blocks available were, according to Ogawa, capable of printing 564 wrappers covering over 1430 titles in more than 5700 *chüan*. The Tsang-yüan continued in use throughout the Southern Sung period, printing 16 additional wrappers in the Ch'ien-tao and Shun-hsi eras (1165–1189).[48] In fact, prints were made here as late as the Chih-chih and T'ai-ting eras (1321–1327) in Mongol times, as Pelliot has observed.[49]

Presumably that Fukien monastery sold its prints widely, as it was neither supported nor restricted by the government. Several copies of its *Tripiṭaka* still exist in Japan today. Nakayama lists those of the Toshoryō of the Imperial Palace, of the Chionin in Kyōto, of the Kangakuin on the Kōyasan, and of the Kompon Chūdō on the Hieizan.[50] Another possibly complete set is owned by the Kanazawa Bunko in Kanazawa near Yokohama.[51] In addition, there occur single items such as those in the Yasuda Bunko (two, dated in accordance with A.D. 1097 and 1103);[52] at Chūsonji, Hiraizumi (one, dated 1100);[53] in the Ryūkoku University Library in Kyōto (one, dated 1085);[54] at Ōtani Uni-

versity in Kyōto (two, dated 1085 and 1091);[55] at Tenri University Library (one without a date);[56] in the British Museum (one, dated 1097).[57] More or less complete copies are in the *sūtra* repositories of the Tōji, Kyōto,[58] (including the Sung Imperial prefaces, printed in Ta-kuan 3 or A.D. 1109), and of the Daigoji, Kyōto.[59] Other examples have survived in China: prints dated in accordance with A.D. 1080, 1085, 1091, 1100, 1110, and 1112 are mentioned in *Wen Wu*, 1962.[60]

The Fu-chou A *sūtras* are folded books with 17 characters to the column, 6 columns to the page, and 5 pages to the sheet. They are printed on strong paper that did not require mounting. Though modeled on the Imperial *Canon*, this edition was carried out with greater economy. Illuminations like those found in the Imperial Sung, Korean, and Chin editions apparently were a luxury the monastery could not afford.

THE K'AI–YÜAN CH'AN–SSU EDITION
(FU-CHOU B; 1112–1151 AND LATER)

The K'ai-yüan edition was begun the very year that saw the Tung-ch'an-ssu or Tung-ch'an Teng-chüeh Ch'an-yüan edition (Fu-chou A) completed. The K'ai-yüan Monastery, like the Tung-ch'an-ssu, was located in the district of Fu-chou. That rivalry was the motivation behind the gigantic project of duplicating the achievement of the Tung-ch'an Monastery cannot be doubted. Ogawa Kanichi has pointed out that the position of eminence which the Tung-ch'an-ssu had only recently achieved, as the sanctuary officially designated to perform the rites observed on the emperor's birthday — Hui-tsung's in this case — was enjoyed by the K'ai-yüan-ssu far earlier, during the K'ai-yüan era (713–741) in T'ang Ming-huang's reign (the era after which the often mentioned *K'ai-yüan-lu* was named); and that the superior of the K'ai-yüan-ssu was a follower of the Ch'an sect called Ts'ao-Tung (Japanese, Sōtō), while his counterpart at Tung-ch'an-ssu belonged to the Lin-chi Sect (Japanese, Rinzai) of Ch'an Buddhism.[61]

At any rate, the result of this rivalry was a new *Tripiṭaka* consisting of 6000 *chüan* of scripture in the form of folded books (*che-pen;* Japanese, *orihon*), folded in the manner of an accordion, issued in the year Shao-hsing 21 (A.D. 1151), and followed by additional issues in 1164, 1176, and 1268. Printing continued down to the Ta-te era (1297–1307) of the Yüan Dynasty. The format, identical with that of the Tung-ch'an edition, was one of 17 characters to the column and 30 columns to the sheet. It may have been executed a trifle less carefully than was the Fu-chou A edition.[62]

Numerous prints of this edition have survived, though often mixed with Fu-chou A prints. The sets at Chionin in Kyōto, at Shimpukuji in

Aichi Prefecture, at the Kanazawa Bunko in Kanazawa, and at the Chūsonji at Hiraizumi in Iwate are listed as K'ai-yüan-ssu issues by Ogawa.[63] Samples published of the holdings of Chūsonji carry dates corresponding to A.D. 1112, 1125, 1126, 1129, and 1148 — the last taken by Nakayama to be the terminal year of the edition.[64] Stray volumes which I have seen fall within the same time range; they are in the British Museum (1124, 1148), in the Tōkyō Imperial Library (1148), and in the Ōtani University Library in Kyōto (1125). The prints were made on strong yellow paper and covered with dark blue paper envelopes. They were not illuminated.

THE SSU-CH'I EDITION
(CHEKIANG; BEGUN IN 1132)

As the first *Canon* to be begun in the Southern Sung period, the Ssu-ch'i edition was anciently known as the "Southern Sung Tripiṭaka," though other and more specific designations such as *Ssu-ch'i Tsang* (from the locality of the monastery), *Hu-chou pan* (from the name of the district, Hu-chou), or *Che pen* (from the name of the Province of Chekiang) were current as well. Its timing suggests that it was meant to replace the Northern Sung *Canon* lost during the sack of Pien-ching in 1127. The initiative in the printing of this edition was taken by a private group, a clan headed by Wang Yung-ts'ung, former Supervisor (*Kuan-ch'a-shih*) of Mi-chou in Honan, who with his wife, his younger brother, two nephews, and two grandsons and their wives not only financed the printing of this edition but even built — between 1127 and 1130 — the monastery where the printing was to be undertaken, complete with an eleven-storied pagoda and printing shop (*yin-ching-fang*). Their names are known from one of the rare colophons of this edition, contained in Chapter XXII of a *Ch'ang-a-han-ching* (Sk., *Dīrghāgama-sūtra;* Nanjio, No. 545) now at Nanzenji in Kyōto.[65] Quoted *in extenso* in Wang Kuo-wei's *Liang Che ku-k'an-pen k'ao*, "Investigation of ancient block-prints from Chekiang," the colophon is dated Shao-hsing 2 (A.D. 1132) and is signed by the superior of the monastery, Huai-shen,[66] who lived 1077–1132.[67] Before joining the monastery at Ssu-ch'i, which was named Yüan-chüeh Ch'an-yüan, "Meditation Court of Complete Enlightenment," Huai-shen was a priest of the Hui-lin Ch'an-yüan, or "Meditation Court of the Forest of Intuitive Insight," in the Northern Sung capital of Pien-liang.[68]

In a passage quoted by Wang Kuo-wei from the *Wu-hsing Gazetteer* of the Chia-t'ai era (1201–1204), we find a statement to the effect that the *Canon* printed at Ssu-ch'i consisted of 5480 *chüan*.[69] Unless that figure was merely an estimate, not to be taken literally, these *chüan* were

apparently arranged in such a manner that ten of them formed one wrapper (*han*), for the number of wrappers was exactly 548 — corresponding to the characters from 1 (*T'ien*) to 548 (*Ho*) in the order given in the *Thousand-Character Classic*. This may be seen from the catalogue of the Canon, *Hu-chou Ssu-ch'i Yüan-chüeh Ch'an-yüan hsin-tiao Ta-Tsang Ching Lü Lun teng mu-lu*, where the titles are listed under those characters, and where in fact the proportion of ten *chüan* to one *han* (symbolized by such a character) was as a rule observed. It is not known precisely when the work on this edition was concluded.

The contents of the aforesaid catalogue were reproduced in a second one, issued in 1242 when the *Canon* was enlarged by 450 *chüan*, which, according to Ogawa, were divided among 51 wrappers with the *Thousand-Character* designations corresponding to the numbers 549 (*Chi*) through 599 (*Tsui*).[70] The title of the second catalogue, however, differs from that of the first one, because the name of the district (Hu-chou) had been changed to An-chi (in A.D. 1225) and the monastery itself renamed Fa-pao Tzu-fu Ch'an-ssu. Hence the new title was *An-chi-chou Ssu-ch'i Fa-pao Tzu-fu Ch'an-ssu hsin-tiao Ta-Tsang-ching mu-lu*. This change may have given rise to the belief that here was yet another complete *Canon*, distinct from that of Hu-chou Ssu-ch'i. Details supplied by Ogawa confirm the view held by Wang Kuo-wei and Demiéville that there was only *one* Ssu-ch'i edition with later supplements.[71]

In 1276 the temple with its printing shop and the printing blocks perished in a fire set by Mongol soldiers. Fortunately Japan was by then in possession of several copies of the *Ssu-ch'i Tripiṭaka*, which today are found in the libraries of the following temples: Zōjōji, Tōkyō; Rinnōji, Nikkō; Kita-in, Saitama; Iwayadera, Aichi; Chōrōji, Gifu; Tōshōdaiji, Nara; Hasedera, in Yamato. Another copy is owned by the Ōtani University in Kyōto.[72]

Like the two Fu-chou editions, the *Ssu-ch'i Canon* was in the form of folded books with 6 columns of 17 characters to the page and 30 columns to the sheet, each sheet consisting of 5 pages and being folded 4 times. There are no colophons at either the heads or the ends of the texts, and only once or twice in the entire *Canon* does the long colophon appear that mentions the names of the contributing members of the Wang clan and the date Shao-hsing 2 (1132). One instance of this colophon may be seen preceding the title of *Fa-yüan chu-lin*, Chapter LI, owned by the Chūsonji in Hiraizumi.[73] Another distinguishing feature of this edition is the placing of its glossaries, which are appended to the ends of the chapters (*chüan*), rather than relegated to separate sheets within the wrappers, as they were in the Tung-ch'an-ssu edition.[74] The envelopes, moreover, were made not of dark blue but of yellow paper with the titles written in ink, not in gold.

THE CHI-SHA EDITION
(KIANGSU; 1231–1363)

The last of the printed editions of the Chinese *Tripiṭaka* begun, but not completed, in the Southern Sung period, originated at a monastery located on Chi-sha, "Sand Holm," an islet in the Ch'en Lake east of P'ing-chiang-fu in Kiangsu, near the Yangtse estuary. A priest from Hua-t'ing had built a hermitage on the islet in 1172. After his death a *stūpa* was erected by his disciples over his remains, while the hermitage was raised to the rank of Yüan and named Yen-sheng Ch'an-yüan, "Meditation Court of Lasting Holiness."

Printing was begun here, presumably with local support, about 1231, which is the earliest date encountered in the colophons. In the following year a descendant of the Imperial clan, Chao An-kuo, took charge of raising funds for this purpose in Kiangsu and Chekiang, and himself contributed toward the expense of carving and printing the *Mahā-prajñāpāramitā-sūtra* in 600 *chüan* (Nanjio, No. 1) and the *Pañcaviṃśati-sāhasrikā-prajñāpāramitā* or "Prajñāpāramitā in 25,000 articles" in 30 *chüan* (Nanjio, No. 3). A catalogue of the edition as it was planned was issued in 1234. Though largely still in the nature of a prospectus, it may have facilitated the flow of further contributions, for between 1237 and 1252 (Chia-hsi and Shun-yu eras) a large number of *sūtras* appeared in print, evidence that money had been forthcoming. A fire which occurred in 1258 brought this activity to a standstill, so that at the end of the Sung period the Chi-sha edition was still incomplete.[75]

It was not until about 1299, the country under Mongol domination, that the carving of new blocks was started again, by which time the Yen-sheng Ch'an-yüan had been designated Yen-sheng-ssu. Fresh support was soon forthcoming. In 1305 (Ta-te 9) Chu Wen-ch'ing, Left Deputy of the Secretariat, and his clan supplied the money necessary to bring out 1,000 *chüan* (about 10,000 blocks). When in the following year Kuan-chu-pa, "Former Administrator of the Buddhist Clergy of Sung-chiang Prefecture," whom Pelliot[76] took to be of Tangut or, possibly, of Tibetan origin, lent his support to the monastery of Chi-sha, it took no more than a year's time to print the more than one thousand *chüan* (contained in the prospectus) which were still missing. In addition he edited several hundred *chüan* from Sūtra, Vinaya, and Abhidharma texts of the esoteric sects.[77] Yet some additions were made even later, for the latest colophon, according to Demiéville's account, bears a date corresponding to A.D. 1363.[78]

In 1929 a nearly complete copy of the *Chi-sha Tripiṭaka* was discovered in two temples in Hsi-an in Shensi, the Wo-lung-ssu and the K'ai-yüan-ssu. Of this copy a reprint in reduced size was made in Shanghai a few

years later.[79] Another copy is said to have been found, Demiéville noted, in private hands at Osaka by Ono Gemmyō in 1939.[80] Surprisingly, a set of this *Canon* came to light more recently at the Ch'ung-shan-ssu in T'ai-yüan, Shansi. Its contents, according to Ogawa, exceed those of the prospectus of 1234 by 28 wrappers of esoteric scripture and 3 wrappers containing the 30 *chüan* of the *T'ien-mu Chung-feng kuang-lu*, "Extensive record [of the sayings] of Chung-feng from T'ien-mu [Mountain]," a compilation of 1321–1323 by a disciple of the Ch'an master Chung-feng (Nanjio, No. 1533).[81]

The Sung blocks of the Chi-sha edition were modeled on the Ssu-ch'i prints. The Yüan blocks, on the other hand, followed the pattern set by the Hang-chou Ta-p'u-ning-ssu edition (1269–1285), and some of the texts were printed from blocks sent from Hang-chou in 1363. The format of this edition is that of the folded book with 6 columns of 17 characters to the page. The Yüan prints found at Hsi-an and T'ai-yüan are embellished with frontispieces showing the Buddha discoursing to a large audience.[82] Their style, which reveals a strong Tibetan influence, recurs in the frontispieces of the *Tangut Tripiṭaka* in Tangutan or Hsi-Hsia characters that was printed also at Hang-chou between 1302 and 1307.[83] Curiously, the *Chi-sha Canon* is linked to the *Tangut Canon* in a factual matter: some of the Chi-sha prints made between 1307 and 1315 were printed from blocks of the Tangut version that had large blank spaces left.[84]

Chi-sha was the last edition to contain Imperial prefaces of the Sung period. The subsequent Chinese editions suppressed them, as the first annotation to the *Yü-chih pi-tsang-ch'üan* (Japanese, *Gyosei Hizōsen*) in the *Dai Nihon kōtei Daizōkyō* (Vol. 386) states simply and unequivocally. It is unnecessary, therefore, to carry our survey of the printed editions of the Chinese *Tripiṭaka* into post-Sung times.

CONCLUSION

Can the foregoing survey, aside from its intrinsic interest for the history of the Buddhist *Canon* and of printing in Sung China, provide any clues to the age and authenticity of the *Pi-tsang-ch'üan* Chapter XIII in the Fogg Art Museum? Do the descriptions of the various editions and extant specimens confirm the validity of the date of A.D. 1108 given in the colophon? Is there any evidence which contradicts that of the prints themselves?

If these questions seem overly cautious or pedantic, it should be borne in mind that these prints and woodcut illuminations are unique. They cannot be judged by comparing them with another copy of this edition, for no other is known to exist. Of the other editions none has woodcut pictures like those of the *Pi-tsang-ch'üan* except the Korean one at Nan-

zenji in Kyōto, which has not yet been published. Though I deal at greater length with the woodcuts of the *Pi-tsang-ch'üan* in Chapter III, I will here briefly sum up those points which seem most relevant in an appraisal of the prints in question.

1. The existence of Imperial prefaces of the late tenth century cannot be doubted because they are contained in various editions based on the Northern Sung *Canon*, those of the Koreans, of the two Fukien monasteries, and of the Chi-sha-ssu. As for the *Pi-tsang-ch'üan* in particular, the record of the *Kao-li ming-ch'en-chuan* mentioning Han Ŏn-gong's mission to Sung China proves that it was printed by A.D. 991 at the latest.

2. Of the earliest likely date for the printed edition of the *Pi-tsang-ch'üan*, there are two indications. Chōnen, visiting the Sung capital in 984, received the *Hui-wen chi-sung* but not, apparently, any other Imperial *opus*. This would indicate, then, that the *Pi-tsang-ch'üan* had not at that time appeared in print. The second indication is provided by the numbers of the wrappers of the *Pi-tsang-ch'üan* in the Northern Sung, Korean A, Tung-ch'an-ssu, and K'ai-yüan-ssu editions, which were consistently "*Yin*" and "*Tso*" (532, 533). That means that in the order of blocks to be carved, the blocks for these wrappers ranked well behind the last for the Ch'eng-tu series, which ended with "*Ying*" (480). This, too, places the carving of the *Pi-tsang-ch'üan* blocks no earlier than about A.D. 985. Hence we may assume for the *Pi-tsang-ch'üan* blocks a date between 984/85 and 990/91.

3. The chapter in question has 14 characters to the column. In this it agrees with the Korean, the Khitan, and the Chin editions. All the later editions, beginning with Fu-chou A, have 17 characters to the column. Our *Pi-tsang-ch'üan* chapter, therefore, belongs with the former group. It is very close to but not identical with the Korean A chapters which actually exist. It cannot be of the Khitan (Liao) edition because the numbering of the latter differs. Nor can it be of the Chin edition because the framing lines which appear in that edition above and below the text are absent in our print.

4. The sheets of the *Pi-tsang-ch'üan* Chapter XIII were apparently never folded, suggesting that they belong with none but the scroll-form editions, namely, Northern Sung, Khitan(?), Chin, and Korean A editions in their original form. The Fukien and later prints are folded books always. Possibly, however, the purchaser of a set of printed sheets decided for himself whether the prints were to be mounted as scrolls or in the handier *orihon* form of the folded book. Thus, while not insisting on the importance of this feature, I wish to record it as one favoring a Sung date.

5. A technical detail indispensable in the production of these monumental editions was the systematic numbering of blocks and printed sheets. As a rule, we find on the right margin of each sheet in small characters (a) the title of the work, (b) the chapter number, (c) the sheet or leaf number, and (d) the wrapper or box number expressed by a character from the *Thousand-Character Classic*. These would ordinarily disappear when the margin was covered by the preceding sheet. In many of the folded books such as the Fukien *sūtras* we notice an innovation: the numbers have moved from the margin to the intercolumnar space of the first fold (between columns 6 and 7), where they remain visible. In some of the Yüan prints the numbers are printed on the second fold (between columns 12 and 13), at the outer edge, where they are more readily visible — more or less in keeping with the standard form of pagination in Chinese books.

The various editions differ slightly in the designations used to identify sheets, so that these designations may be useful in determining the origin of a stray print. In the case of the *Pi-tsang-ch'üan* prints, the designations are very brief:

"*Pi* (title abbreviated), 13th (*chüan*), . . . (sheet number)."

On some of the sheets follow what may be the block-carvers' names (text leaves 5, 6, 7, 11, 13, 14). Unfortunately they are illegible because of the overlapping of the preceding leaves, except in two cases: leaf 6 shows the character *yeh*, "leaf" (or family name Yeh); leaf 14, two characters, *yang*, "willow" (or family name Yang) and *yün* (or *wen*) "to collect." On leaf 7, two radicals or classifiers are clear, namely, *kung*, "bow" (conjecturally, part of the family name Chang) and *ch'o*, "move" (Radical 162).

I am not aware of any parallel to the extreme terseness of the designations and the addition of the names(?) in these prints, where, moreover, the *Thousand-Character* number is suppressed. These features, differing from those of the Szechwan blocks, may point to an origin of these blocks other than Szechwan.

6. The name of the printer appears below the title repeated at the end of our Chapter XIII: Shao Ming *yin*, "printed by Shao Ming." The presence of such a signature at the end of the text recalls the four extant prints of the *K'ai-pao Tsang* mentioned above, which bear the following names:

Lu Yung (973/1071/1108 print from T'ai-yüan),
Lu Yung (974/1108 print in the Shodō Hakubutsukan),
Sun Ch'ing (974/1108 print at Nanzenji, Kyōto),
Ch'en Yüan *yin* (974/1108 print in the Yeh Kung-ch'o collection).

Undeniably the signature and its position in Chapter XIII of the *Pi-tsang-ch'üan* continue a practice in use in the K'ai-pao blocks from Szechwan.

7. Among the features which must be taken into consideration are the measurements of the prints of the several editions under discussion. The measurements that I was able to ascertain are given below:

Edition	Width of sheet	Height of text	Collection
N. Sung	*ca.* 52.0 cms	22.4 cms	Fogg Museum
Korean A	*ca.* 52.4 cms	*ca.* 23.0 cms	Nanzenji
Korean B	*ca.* 56.8 cms		Toshoryō
Liao(?)	48.0 cms	21.0	Ryūkoku
Chin	*ca.* 48.0 cms		Tenri
Fukien A	67.8 cms	*ca.* 25.0 cms	Tōji
Fukien B	67.2 cms	*ca.* 30.5 cms (leaf)	Toshoryō
Ssu-ch'i	56.0 cms	*ca.* 25.0 cms	Ryūkoku

Clearly the blocks chosen to print these editions differ greatly in size. Editions more frequently encountered, such as Fukien A and B, show that their size was persistent and standardized. It should be noted that the dimensions of the Korean A and B editions are virtually identical with those of the Northern Sung edition.

8. The cartouche of A.D. 1108 at the end of Chapter XIII, which from analogy with the few extant prints bearing the same cartouche must be considered as reliable evidence for the date and origin of the fragment, gives no direct indication of where it originated. It mentions neither a monastery nor a town or district. But its recurrent connection with the K'ai-pao prints and the Hsien-sheng-ssu cartouche of 1071 in the T'ai-yüan specimen links it to the Hsien-sheng-ssu at Pien-liang, the repository of the blocks in use down to the time of the catastrophe of 1127. There is no other known or likely source for any of those prints.

The text of the cartouche runs as follows:

We hear that to donate *sūtras* is a wonderfully meritorious act, reaping the beneficial consequences of the three Vehicles, [and that] to praise and intone the true discourses will save [one] from the fruits of Karma leading to the five destinations [i.e., the realms of hell, ghosts, animals, men, and Devas]. Thus [it is our] vow that in the whole Dharmadhātu and in the boundless waters and lands all living beings alike may ascend to the shore of enlightenment. — Completed in the year Ta-kuan 2 [A.D. 1108] of the august Sung [Dynasty], the cyclical year *mou-tzu*, tenth month, . . . day.
Monk in charge of the estate, Fu-tzu;
monk in charge of residential and refectory courts, Fu-hai;
monk heading the treasury, Fu-shen;
monk in charge of sacrificial offerings, Fu-chu;
chief supporter who has declared the vow, the Superior, Śramana Chien-luan.

9. It remains to ask whether, as a matter of hypothesis, any of the existing examples of the Imperial edition can have been printed later than A.D. 1108 or even after the loss of the blocks in 1127. Since there is no record of what happened to those blocks after 1127, one might think of the possibility that they were dispersed with the loot and later occasionally used to print unauthorized impressions.

But no such prints have so far come to light. Nor are the chances of their existence very great, for four reasons: first, the blocks were confiscated by the Chin army and were therefore hardly accessible to civilians, whether Jurchen or Chinese; second, the blocks were an un-alluring, bulky, and unprofitable type of war spoil for an individual; third, they were of no value whatsoever unless their owner happened to be a printer, and even to him such blocks must have been an embarrassing possession because of their obvious illegality; finally, the only likely purchasers, Buddhist priests or scholars, were scarcely interested in any-thing but a complete text — a Sung print, in the twelfth century, was as yet no object of antiquarian interest. The extreme scarcity of the prints today is a circumstance that speaks against the probability of recent impressions.

The fact that the extant fragments of the *K'ai-pao Tsang* and of the *Pi-tsang-ch'üan* all bear — with the exception of the Nanzenji print of 1071 — cartouches of 1108 of apparently identical shape is of crucial importance. It permits but one sensible interpretation, that the fragments are of identical origin. This means that we have to do with prints made from the tenth-century blocks kept at the Hsien-sheng-ssu between 1071 and 1126/27.

Yet it must seem rather peculiar that the four prints now known to exist should all date from one and the same year, A.D. 1108. Perhaps we should assume that the colophon block of 1108 was used over several years, much as may have been true of the colophon of 1071. It is con-ceivable that these colophons were rewritten and redated not with each successive year but only for particular reasons.

In the foregoing pages are summed up the criteria (1–9) on which is based the identification of the *Pi-tsang-ch'üan* Chapter XIII as a frag-ment of the Northern Sung *Tripiṭaka*, printed in 1108 or soon thereafter from blocks carved between 984/85 and 990/91. There appears to be no contradictory evidence. Moreover, to anticipate what will be brought to the reader's attention in Chapter IV, it may be mentioned here that any uncertainty about the age and authenticity of the *Pi-tsang-ch'üan* fragment is dispelled by the testimony of a Korean edition of the eleventh century now at Nanzenji in Kyōto. which is a copy of the Sung text with its landscape woodcuts that concern us here.

CHAPTER III / THE LANDSCAPE WOODCUTS
OF THE PI-TSANG-CH'ÜAN

The four landscape illuminations mounted with the text leaves of the fragmentary Chapter XIII of the Imperial preface entitled *Yü-chih Pi-tsang-ch'üan* were printed, as I have tried to show in the previous chapter, in 1108, or at any rate before 1127, from woodblocks carved some time between 984 and 991.

These landscapes, older than any other landscape woodcuts known, are of a completely unfamiliar character. We feel certain at first sight that their style is not derived from any of the paintings of the period known to us today. On the contrary, we are faced with what seems to be an entire school of landscape painting suddenly returned to life.

To be sure, the woodcut technique, working as it does with purely linear definitions, enhances the antique character of the designs. The outlines are even and thin. No attempt is made to imitate the flexible brush. Linear definitions are clear even in the smallest detail; there is no blurring of any part for the sake of suggesting atmosphere or producing pictorial effects. There is no such thing as modulation of tone in these woodcuts, of course, except in the recurrent contrast of the plain surfaces of light terrain with the darker surfaces of expanses of water with their densely placed horizontal lines. A few dark accents do occur, however, resulting from slightly thicker lines and occasional dots, used to render the foliage of distant forests or large drooping ferns hanging over rocks. As a rule, the foliage is represented by exceedingly fine linear patterns compatible with the patterns known from paintings of the Five Dynasties and Northern Sung.

The compactness and density of the compositions is striking. Full of towering crags and overwhelmingly rich in detail, they agree well with the landscape ideals of the tenth century — as far as we can judge from what today remains of the largely lost works of such masters as Ching Hao, Kuan T'ung, and, perhaps, Tung Yüan [1] — while there appears to be no reminiscence whatever of the great innovator from about the mid-tenth century, Li Ch'eng. As in the art of the T'ang period, the landscape of the tenth century was not seen but imagined. It was com-

posed of innumerable elements known from and handed down by tradi-
tion, though here and there enriched and differentiated by new ideas
and observation. However, the four woodcuts offer so much that is un-
known in other works ascribed to this period, the last quarter of the
tenth century, that it is necessary to study them individually in greater
detail. Recurrent features characteristic of the style of these woodcuts
as a group will not be described here, but will be discussed for the whole
set after the individual descriptions.

FIRST WOODCUT: LANDSCAPE WITH A HERMIT'S HUT
(PLS. 1, 6, 7, 8)

Mounted between text leaves 3 and 4, this picture may have been the
second in the original order of the chapter, which very likely was pre-
ceded by a frontispiece. Its measurements are 53.0 by 22.6 cms.

A wide expanse of water stretches right across the foreground and winds
back into narrow inlets bordered by hilly terrain. The hills rise slowly;
they are sharply dissected and almost bare. Only in the upper right
half of the picture are their contours lined with fir trees. Around the hills
with the fir trees and behind the hills in the center hover curlicue clouds.
They are quite uniformly treated, with slightly angular outlines, their
heads forming a pair of small volutes like misshapen Ionic capitals.
What might be called the central massif breaks off to the left in abrupt
escarpments. Large fern-like feathery leaves are hanging from the ex-
posed rock of the overhanging escarpments, which adjoin a gully with a
stream that is fed by a small waterfall. Farther to the left, halfway up,
is a hermit's round straw hut. The tiny figure of the hermit is shown seated
on a chair in the hut. He is receiving two visitors, a young man or
official, who pays his respects, and the monk who has brought the young
man to him. A footpath leads from the hut toward the stream that may
be crossed over a small bridge, rendered with a sure sense of foreshorten-
ing. A young person carrying a load on his pole approaches this bridge
from the right. Trees of many kinds grow in the valleys and near the
water; some are leafless, but most of them have foliage which is executed
with an unflagging precision.

There is little depth. The spatial continuum does not seem to extend
beyond the solid forms of the bluffs and ridges. But the terrain has
structure and coherence, and the spatial relationships are brought out
very clearly. It will be noticed that the ground plane is tilted forward
and that the rendering of receding formations is effected by the use of
regular overlapping. Both devices are rather archaic, and account for
the staccato rhythm of the sharp, successive overlappings. Above the
escarpments with the drooping ferns we see a series of narrow plateaus.

Their tips correspond with the outline of the sheet of rock jutting out underneath; it is a common formation, seen as far back as the T'ang period, that was developed from the archaic devices used to render receding walls of rock.

It may be noted that the surfaces of the terrain and the bare rock are virtually without texture. It is through a cunning use of sparsely applied modeling lines that the shapes are defined and textures at least suggested. Series of gently curving parallel strokes indicate folds in the terrain by the water and in the meadows on the hills, while the rock is characterized through rectangular formulae, hooks and steps and, sometimes, crosses. The only texturing formula appearing on rock surfaces is clusters of small dots, restricted to the overhanging escarpment. Owing to the absence of texture, the surface of the terrain is light in tone when compared with the surface of the water, which is generally slightly darker and rendered in the form of a pattern that is strictly repeated as far back as the open water extends: two straight lines, an undulating line, a single straight line, an undulating line, and again two straight lines as the pattern begins again. The effect is that of a slightly ruffled surface. The lines are never broken. It is questionable, however, whether the contrast in tone of terrain and water was intended. It is more likely, I think, that the contrast was incidental to the characterization of the respective surfaces or "elements."

A point of some significance concerning this landscape should be mentioned before we turn to the next picture, the fact that even though it functions as an illumination or embellishment of a Buddhist text it does not at all emphasize the religious character of its theme. Primarily we have to do with a landscape. Only on closer inspection do we discover the figures of the hermit and the monk and the pious layman. Moreover, there seems to be nothing to indicate an iconographically determinable subject or personage. As far as its Buddhist content is concerned, the picture shows no more than "a nameless priest or sage in remote hills." Yet the vast and serene setting of the landscape does not diminish the meaning of the tiny figure but rather enhances his dignity.

SECOND WOODCUT: LANDSCAPE WITH A NATURAL GATEWAY (PLS. 2, 9, 10, 11)

The picture, measuring about 22.6 cms in height and 52.5 cms in width, follows text leaf 6.

Against the backdrop of a long range of mountains emerging from a sea of clouds we see flat land in the middle distance and, surrounded by the water of a lake, rocky banks in the foreground. The scene is dominated by pillar-like tors rising from the rocky banks and forming a picturesque pylon or gateway.

The pylon pillar on the right half hides a hut built over the water, which here is indicated by alternating straight and wavy lines. On its left side, the rock rises sheer above its receding base. The pillar on the opposite side answers with a perfectly straight vertical wall on its right side. They are separated by the water of a bay that narrows as it recedes toward the flat land beyond. There, in a grove of pine trees framed by that natural gateway, a priest sits on his mat and speaks to three monks standing before him in polite attention. On the other side of the left pillar is a homestead, protected by a high fence and surrounded by tall trees with abundant foliage. In front of the gate, which like the buildings is covered with a thatched roof, stands a young scholar. The cap he wears is the headdress of the educated man and official in late T'ang times and, according to the testimony of dated pictures from Tun-huang, throughout the tenth century. He bows toward another priest who seems to be on his way to join the group in the pine grove. This priest approaches a road constructed of wooden logs leading around the pillar. Beyond the homestead and a narrow causeway that leads on to the left edge, the water stretches back toward the distant horizon where it merges with the clouds. Long horizontal lines interrupted by small curls are used to render these clouds, from which emerge peaks lined with dense forests.

The trees with their diversified foliage are designed and carved with infinite care, as are the small plants, grasses, reeds, and ferns strewn over the ground. The rocks are indicated with sharp, clear outlines which perfectly define their structure, in a manner that is reminiscent of the rock design in the famous late T'ang(?) painting, Emperor *Ming-huang's Journey to Shu* (Pls. 29, 30).[2] Again, the only texturing device applied to the rocks is clusters of small dots, more liberally applied than in the first picture. Quite distinct from those of the first picture are the forms of the clouds drifting in both directions behind the pylon and the pine grove, suggesting different hands in both the original drawing and the woodcut.

The large and almost architectonic shapes of the two tors forming the gateway lend a quiet, monumental touch to this landscape which contrasts markedly with the slow movement of the diagonally rising formations and the gentle monotony of the first.

THIRD WOODCUT: LANDSCAPE WITH A POND
 AMONG FORESTED HILLS (PLS. 3, 12, 13, 14)

This picture, mounted between text leaves 9 and 10, measures 53.1 cms in width; its height is the same as in the other pictures.

In this picture trees dominate the landscape, composed of a secluded pond locked in on all sides by trees and forests, cliffs and hills.

A group of tall trees in full foliage growing on a rocky slope frames the scene at the right-hand side. Behind these trees, in the middle distance, is a flat bank where a small congregation of laymen and a kneeling monk listen reverently to the words of an elderly priest. The priest is seated on a bench-like rock, with a fan or fly-whisk in his left hand and a water bottle or collared flask (*kuṇḍika*) standing near him. With extraordinary economy of means the designer has brought out the features which characterize these figures individually. Farther back in space, separated from the trees in the foreground by swirling clouds moving in from the right edge of the picture, rise layered cliffs. They are covered with very simply rendered rows of trees which look like distant forests. In their disregard of scale (given by some tall trees near and beyond the cliffs) these cliff-top forests represent a highly archaic tradition, which can be traced as far back as the primitive mountain images of the Han period. The technique used to render them, with plain parallel strokes or strokes with triangular tips in coherent rows, differs considerably from that of the first and second pictures. Finally, where the cliffs drop toward a distant cove, near the middle of the picture, we again observe small texture dots, sparingly applied on the vertical walls.

Across from the flat bank where we found the priest with his congregation stands a pavilion with a covered platform which, erected over heavy piles, juts out into the pond. The near side of the pavilion is hidden behind a grove of tangled trees growing from a rocky ledge in the foreground of the left half of the composition. An elderly man with a pilgrim's hat and staff, having passed a leaning tree with split trunk in the middle of the picture, moves toward that grove. In the upper left corner a very distinctive cliff formation emerges from a mass of whirling clouds with their typical curls. Small and less neatly and ornamentally treated clouds drift around the farthest peaks all along the low sky. In principle they are the same clouds we have seen in the two preceding landscapes, but the manner of execution differs so much that again we must assume another hand for the woodcut or for the design or for both. The difference in the linear formula used to render the water points in the same direction, just as does the different design of the cliff-top forests described above.

Most admirable in the present work is the rich, varied, and precise treatment of the trunks, limbs, and foliage of the trees. Nothing of the original drawing's strength seems to have been lost by its translation into a woodcut, and nowhere does the enormous intricacy of the foliage pattern obscure the organic structure of the individual tree. In the execution of trees, none of the other three woodcuts measures up to the present one in feeling, skill, and elaborateness.

FOURTH WOODCUT: LANDSCAPE WITH BARREN
MOUNTAIN RANGES (PLS. 4, 15, 16, 17)

This picture, which follows text leaf 12, is 53 cms wide and 22.7 cms
high, almost exactly the size of the first.

The last of the four, this landscape has a feeling of vastness and
solemnity. A wide, open valley with a meandering river surrounds a
formation of steep, evenly creviced conical crags in the center, while
similar cones, peak after peak, powerful in their uniformity, stretch across
the horizon. Over the peaks roll curly clouds, variants of those seen in
the other landscapes.

The vegetation is sparse throughout; instead of the forests lining the
hilltops there appear only scattered fir trees. The drooping ferns hang
limp and thin, and the trees quite generally seem frail and unsubstantial.
Only in this picture do we see the weeping willow, its branches hanging
straight and flat like curtains — in a manner hardly ever encountered
in paintings, if simply on account of the difference in technique of painting
and woodcut. Something, however, of that flattish, curtain-like treatment
does appear in an anonymous work of possibly tenth-century date in the
Palace Museum collection, a painting in color on silk entitled *Fishing
in Seclusion on a Clear Stream* (Pl. 33).[3] This painting happens also to
resemble the woodcut in the structure of its rocks and mountains, which,
owing to the ingenious but simple method of repeating the outer contour
on a diminishing scale within each of the cones, exhibit a neat, angular,
crystalline quality. The rhombic shapes found in several early paintings
are, however, avoided in this woodcut.

Only after a search does one discover the unobtrusively placed figure
who is the focal point of this grand panorama. He is a priest, seated
cross-legged on his chair in the middle of a small plateau amidst the
crags in the center. A table with a water bottle sits within his reach,
and his shoes are placed on the ground. A monk stands before him,
bowing. Obviously this spot, which offers such a beautiful view of valley
and mountains, is the customary retreat of the priest. A boy (with his
hair arranged in double topknots) is on his way down from the plateau
to a cluster of buildings by the water's edge that may be the priest's
abode. An open kiosk built over the water adjoins these buildings. On
the right side, where one of the willow trees stands, a pilgrim and his
disciple cross a bridge. The boy, having crossed the bridge and put down
his staff and small bag, turns and waits, his arms stretched out, for the
older man to join him. To the left, another wayfarer just passes the
hermitage by the water, beyond the second of the willow trees.

Clouds or curling vapors are spiraling upward from the water and
gullies. Most of them are drifting to the right, as if blown by a gentle

breeze. But the vapors rising by the right edge, forming a foil for the two trees there, move toward the left side. Obviously there is here no intention of suggesting a breeze; the movement of the vapors is simply a part of their nature. "Vapors behind trees" recurs as a feature in the middle and on the left. They prevent the foliage of the trees from merging with the pattern of the water, so that the silhouettes of the trees always remain clear. The water surface, by the way, lacks the regular pattern of wavy lines noted in the other pictures. This is a feature which suggests that the carver of the block may have been yet a fourth man, different from those responsible for the blocks of the preceding three prints. Without wishing to stress stylistic differences among these prints, I would say that the master who designed the fourth landscape was more conservative than were the others, in particular more conservative than the author of the first picture, whose composition reveals boldness and sophistication.

THE STYLISTIC PROPERTIES OF THE FOUR WOODCUTS

It cannot be mere accident that all the four prints exhibit the same theme, that of a Buddhist priest or hermit receiving visitors or worshippers in a landscape so vast that the figures all but disappear within it. Whether this theme was repeated throughout the series of perhaps one hundred pictures that would have been included in the complete sequence of twenty *chüan* is a question we are unable to answer, at least until the Korean edition of the Nanzenji is some day published. A single example from this edition, a frontispiece to the *Fo-fu*, "Verses to the Buddha," counted as *chüan* XXI of the *Pi-tsang-ch'üan*, was published in Tokushi Yūshō's *Kodai hanga-shū* and elsewhere (Pl. 39B).[4] What this frontispiece depicts — the palace of Kapilavastu (an architectural ensemble of purely Chinese character) and the birth of Siddhārtha in the Lumbinī Park — points to a thematically different cycle of pictures, that is, scenes from the life of the Buddha. A small part of another picture from the same *Fo-fu* chapter reproduced in Ono Gemmyō's *Bukkyō no bijutsu to rekishi* is unfortunately not sufficiently clear to enable us to make out its subject, but it seems to be a river landscape, suggesting a motif such as the Nairañjanā River scene.[5] The evidence, however, is too scanty to permit of an interpretation of the thematic range of the illuminations attached to each text. As for the two chapters in question, we may assume that each of them presupposes a definite program of pictorial content. Neither appears to be linked to any particular doctrine or school.

With whom did the original drawings for the four woodcuts of the *Pi-tsang-ch'üan* originate? The fact that they embellish a Sung emperor's

literary contributions to the *Canon* might intimate that they were made by an artist, or artists, close to the court. It is not likely that the choice of designers was left entirely to the discretion of the priests in charge of the text edition, who, however learned Buddhists, may not at all have been conversant with qualified artists or willing to take the risk of displeasing the emperor in matters of taste — much as the emperor himself would, conversely, have wished to avoid offending the priests in matters of doctrine or of spiritual import. Consequently we may surmise that the drawings were commissioned with the emperor's consent and with advice from the clergy.

The woodcuts themselves suggest, as we have seen, that several carvers and probably more than one designer participated in their production. It stands to reason that the designers engaged were artists of established reputation — thus hardly of a lesser age than thirty, and possibly far older. They may not have ranked among the very great; the work to be done did not really call for innovations, and painterly bravura would have resulted in insuperable technical difficulties for the woodcutters. What the work did require was competence and inventiveness within the limitations of strictly linear conventions commensurate with the technical procedure apparent in the prints. We should not expect, therefore, to find a style modeled on the work of the leading masters of landscape painting who were active up to the time of about 980 — masters like Tung Yüan from Nanking (d. 962), Li Ch'eng (d. 967), Kuo Chung-shu from Loyang (d. 977), and Chü-jan from Chiang-nan, who followed his sovereign to the Sung capital in 975. Whether Fan K'uan from Hua-yüan in Shensi (still active or, at least, alive in the T'ien-sheng era, 1023–1031) and Yen Wen-kuei from Wu-hsing in Chekiang (967–1044?) had attained positions of prominence in time to be invited to collaborate is doubtful; Fan K'uan apparently never lived in the capital, while Yen Wen-kuei, who did go there after quitting military service some time in T'ai-tsung's reign (976–997), may not even have begun to paint when the work on the *Pi-tsang-ch'üan* woodcuts was started. These woodcuts do not in fact call to mind the style of any of the masters just mentioned, except for one intriguingly atypical work said to bear the signature of Tung Yüan's, *The River Bank* (Pl. 35).[6] It is with an earlier stage that they must be linked.

Even so, looking back as they did to the traditions of Late T'ang and to those of the early half of the tenth century, great masters and lesser ones cannot but have shared some features, motifs, or conventions derived from those traditions. Such details may recur in paintings of dissimilar style and different age; we might even find them in some work or other from the hands of the masters mentioned above. But, tenth-

century paintings being scarce, instances of details or motifs which parallel those in our woodcuts are, of course, none too numerous. What is worse, the attributions are in most cases debatable, as are the dates.

The style of the woodcuts, however, would seem to antedate the contributions of a Li Ch'eng or a Tung Yüan, and take us back to the stage governed by Ching Hao and Kuan T'ung, the greatest masters of landscape painting in the first half of the tenth century. It was Ching Hao who laid the foundations for the monumental landscape style of the tenth century, an echo of which is, perhaps, perceivable in the fourth woodcut (Pl. 4). Kuan T'ung, "who surpassed Ching Hao," [7] had a large following right into the eleventh century; his influence must have remained pervasive even after the appearance of Tung Yüan, Li Ch'eng, and Fan K'uan. Unfortunately the oeuvres of Ching and Kuan are all but lost, so that we cannot be sure whether any of the paintings attributed to them or purporting to have been copied after them are authentic. Those given to Ching Hao are not inconsistent stylistically, but only one of them, *The K'uang-Lu Mountain* (Pl. 31), possesses convincing authority on grounds of style. Kuan T'ung, by contrast, is elusive. Each of the works that go under his name points to a different hand, and no decision in favor of any of them can be made except on the basis of internal evidence. A satisfactory case resting on such evidence can be made only for the important painting in the Palace Museum collection, *Waiting for the Ferry* (Pl. 38). Yet we should not on account of a dubious attribution dismiss any of the works which justifiably claim to date back to Northern Sung, the Five Dynasties, or late T'ang, provided that they offer some instance of comparable elements of design. The same applies to anonymous works which, while free of misguiding labels, cannot securely be placed.

A catalogue of motifs typical of the four woodcuts and of various paintings in which the same motifs occur is not, strictly speaking, concerned with questions of style but with components of design. These components persist longer than does a style. Hence they are less revealing than style in regard to chronology. But since the sequence of styles during the period in question is rather obscure, to say the least, we cannot afford to neglect these components. They may shed some light on the position of the woodcuts within the fragmentary material that has survived. A critique of the style of the woodcuts will be attempted after a survey of the motifs, which now follows.

1. MOUNTAINS AND CLIFFS IN THE SHAPE OF BOXED CONES (PLS. 4, 16). This is an archaic and enduring device, systematically applied as early as the seventh century. It was apparently abandoned in the course of

the late tenth and the eleventh centuries, when subtler, more differentiated formations were developed. Examples in paintings:

Spring Time Travelers, attributed to Chan Tzu-ch'ien. Early T'ang(?).[8]

Wang-ch'uan Scroll, Ming engraving after Wang Wei (699–759).[9]

Travelers in the Spring Mountains (Pl. 28), attributed to Li Chao-tao. Sung copy after one version of an eighth-century composition, perhaps exaggerating the archaic characteristics of the original(?).[10]

Snow Landscape, anonymous artist of the eighth century(?).[11]

The K'uang-Lu Mountain, attributed to Ching Hao, about 900 (Pl. 31).[12]

Wu-t'ai-shan Panorama, mural in Cave 61 (Pelliot's No. 117) at Tun-huang, datable between 980 and 1001.[13]

Fishing in Seclusion on a Clear Stream, anonymous. Tenth century(?) (Pl. 33).[14]

2. SHARP-EDGED ROCKS (PLS. 2, 10, 11: TORS; PLS. 3, 12: FOREGROUND). This is a rather rarely encountered linear technique of rock design resulting in sharp edges and *arêtes* and more or less crystalline formations. It was apparently current in the eighth, ninth, and tenth centuries. The outlines are drawn with hard precision; there are no texture dabs (*ts'un*) whatsoever. Examples:

Ming-huang's Journey to Shu, late T'ang(?) replica of an eighth-century original (related to the *Travelers in the Spring Mountains*, mentioned above) (Pls. 29, 30).[15]

Buddha on the Vulture Peak, eighth-century embroidery from Tun-huang in the British Museum.[16]

Fishing in Seclusion, anonymous. Tenth century(?) (Pl. 33).

Fairy Dwellings on a Pine Cliff, anonymous. Sung copy after a T'ang work(?).[17]

3. UNDERCUT ESCARPMENTS (PLS. 2, 9: FOREGROUND). This formation consists of low rocky banks or spurs with concave, hollowed out, receding walls. The motif appears in variant forms in the foremost example I know of,

Ming-huang's Journey to Shu (Pl. 29; see above, Section 2).

It is also present in

Travelers in the Spring Mountains (Pl. 28), mentioned under Section 1 above; and

Remote Monastery in Snowy Mountains (Pl. 37), a copy by Wang Hui (1632–1717) after an exquisite late T'ang(?) work attributed to Wang Wei (699–759).[18]

4. ESCARPMENTS RECEDING IN STEPS (PLS. 1, 6: CLIFF). Reduced to the plain lineament of the woodcut, this motif seems quite distinct from formations of this kind in paintings. It appears to be a simplification of notched recesses, examples of which may be seen in the following paintings:

Waiting for the Ferry, attributed to Kuan T'ung. Mid-tenth century(?) (Pl. 38).[19]

Landscape, attributed to Fan K'uan. Excellent copy after a painting close to Kuan T'ung and certainly of an earlier style than Fan K'uan's famous *Travelers Among Streams and Mountains*. Princeton University.[20]

Remote Monastery in Snowy Mountains (Pl. 37), the copy by Wang Hui mentioned in Section 3 above.

5. ROCKY WALLS RECEDING IN ECHELONS (PLS. 4, 16: ALONG ROAD LEFT OF CENTER). This common device brings out the effect of recession in walls of rock rising from flat ground or in the walls of steep river banks rising from sheets of water. Applied with powerful effect in a primitive eighth-century mural at Tun-huang, Cave 172 (Pelliot's No. 33),[21] the formula seems to have been superseded by the time of the eleventh century. Examples:

The K'uang-Lu Mountain, attributed to Ching Hao, about 900 (Pl. 31), mentioned in Section 1 above.

Fishing in Seclusion (Pl. 33), mentioned in Sections 1 and 2 above.

Travelers in the Autumn Mountains, attributed to Tung Yüan (d. 962), in the collection of J. D. Chen, Hong Kong.[22]

Buddhist Temple Amid Clearing Mountain Peaks, attributed to Li Ch'eng (d. 967), and likely to date from the early eleventh century. Nelson Gallery, Kansas City.[23]

6. ECHELONED, TONGUE-SHAPED PLATEAUS (PLS. 1, 6, 7: CLIFF TOPS). This peculiar, very widely used pattern closely resembles the preceding one, except that it does not define the receding base but the receding top of an echeloned wall or cliff. On the uncertain authority of the *Wang-ch'uan-t'u* engraving (mentioned in Section 1 above), it would appear that the motif goes back to the eighth century. It appears subsequently to have become a standard feature in Tung Yüan's and Chü-jan's landscapes. Examples:

Lung-hsiu chiao-min t'u, a river landscape attributed to Tung Yüan (d. 962) in the Palace Museum collection.[24]

The River Bank, bearing the signature of Tung Yüan (Pl. 35, see Ch. III, n. 1), a painting which conceivably dates from the mid-tenth century or so.

Three landscapes attributed to Chü-jan (about 975), reproduced in Osvald Sirén's *Chinese Painting*, III, 168–170.

First Snow over Rivers and Mountains, anonymous work, known through several copies based on a tenth-century(?) composition of a grand and solemn character. Copies are in the Palace Museum collection, in the Freer Gallery (Pl. 32), and, in a reproduction of poor quality, in the catalogue of the former F. S. Kwen collection.[25]

7. CREVICED SLOPES (PLS. 1, 7, 8). What I refer to here is not the common crevice or fissure of rocks but the dissecting or rupturing of hilly terrain at large. The torn terrain evokes a feeling of untamed nature and primeval violence. Yet its *raison d'être* may well be a technical one, namely, that of giving shape to, and rendering legible, an area of terrain which if left featureless would remain a kind of blank. Since we have here to do with ever varying formations affecting composition or pictorial structure, this feature does not lend itself to ready identification as a distinct motif. For this reason I mention only one painting, which with regard to its creviced slopes compares very well with the first woodcut:

The River Bank (Pl. 35), bearing the signature of Tung Yüan (d. 962) and likely to date from the mid-tenth century, a painting mentioned in Section 6 above. Among the works connected with Tung Yüan it is the only one that bears a signature. Its tenth-century date appears to be unquestionable on grounds of style. But it least resembles the kind of landscape design commonly connected with Tung Yüan, a fact which poses an interesting problem. Whatever the conclusion concerning Tung's authorship, the picture is tentatively listed here as a major work of about A.D. 950.

8. ROCK SURFACES MARKED BY DOTS (PLS. 1, 2, 3, 6, 9–11, 14). In the absence of shading or texturing of the rock surfaces, the humble device of marking or enlivening them with clusters of simple dots (most noticeable in Pl. 2) acquires some importance. These dots, applied to the rocks irregularly, do not read as a formula suggesting vegetation; they are distinct from the tufts of grass growing along the edges or out of clefts, from the hanging ferns, and from the little plants shaped like starlets and the small bamboo leaves. They have nothing in common with the later "moss dots" (*t'ai-tien*), nor do they recall any form of texture dabs (*ts'un*), developed after T'ang in the quest for the perfect rendition of the nature of rock. It is interesting to observe that there are no true analogies in painting. If dots do occur in paintings, they invariably denote not rock but living matter, moss, lichens, scrub, and the like. The only true parallel I know of is found in the following example:

An Iconographic Study of Buddha Images in Western Countries (Pl. 39A), a painting on silk, from Tun-huang, in the Collection of Central Asian Antiquities, New Delhi. Considered as "early" by Sir Aurel Stein, this picture may date from about the ninth century.[26]

9. TREES OF MIXED KIND WITH DISTINCT FOLIAGE PATTERNS (PLS. 1–4, 9, 12–17). The foliage in these woodcuts is defined throughout in clear linear patterns. There is no imitation of such brush effects as dabbed silhouette or dark wash, except in the diminutive forests on distant cliff tops in Plate 2. The astonishing precision and patient labor betrayed in these woodcuts presuppose equally flawless models furnished by the designers.

An important thing to note about these patterns is that, with a few exceptions, they do not actually depict leaves. Most of them consist of botanically undefinable geometric elements such as triangles and the like, which taken singly do not even remind us of leaves. Yet, applied en masse, they create the effect of foliage. Exceptions are the pattern for pine needles, another pattern reminiscent of oak leaves (see the following Section, 10), and patterns derived from a stylized rendering of the Sal tree (*Shorea robusta*).

Apparently it was no earlier than about the seventh or eighth century that the method of rendering foliage with patterns of this kind was adopted. In the glorious tree designs of the Nelson Gallery sarcophagus in Kansas City [27] every leaf is individually portrayed. The earliest appearance of a pattern *simulating* foliage occurs, to my knowledge, in the eighth-century(?) scroll of *Spring Time Travelers* attributed to Chan Tzu-ch'ien of the Sui Dynasty (mentioned in Section 1 above). In the *Ming-huang Hsing Shu* picture (Pl. 29), which may date from the end of the eighth or early ninth century, foliage patterns of great variety are applied systematically and to perfection. By the end of the tenth century Fan K'uan, in a section of design unsurpassed in precision and verve, the wooded plateau in his *Travelers*,[28] adds tone to bind the foliage mass together for a more corporeal and painterly effect. A less painstaking, freer, and looser technique than Fan K'uan's may have been practiced by some painters before him, and become the rule rather than exception after his time, so that from the eleventh century onward there are no comparable foliage patterns to be found. Where they do occur, as for instance in a copy after Li Kung-lin (d. 1106),[29] they function as archaistic devices. Examples:

Spring Time Travelers, attributed to Chan Tzu-ch'ien. See Section 1 above.

Ming-huang's Journey to Shu (Pl. 29), see Sections 2 and 3 above.

Fairy Dwellings on a Pine Cliff, mentioned in Section 2 above.

Travelers Among Streams and Mountains, by Fan K'uan, about A.D. 1000.

Lu-shan, copy by Chiang Ts'an (twelfth century) after Fan K'uan.[30]

Pine Wind on the T'ai-shan, copy by Wang Hui (1632–1717) after Chü-jan (about 975). Formerly in the collection of P'ang Lai-ch'en.[31]

10. FOLIAGE PATTERN RESEMBLING AN OAK LEAF (PLS. 2, 11). As said above, this type of pattern is not an arbitrary, botanically nondescript geometric pattern but resembles an oak leaf. The form of the leaf is not rigorously standardized, but a recurrent feature of it is the ribs in herringbone order. Examples:

Ming-huang's Journey to Shu (Pl. 29), anonymous. Late T'ang replica of an eighth-century original(?). See Sections 2, 3, and 9 above.

The Four Gray-Heads, attributed to Sun Wei (late ninth century).[32]

Deer Among Red-Leafed Maples, anonymous. Post-T'ang(?).[33]

Fairy Dwellings on a Pine Cliff, anonymous. Sung copy after a T'ang work(?). See Sections 2 and 9 above.

Travelers Among Streams and Mountains, Fan K'uan. See Section 9 above.

Streams and Hills Under Fresh Snow, signature of Kao K'o-ming. Date corresponding to A.D. 1035. Crawford collection, New York.[34]

11. WEEPING WILLOW BRANCHES HANGING LIKE CURTAINS (PLS. 4, 15, 17). This is a rather primitive rendering of these trees which occurs only rarely. The few examples I am able to assemble belong in the ninth and tenth centuries.

Procession of Lady Sung, mural in Tun-huang Cave 156 (Pelliot 17 *bis*); datable A.D. 851.[35]

Fishing in Seclusion on a Clear Stream (Pl. 33), anonymous. Tenth century(?). See Sections 1, 2, and 5 above.

Landscape, by a follower of Ching Hao. Tenth century. Palace Museum.[36]

12. THE SLANTING TREE (PLS. 3, 13: FOREGROUND CENTER). The heavily slanting tree apparently was a favorite motif in the Later T'ang and Five Dynasties period — presumably as much for the startling effect of its oblique trunk in a composition as for its expressive touch of suffering or decay. Examples:

Snowy Landscape, anonymous. Eighth century(?). Mentioned in Section 1 above.

Clearing After a Snowfall, anonymous copy after Wang Wei. Honolulu Academy of Art.[37]

Remote Monastery in Snowy Mountains (Pl. 37), copy by Wang Hui after a late T'ang(?) work attributed to Wang Wei. Mentioned in Section 3 above.

Mountain Landscape, anonymous. Ninth century(?). William Rockhill Nelson Gallery, Kansas City.[38]

Autumn Mountains (Pl. 34), anonymous. Tenth century. Palace Museum.[39] The style suggests a follower of Ching Hao, who may be identical with the painter of the *Landscape* listed in Section 11 above.

Fishing in Seclusion on a Clear Stream (Pl. 33), anonymous. Tenth century(?). Palace Museum collection. Mentioned in Sections 1, 2, 5, and 11.

Clearing Autumn Skies over Mountains and Valleys, by Kuo Hsi, late eleventh century. Freer Gallery of Art.[40]

Streams and Mountains Without End, anonymous. Early twelfth century. Cleveland Museum of Art.[41]

13. DROOPING FERNS (PLS. 1–4, 6, 10, 14, 16). Conspicuous in the series of the woodcuts, this motif is hard to trace in paintings. In the two examples adduced its appearance differs from that in the woodcuts; the placement on steep walls of rock, however, is essentially the same.

The Ch'ü River, attributed to Li Chao-tao (eighth century). Palace Museum collection.[42]

Pine Wind Resounding in a Myriad Valleys, copy by Wang Hui (1632–1717) after Tung Yüan.[43]

Pine Wind on the T'ai-shan, copy by Wang Hui after Chü-jan. Listed in Section 9 above.

14. CURLING VAPORS AND CLOUDS (PLS. 1–4, 6–17). This is a common and enduring motif, found especially in T'ang religious painting and decorative art. In secular landscape painting it may have given way to a less ornamental, more rationally conceived means of depicting atmospheric phenomena well before the end of T'ang. In the tenth-century landscapes referred to in the foregoing entries these clouds no longer appear. As for the curly clouds in the woodcuts, the necessity imposed by technique of defining the atmosphere in linear terms accounts to a large extent for the presence of what must seem, if judged by the standards of contemporary painting, a surprisingly archaic feature. Examples in paintings:

Ming-huang's Journey to Shu (Pl. 29), late T'ang replica of an eighth-century work(?). Previously listed in Sections 2, 3, 9, and 10.

Travelers in the Spring Mountains (Pl. 28), attributed to Li Chao-tao (eighth century). Sung(?) copy after an earlier version of the preceding picture. Mentioned in Sections 1 and 3 above.

Wu-t'ai-shan Panorama, Tun-huang mural, Cave 61 (Pelliot's No. 117). Mentioned in Section 1 above.

Fairy Dwellings on a Pine Cliff, Sung copy after a T'ang work(?). Listed in Sections 2, 9, and 10 above.

15. THE WATER PAVILION WITH HIPPED ROOF (PLS. 2, 3, 11–13) Homesteads by the water appear in three of the woodcuts; apparently they were an important motif. In two of the woodcuts we find a seemingly less common and therefore rather more noteworthy feature, a pavilion on piles covered by a thatched roof of the hipped-roof type. A very similar pavilion occurs in the following painting:

The River Bank (Pl. 35), bearing the signature of Tung Yüan (d. 962) and likely to date from about the middle of the tenth century. Mentioned in Sections 6 and 7 above.

The motif occurs in a few other paintings which in view of their chronological position should be added here:

Drinking and Singing at the Foot of a Precipitous Mountain, attributed to Kuan T'ung. Tenth century(?). Museum of Fine Arts, Boston.[44]

Sitting Alone by the Mountain Stream, attributed to Fan K'uan. Palace Museum collection. The attribution may be questioned, but the painting may date from the first half of the eleventh century.[45]

Buddhist Temple Amid Clearing Mountain Peaks, attributed to Li Ch'eng (d. 967). Likely to date from the early eleventh century. Nelson Gallery, Kansas City. Mentioned in Section 5 above.

16. THE CANTILEVERED PLANK ROAD (PLS. 2, 10: CENTER) In T'ang poetry the boldly constructed and hazardous plank roads suspended above chasms formed by mountain streams were so intensely experienced and so often described that they could not fail to impress themselves on the reader's mind. Tu Fu (712–770), for one, speaks of plank roads which, "like a ladder firmly built ascend as high as the clouds" (VI.63), "wind perilously across precipitous walls, dangling like threads, when seen from below" (VI.65), or "run high above the waters of the stream, swaying in the air over the tall cliff" (VI.66).[46] Painters as late as the tenth and eleventh centuries continued to occupy themselves with variations on this motif. The road in our woodcut, atypically, lacks the nuance of dizzying height and danger. Examples:

Ming-huang's Journey to Shu (Pls. 29, 30), late T'ang replica of an eighth-century work(?). Mentioned in Sections 2, 3, 9, 10, and 14 above.

Travelers in the Spring Mountains (Pl. 28), attributed to Li Chao-tao. Sung copy after an earlier version of the "Ming-huang Hsing Shu" picture(?). See Sections 1, 3, and 14 above.

Remote Monastery in Snowy Mountains (Pl. 37), copy by Wang Hui

(d. 1717) after a late T'ang(?) work attributed to Wang Wei. Mentioned in Sections 3 and 12 above.

Pine Wind Resounding in a Myriad Valleys, copy by Wang Hui (d. 1717) after Tung Yüan (d. 962). Listed in Section 13 above.

Winter Mountains, anonymous. Tenth century(?). Freer Gallery of Art.[47]

Temples Among Streams and Mountains, by Yen Wen-kuei (967–1044). Palace Museum collection.[48]

The foregoing catalogue of motifs — referring as it does to a period depleted of original, authenticated, and important works, whose places are taken by works of loose attributions and of uncertain date — can do no more than provide orientation. Paintings alleged to be copies of lost pictures from this period enter into this survey as a matter of course, for we have no sure criteria on which to rely to deny their sig-

MOTIFS IN APPROXIMATE CHRONOLOGICAL ORDER

Approx. period	Artists, schools, works, copies	Motifs as they are numbered in the catalogue above —															
		1	2	3	4	5	6	7	8	9	10	11	12	13	14	15	16
750	Wang Wei	×		×	×		×							×			×
?	*Travelers in Spring Mountains*	×		×											×		×
800	*Ming-huang*			×	×						×	×			×		×
?	*Fairy Dwellings*			×							×	×			×		
?	Iconogr. study								×								
851	*Lady Chang*												×				
900	Ching Hao	×					×										
?	*Fishing in Seclusion*	×	×				×						×	×			
930	Kuan T'ung				×												
950	Tung Yüan					×	×	×						×		×	×
975	Chü-jan						×		×				×				
980+	Tun-huang 61	×													×		
1000	Fan K'uan										×	×					
1020	Yen Wen-kuei	×															×
1035	Kao K'o-ming											×					
1070	Kuo Hsi													×			

nificance; worse than that, we might deprive ourselves of clues even more significant than those in some of the ancient but unattributable works that happen to survive.

It seems desirable to sum up in the form of a chart the occurrence of the motifs which have been listed. Since the chart (p. 50) is limited to motifs, it has little relevance to style. Its art-historical significance will depend rather on the connection of motifs with masters or schools of approximately known date. Stray works, therefore, whose dates and affiliations cannot be established, are omitted.[49]

This chart, which is based on objectively definable subject matter, shows clearly that there is a relative abundance of the motifs found in the four woodcuts down to about the middle or the third quarter of the tenth century. In other words, the four woodcuts of the *Pi-tsang-ch'üan* are demonstrably linked with paintings of about A.D. 950 and before in their characteristic subjects or motifs, while rather few of these motifs remain in paintings of later date. It may, however, be objected that the dates assigned to the older material are too uncertain to be helpful. Accordingly, our chart will be modified so that the period divisions are less elaborately drawn, in the following version. Here T'ang material forms the first division, material of the Five Dynasties through 980 — which is the period preceding the likely date of the woodcuts — the second, and material of early Sung, beginning with Fan K'uan, the third:

Divisions	1	2	3	4	5	6	7	8	9	10	11	12	13	14	15	16
T'ang, before A.D. 900	×	×	×	×		×		×	×	×	×	×		×		×
Five Dynasties, A.D. 900 to 980	×	×		×	×	×	×		×		×	×	×	×	×	×
Northern Sung, A.D. 1000–1070	×							×	×		×					×

(Header: Motifs as they are numbered in the chart)

It is in this simplified, more inclusive tabulation that we become aware, at a glance, of a change which occurs in the second half of the tenth century, a change that is not reflected in the four landscape woodcuts. Of the motifs which disappear by the end of the tenth century, the numbers 2, 3, 4, 5, 6, 7, 8, all pertain to the same category, that of terrain formation. The other four motifs, (11) the curtain-like willow branches, (13) the drooping ferns, (14) the archaic cloud curls, and (15) the water pavilion, are not as important. The willows are a primitive element even in the context of the woodcuts. The absence of the inconspicuous motif of the ferns may somehow be connected with changes, introduced about

the middle of the tenth century or soon afterward, in the physiognomy of the terrain; the overhang, in particular, where the ferns nestle, was discarded. The archaic clouds would not present themselves even in the Five Dynasties division if the Tun-huang mural of Cave 61 (Pelliot 117) had not been included because of its date.

Thus the T'ang and Five Dynasties formulae of terrain formation indicated in the chart were discarded in the landscape paintings of Northern Sung. Other structures, presumably more differentiated, less obvious, and therefore less readily classifiable, must have taken their place. We need not pursue the question further; what matters is that they cannot be perceived in the woodcuts of the *Pi-tsang-ch'üan*. On the other hand, we may justifiably suspect that the features discarded by Northern Sung but still present in the woodcuts will aid us in recognizing the style of which they are symptomatic. Do these features collectively represent a criterion of style? Examining them in a body, I enumerate them here first:

2. sharp-edged rocks,
3. undercut escarpments,
4. escarpments receding in steps,
5. rocky walls receding in echelons,
6. echeloned, tongue-shaped plateaus,
7. creviced slopes,
8. rock surfaces marked by dots.

These motifs have certain qualities in common. They are bold, even drastic motifs, out of the ordinary and indicating delight in spectacular statements. There is an element of exaggeration in them, not controlled by rational restraint nor leavened by the experience of consciously explored visual reality. While embodying knowledge of actual appearance, these features were created largely by the imagination and accepted as conventions required in landscape. They were the elements with which a landscape was built. And none of them depend on means other than outline, shading or color in the paintings notwithstanding. Their linearity concurs with their relatively archaic character. For the archaic landscape designs are conceived in terms of linear patterns. Color is secondary, and tone does not yet exist. In the woodcuts, where there is neither color nor tone, the device of texture dabs as developed by Five Dynasties artists is absent also. The unmitigated linearity of the woodcuts, as observed before, does make them seem more archaic than coeval paintings. Nonetheless it is not the woodcut technique that accounts for their linearity of design; the same linear motifs are found in the paintings of the period.

In the chart of motifs it is Tung Yüan, active about 950, in whose

oeuvre we detect the greatest number of analogies with the Sung wood-cuts. But it is not the typical Tung Yüan of murky marshlands executed in the coarse and rough manner attributed to him; it is a Tung Yüan in keeping with tenth-century ideals of rich and dense and diversified composition, as exemplified by *The River Bank* (Pl. 35). In Chü-jan's work, of about 975, even though perhaps known only through copies, analogies decrease markedly — despite the fact that he was Tung Yüan's foremost follower. It must have been Tung Yüan's late style, unobserv-able in our four woodcuts, that Chü-jan took as his model. At any rate, while still patterned enough when compared with later Northern Sung landscapes, Chü-jan's designs are characterized by a simplicity and uniformity which clearly set them apart from the complexity of earlier tenth-century masters. More than merely renouncing diversity, he made his uniformity an expressive factor. Stylistically the four woodcuts have to be placed before Chü-jan and the late work of Tung Yüan.

Among the great names which appear in the chart one is missing, that of Li Ch'eng (919–967). Or, as we might rather say, the most important name at exactly the critical horizon is not represented. Neither among ancient works attributed to the master, nor among later copies credibly reproducing his style, have I found any features agreeing with the motifs and formal properties of the woodcuts. One analogy mentioned above in Section 5, rocky walls receding in echelons, does refer to Li Ch'eng; as stated before, however, that painting is unlikely to antedate the eleventh century and therefore forms no exception so far as Li Ch'eng's style is concerned. This apparent absence of Li Ch'eng is puzzling. For it is rather unlikely that the works of a painter who was forced to come to terms with the achievements of Wang Wei, Ching Hao, and Kuan T'ung should have had nothing at all in common with them. He doubtless had, and if his works had not virtually vanished we might find proof of it. Proof of this kind, however, would contribute little to our understanding because it is concerned not with Li Ch'eng's unique contribution but with his early sources. What matters here are his stylistic innovations. If Li Ch'eng was widely copied or imitated through-out Northern Sung — in versions accurate enough to be mistaken for originals, as we learn from the *Hsüan-ho hua-p'u* (*ch.* 11) — it was in recognition of his own ideas. And these were incompatible with the style of the *Pi-tsang-ch'üan* illuminations, to judge from what both literary sources and extant paintings (attributed to the master or copied after him) have to tell. In contrast to the "overstatement" in the landscapes of a Ching Hao or Kuan T'ung, Li Ch'eng seems to have fascinated the critics by his "understatement," a sparingness or elusive-ness of technique which is beautifully described in a remark by Wang

Ming-ch'ing (1127–1214): speaking of Li's most exquisite pictures he says that "it seemed almost as though they were not made with brush and ink." [50] Kuo Jo-hsü's description, that "his brush-point was as fine as a needle, his ink, infinitely sparing," [51] implies that the contours of his mountains were thin, without linear bravura, and the surface of his rocks almost free of texture pattern. Even so, "the inner structure was spontaneously present," as an eighteenth-century writer feelingly puts it.[52] In addition, Li Ch'eng seems to have discovered new aspects of landscape, none of which are seen in the four woodcuts: "marshy plains, . . . wind and rain, darkness and light, vapor and clouds, snow and fog," to quote the *Hsüan-ho hua-p'u* again,[53] and "misty woods and level distances," admired by Kuo Jo-hsü.[54]

Ancient paintings ascribed to Li Ch'eng which, if they should not be taken to be original works, appear to represent his style fairly faithfully are the *Travelers Among Snowy Hills* of the Boston Museum [55] and an exquisite small hanging scroll entitled *Mountain Peaks After a Snowfall* (Pl. 36) in the Palace Museum collection in Taiwan.[56] This small picture is the only Li Ch'eng to exhibit at least one feature specific enough to compare with the fourth woodcut (Pls. 4, 17), namely, the curiously shaped head of the pinnacle farthest right, which resembles some of the cliff formations observable in the woodcut. Though worth mentioning, it is a feature which seems too insignificant and uncommon to group with the important motifs covered above.[57]

On the whole it seems certain that a style typical of Li Ch'eng is not found in the four woodcuts of the *Pi-tsang-ch'üan*. This would seem to confirm what we observed in the case of Tung Yüan, who died five years earlier than Li Ch'eng, in 962: Tung Yüan's late style had as little influence on the woodcut designs as had Li Ch'eng's. The style of the four woodcuts appears to agree with what was "modern" around A.D. 950, but increasingly conservative in the following two or three decades.

The stylistic position here proposed, though without a broad demonstration of the tenth-century landscape styles in general, suggests Kuan T'ung and his early Sung followers as the likeliest source of the woodcut landscapes described above.

CHAPTER IV / AN ELEVENTH-CENTURY
KOREAN COPY OF THE PI-TSANG-CH'ÜAN

It has long been known that the Nanzenji, chief of the five great Zen temples or Five Mountains (*Gozan*) in Kyōto, the history of which goes back to the year 1291, owns an ancient printed edition of the Buddhist *Canon*. Precisely what edition remained a matter of conjecture until Ono Gemmyō was allowed to inspect it in part, such copies being, as a rule, inaccessible to the world outside the monastery. "These copies," Nanjio complained, "have not been allowed to be read or examined by the public since olden times, and Buddhist scholars have had to submit to this inconvenience." [1] While Ono's investigations were far from complete, they did permit him to establish beyond a doubt that the Nanzenji copy consists — as had been widely believed but never before proven — of Korean prints older, in the main, than the second Korean edition (Korean B) of 1236–1251.[2] This edition, the blocks of which, it may be recalled, are still in existence at the Haeinsa (Chinese, Hai-yin-ssu) monastery, is referred to as "the new edition" by Ono, who distinguishes a first edition, a second or re-edition, and this new edition. Since the Korean B edition is known in several copies which can be compared with the Nanzenji edition, there is nothing problematic in eliminating it from the editions which might be identical with that of the Nanzenji.[3]

The theory that there were three Korean editions rather than only two is not historically ascertainable, and it is not shared by other Japanese scholars. Ono himself admitted that he could not answer such questions as when, where, and by whom a second edition of the *Canon* was made.[4] His theory is based on the evidence of the Nanzenji copy itself, considered by him to exemplify a [hypothetical] second edition, distinct from the first (corresponding to Korean A) but identical with the edition whose blocks were stored at the Puinsa (Chinese, Fu-jen-ssu) and destroyed by the Mongols in 1232. The Nanzenji *Issaikyō* contains only a fragmentary portion of the prints of the first edition, perhaps no more than about one hundred leaves — occurring in *sūtras* which, as Ono describes them, are pieced together of prints whose margins differ markedly in size, and whose characters differ in style as well. What

Ono refers to as the first edition were the texts of the *K'ai-yüan-lu* (5048 *chüan*) and the "Sung additions" (about 2000 *chüan*) issued, respectively, during the reigns of Hyŏnjong (1010–1031) and Munjong (1048–1083). This first edition he believes to have been lost, and to have been replaced almost completely by a re-edition.[5] Based on observations made when surveying parts of the Nanzenji holdings, this hypothesis appears to be at variance with historical records, and is implicitly rejected in the general accounts given by Ikeuchi, Fukaura, and Ogawa, quoted in Chapter II.

There exists no record concerning the transfer of the Nanzenji copy of the *Issaikyō* from Korea to Japan. Ono's theory that the copy left Korea only by the time the "new edition" of 1236–1251 had appeared is convincing; no Korean monastery was likely to part with a possession of the importance of a printed *Canon* unless it was thereby enabled to acquire another even finer set, such as Korean B. The copy now in possession of the Nanzenji can be traced back to A.D. 1400 (Ōei 7), when it was presented to the Zenshōji, a Zen temple in Hyōgo;[6] it must have been brought to Japan before that year — in all probability after Korean B had become current.

As for the date of the Nanzenji copy, the following points were noted by Ono. The copy contains some handwritten replacements of lost chapters. The text of *Kao-seng-chuan*, Chapter XIV, is handwritten and dated T'ai-ho 2, a Chin Dynasty year corresponding to A.D. 1201; that of *Ssu-fen-lü*, Chapter XVIII, also handwritten, bears the date of *ping-ch'en*, to be equated, according to Ono, with A.D. 1196.[7] No serious objection can be raised against his conclusion that the printed copy antedates, perhaps by a considerable interval, these replacements. Ono also adduces the exceptional case of the print from Sung China, mentioned in Chapter II above, the *Buddhacarita*, Chapter XIX, of A.D. 1071, inserted in the wrapper *Ling* (No. 296).[8] Being exceptional, this case does not, in my opinion, prove anything regarding the date of the Nanzenji prints. Ono's general conclusion is that the Nanzenji copy was printed from the blocks stored at the Fu-jen-ssu at an unspecified date, early enough to have become defective by the late twelfth century, when replacements had to be made, yet late enough to account for the fact that this copy contains not one complete text of the 5048 *chüan* of the time of Hyŏnjong (Korean A, first division), and also exhibits features linking it with the "new edition" (Korean B). Such features are (1) the designation of the sheets as *chang* ("ten feet") instead of *fu* ("hanging picture"), (2) the observance of character taboos, and (3) the order of the wrapper numbers, which in Ono's hypothetical "second edition" were changed in accordance with a system that was adopted

also in the "new edition" (Korean B).[9] While this painstakingly gathered evidence merits attention, it is less important than the simple fact that the Nanzenji copy is not Korean B. Therefore, whatever its time of printing, it must be an older edition, and therefore Korean A. Unofficial editions — which might complicate the question of identification of the Nanzenji copy — did not exist in Korea.[10]

Among the prints of the Nanzenji *Tripiṭaka* which Ono investigated were those of the Sung Imperial commentaries, *Yüan-shih* (Japanese, *Enshiki*), *Hsiao-yao-yung* (Japanese, *Shōyōei*), and *Pi-tsang-ch'üan* (Japanese, *Hizōsen*) including the *Fo-fu* (Japanese, *Butsu-fu*) which corresponds to Chapter XXI of the *Pi-tsang-ch'üan*. It is in these prints that the use of the old printing blocks can definitely be demonstrated because, as Ono rightly affirms, their Thousand-Character numbers are twofold, the original number agreeing with the old system of numbering the wrappers, the second number corresponding to the system of Korean B.[11] The second number symbol was inserted in a blank space on the block under the first one, which follows the title of each scroll and, fortunately, was not effaced or eliminated. Thus the two characters under the title of the *Pi-tsang-ch'üan* Chapter XIII of the Nanzenji copy are *Tso* (533) and *Chia* (518), as shown in Plate 19. In some cases the new number symbol was either forgotten or for some reason omitted; *Yü-chih Fo-fu* (i.e., *Pi-tsang-ch'üan* XXI–XXX), for instance, illustrated in Ono's book, has only the number symbol *Lo* (525).[12]

Ono Gemmyō's investigation leaves no doubt that the Korean *Pi-tsang-ch'üan* at Nanzenji was printed from the blocks of the eleventh-century Korean A edition, and thus is in keeping with the view taken by other Japanese scholars. Tokushi Yūshō, for instance, mentioning the woodcut illuminations of the *Pi-tsang-ch'üan*, judges them to be faithful imitations of Sung Chinese originals in a first Korean edition and recognizes their importance for the history of Chinese landscape painting in the beginning of the Sung period.[13] The four Sung woodcuts in the Fogg Museum fragment, unknown to him, fully support his judgment.

With the eleventh-century date of the Korean imitations established, the question of the date of the Sung originals can be considered as settled. They must be earlier than the Korean woodcuts, so that their late tenth-century date — about 984–991, if we may rely on the testimony of the historical records — receives a final confirmation.

The Korean woodcuts of the Nanzenji copy of the *Pi-tsang-ch'üan* have not been published so far, except for the frontispiece of Chapter XXI, the *Fo-fu* (Pl. 39B),[14] mentioned above (p. 40). It would seem excusable, therefore, if photographs that I was permitted to take of the woodcuts of the *Pi-tsang-ch'üan* Chapter XIII are appended, even though they are

obviously technically imperfect.[15] These four landscape woodcuts (Pls. 18–27), which thematically and, of course, stylistically agree perfectly with those of the Chinese edition, will be described below.

FRONTISPIECE: WOODED LANDSCAPE WITH A STREAM AND RISING CLOUDS (PLS. 18–20)

Three quarters of the picture's width is occupied by a bewildering array of rocks, layered cliffs, and tall mountains, with trees of all variety scattered between them, growing singly or in groups, with foliage and without. The lay of the terrain is blurred by clouds which, forming foils for trees and groves, obscure its structure and contribute to an appearance of flatness in this part of the design. But to the left the landscape opens, and the eye wanders along the flat, jagged bank of a stream into the distance, where a range of hills and pointed peaks stretches across an unexpectedly lowered horizon. Big clouds with curly heads and slanting, sinuous tails fill the sky above this range, having a strangely powerful effect.

In the lower left-hand corner, where the stream bends, a group of travelers — two of them on horseback, two of them walking — moves toward a small bridge. Some distance from the bridge stands a person who seems to gaze at the travelers, bowing, as if he were inviting them to join him. Beyond this person we discern a kind of pavilion by the water, with bamboo growing behind it, bamboo so tall that it pierces the clouds that swirl over the thatched roof of the pavilion. Still farther back appears a pair of deer at the edge of the stream, the water of which is rendered in the form of waves, without the use of patterns like those depicting the quiet lakes or rivers in the Sung prints earlier described.

In conformity to the iconographic theme of the Sung woodcuts, this picture also shows the unobtrusively placed figure of an abbot or priest. He is seated on a chair inside an open hall with a tile-covered roof placed near the middle of the right half. Two acolytes are standing near him, while two priests are approaching him on a lower platform in front of the hall, their figures half hidden by a cloud. A second building rises behind and above the first. Directly below the group, a pilgrim with his staff walks briskly along a winding road in the foreground.

Among details of design not encountered in the four Sung woodcuts, the following are the most noteworthy:

1. Rocks with holes (*ling-lung*), at the lower edge in the right- and left-hand corners;

2. Layered rocks, built up in ashlar-like, rectangular shapes (near the right edge), and a layered cliff composed of trapezoid shapes (left of center);

3. A rounded ridge (right of center, to the left of the abbot's hall);

4. Choppy, flowing water which forms crested wavelets;

5. Bamboo, with short, radiating, spiky leaves;

6. Farm houses, here quite small and simple (in the distance, to the right of the abbot's hall).

SECOND KOREAN WOODCUT: ROCKY PINNACLES AND ROOFS OF DISTANT TEMPLES (PLS. 21, 22)

Following text sheet 3, this picture corresponds in position to the first of the Sung woodcuts.

Grander and wilder than the rest of the series, this landscape is like a fantastic forest of stone pinnacles towering above groves, rocky terrain, and small expanses of water in the foreground. The pinnacles crowd toward both sides, leaving a gap in the middle where the relentless upward thrust of the crags is interrupted by a clearing. This clearing, a valley, is however neither wide nor open toward the horizon. Above the farthest peaks there hover small curly clouds, all drifting slowly toward the left side. Beyond the peaks near the right edge, in a topographically unexpected and unlikely spot, appear large roofs with upcurved eaves and ridge acroteria, reminiscent of stately temple halls of late T'ang design. This is the only occurrence of monumental architecture in these woodcuts. Between two broader peaks to the left of the valley we can make out the beehive-like straw hut of a hermit sitting in meditation. Partly hidden by trees and clouds, the hermit and his hut are so inconspicuously placed as to be virtually invisible — as if his somehow efficacious presence were all that mattered. There seems to be no visitor here to disturb him. Yet down the road to the left we discover the tiny figure of a man walking away from the recluse's retreat, and, directly below, by the water, two other pilgrims, a priest accompanied by a layman, passing through a forest of tall deciduous trees. They will presently climb through a narrow defile formed by horizontally layered cliffs, where we notice two other men who are about to enter the defile, apparently on their way up to the hermit's not quite inaccessible retreat.

There is much interesting detail and variety in the design of the multitudinous crags, although the basic shape of the "boxed cone" is readily traceable in most of them. In the first massive group, which cuts across two of the temple roofs near the right edge of the picture, the slender cones are topped by expanding rhombic formations. These rhombic tops are very seldom seen in paintings; one painting in which they do appear will be mentioned below, after the description of the four Korean woodcuts. Immediately to the left is an imposing massif of steep cones which are distinguished by small tooth-like projections

along the inner contours. Representing outcrops — or possibly a layering that is hard to reconcile with the smooth drop of the walls — these projections are almost as regular as the microblades in a Mesolithic cutting tool. These projections, or designs like them, do occur in painting. The very slender distant cliffs with slanting tops appearing farther left are an element still in favor as late as Southern Sung painting. Another remarkable rock formation is the intricately drawn, horizontally stratified cliff with a widely expanding top, mentioned above as the defile through which the pilgrims are traveling. Finally, I wish to call attention to a slanting outcrop of rock of large dimensions, whose left side is a smooth slope which descends steeply toward the edge of the picture, joining it above the middle, while its right side has a jagged silhouette formed by slanting layers. It is a formation related to the "stepped escarpment" observed in the Sung woodcuts, which owing to its oblique aspect acquires a peculiar expressive power.

Continuing the list of motifs not encountered in the four Sung woodcuts, I note the following ones:

 7. Roofs beyond cliff tops, suggesting monumental temple buildings;
 8. Rhombic cliff tops;
 9. Tooth-like projections along straight cliff contours;
 10. Slender distant cliffs;
 11. A slanting outcrop.

THIRD KOREAN WOODCUT: BARE MOUNTAINS AND LAKES (PLS. 23, 24)

Inserted between text leaves 6 and 7, this picture corresponds in position to the second of the Sung woodcuts, while in subject matter and style it agrees closely with the fourth of the Sung woodcuts (Pl. 4).

Across the horizon runs a range of mountains which, almost bare of vegetation, clearly display a "boxed cone" structure that is monotonously repeated. They are nearly all of the same size. The only exceptional formation is a cluster of tall peaks which pushes forward (toward the bottom of the picture), the peaks closest to the viewer forming a promontory that rises from a circular platform. Just as the range stretches completely across the picture above, so does the water stretch across the foreground below, receding in a deep inlet to the right of the promontory, and in smaller ones to the left of it. A road leads around this promontory, which is connected by an isthmus and bridge to the land at the far left, which rises abruptly from the water. A low, rocky islet with trees and vapor silhouetted against the water of the deep inlet answers on the far right side. The water is defined by means of horizontal striation.

On a small plateau above and behind the peaks of the promontory

stands the (comparatively large) beehive hut of a priest, who sits on a chair in his hut. He is about to receive two visitors, a monk and a scholar, who are approaching from the left. None of these figures is drawn and carved with the unfailingly clear characterization and incredible precision manifest in the four Chinese woodcuts. No more precise are the two other figures in this print, a pilgrim on the road around the promontory (whose feet are simply omitted) and a traveler who crosses the isthmus (whose entire figure is indistinctly rendered). Near the left edge of the picture, among trees with diverse kinds of foliage, we discern the thatched roofs of a homestead enclosed by a basketry fence. A pavilion supported by piles and covered with a convex thatched roof stands close to these buildings.

This landscape resembles the Sung woodcut of Plate 4 so closely that it would seem safe to assume that the designer was the same in both cases. The close resemblance to the fourth of the Sung woodcuts accounts for the fact that this print contains no motifs that were not already listed before — save, perhaps, the detail of the basketry fence, which I consider too insignificant to take into account.

FOURTH KOREAN WOODCUT: LANDSCAPE WITH A HERMIT IN A GROTTO (PLS. 25–27)

The position of this print, which follows text leaf 12, corresponds to that of the fourth picture of the Sung fragment in the Fogg Museum.

Once more we are faced with a landscape of exceedingly rugged character. The scene opens at the right side with a narrow gorge formed by steeply slanting walls of rock. Through this gorge a road winds down to a flat, level area, where it passes beneath an arch of rock. Two travelers who have come through the gorge and the archway are about to traverse a small bridge. The bridge leads across a kind of inlet, beyond which the level area continues to the left. A body of water lies behind this level stretch. Dissected by rocks and obviously of little depth, the water flows over gentle rapids toward the inlet. It is fed by two small streams. The stream on the left gushes down through a chasm, at the far end of which we discern a waterfall; that on the right cascades fitfully from the rocky face of a plateau, as if it were welling up from a subterranean spring. On the plateau, right above this cascade, there rises the tall arch of a grotto. A hermit or ascetic in the posture of meditation is seated within the grotto on a natural dais of stone. In front of him kneels a priest, while a second priest stands outside.

A tall cliff to the left of the chasm with the tiny waterfall forms part of a beautifully structured massif that slopes toward the left in complicated but coherent formations. Beneath the massif lies an expanse of

open water which connects with the shoals and rapids described before. This open expanse is brought to a halt by a precipitous cliff which rises at the left edge of the picture. The cliff is nearly blotted out by a group of very tall trees and vapors placed in front of it. To the right of these trees, beyond a slightly arched bridge that spans an arm of the open water, there walks another itinerant with his servant, the latter carrying his master's light baggage on a pole over his right shoulder. Before them lies a slanting ledge of rock behind which they will presently disappear, to meet beyond the travelers who have come through the gorge.

Between the jagged peaks at the horizon stretches a compact sheet of cloud in the simple form of horizontal striation. This sheet is not level all across, but varies in height in accordance with the configuration of the peaks, and occasionally shows gaps to provide spaces for the little pine trees growing on some of the peaks. Though comparable in principle to the sea of cloud we see in the second of the Sung prints (Pl. 2), the motif as it is treated in this picture differs considerably in its total effect.

The combination of tall deciduous trees with unfurling vapors placed behind them occurs with minor variations throughout this landscape. Cutting across the more clearly legible and corporeal shapes of the rocks and mountains, these trees and vapor curls, consisting as they do of flattish patterns of tiny leaves and volutes, have an undeniably confusing effect. This effect was perhaps desired for the sake of contrast. For the confusion or blur — brought about by the very minuteness of the foliage elements — would appear to have been the only technically feasible method of enhancing, by contrast, the unrelentingly sharp linear definition of the rock. Perhaps this blurring was not then conceived in aesthetic terms, but accepted as a natural or at any rate unavoidable result of the depiction of trees, which were an essential feature.

There are only a few motifs or elements in this picture which ought to be added to the list of motifs not encountered in the Sung woodcuts. They are as follows:

 12. Rock arches and an arched grotto;

 13. A waterfall;

 14. A cascading stream;

 15. Foliage in the form of sheets composed of small rhombi.

OBSERVATIONS ON VARIOUS MOTIFS IN THE KOREAN WOODCUTS

It is obvious that the four Korean woodcuts described above are stylistically indistinguishable from the Chinese ones, so that they would not fundamentally alter our conclusions regarding the date of the latter.

Nevertheless these Korean woodcuts contain quite a few motifs which are absent in the Chinese woodcuts, and might, therefore, on the grounds of design rather than style, offer clues which could to some extent modify our conclusions about the chronology of the latter. Such elements of design might be related, for instance, to the work of an artist other than those of whom we were reminded by the Sung woodcuts, and hence extend or refine the interval proposed for their date. Conceivably, however, they will not, and will merely confirm the date suggested in Chapter III, in which case an investigation of the occurrence of these elements in paintings will only repeat the names of painters and titles of works mentioned previously. Even so we ought not to be excused from such an investigation, which will be carried out in brief below. The motifs will be discussed in the order adopted for those of the Sung woodcuts, grouped under terrain structures, vegetation, water, and finally architecture. To avoid confusion, the numbers will be preceded by the letter K ("Korean").

K 1. THE ROUNDED RIDGE (PL. 20). The fact that a motif so common as a ridge with rounded crest occurs only once in these landscapes is a reminder of the outspoken angularity of their rock and mountain shapes. Since this angularity persists throughout the woodcuts and does not depend on the technique of the engraver, it cannot but be rated a stylistic feature. Angularity, of course, means "rock" and the strange or imposing lofty cliffs that dominate the landscape image of the early tenth century, whereas roundness means gentle hills and grassy slopes, a distinguishing feature — on the authority of Sung critics like Shen Kua (1030–1094) [16] — of the new landscape style of Tung Yüan and his follower Chü-jan in the second half of the century. In the case of the Korean frontispiece (Pls. 19, 20), however, the rounded ridge remains only an isolated feature, an insignificant detail drowned in a complex composition in which angular rock forms prevail; in its total effect, therefore, the frontispiece is quite unlike the landscapes of the Tung Yüan–Chü-jan tradition, where the motif of the rounded hill so plainly predominates. Consequently the rounded ridge here may not be interpreted as evidence of the influence of the Chiang-nan school.

K 2. RHOMBIC CLIFF TOPS (PL. 22). This motif consists of expanding rock formations of rhombic shape on top of more or less slender cones. The motif was mentioned in the remarks about Li Ch'eng toward the end of Chapter III, in connection with a work in the Palace Museum collection attributed to this master, *Mountain Peaks After a Snowfall* (Pl. 36). [17] It is the only painting to exhibit the motif in question; at the same time

it is the only case of a Li Ch'eng to offer a parallel to the landscape woodcuts.

The importance of this counterpart in a painting depends on its date, which is not at all secure. Neither is its attribution to Li Ch'eng, though I consider it not wholly implausible. What at any rate seems safe to say is that *Mountain Peaks After a Snowfall* is a tenth-century painting, more "advanced" than Ching Hao and Kuan T'ung, on the whole compatible with the *Travelers Among Snowy Hills* of the Boston Museum attributed to the same master, and doubtless much earlier than Fan K'uan's *Travelers Among Streams and Mountains* from the end of the tenth century. The work, then, should offer proof of the existence, around the middle of the century, of the highly curious and arbitrary formation of the rhombic cliff top.

K 3. LAYERED ROCKS AND CLIFFS (PLS. 19, 20). The boldly geometric and entirely conceptual formations of rock consisting of rectangular slabs or layered trapezoids noted in the description of the frontispiece are not exactly matched in any paintings I know.

K 4. TOOTH-LIKE PROJECTIONS ALONG CLIFF CONTOURS (PL. 22). Presumably derived from T'ang geometric formations like those in the Palace Museum *Snowy Landscape* formerly attributed to Wang Wei,[18] these "teeth" are one of the ingenious and expressive conceits of the archaic landscapist in search of rich and convincing mountain images. There are many comparable examples in paintings, of which I list the following:

Autumn Mountains (Pl. 34), anonymous. Tenth century. Palace Museum.[19]

Landscape with Rocky Cliffs, anonymous. Sung(?).[20]

First Snow over Rivers and Mountains (Pl. 32), anonymous. One of several known copies of a tenth-century work.[21]

Landscape, attributed to Kuo Hsi. Eleventh century; probably Ming.[22]

K 5. THE SLANTING OUTCROP (PL. 21). Among the spectacular and in hindsight even bizarre motifs favored by archaic landscapists, the wall of rock dropping sheer, the overhang, the towering cliff, and the slanting outcrop are those most frequently encountered. There is a visual excitement in the slashing verticals and sharply contrasting axes of these forms, as well as an expressive power. Indispensable to the T'ang painter, they seem to have persisted throughout the Five Dynasties and into early Sung. Paintings in which these motifs occur are not wanting. It may suffice to call to mind the landscapes painted on the plectrum guards of two eighth-century lutes in the Shōsōin,[23] and a less securely datable

landscape attributed to Li Chao-tao in the collection of Sasagawa Kisa-burō,[24] which is doubtless a copy after a T'ang work in the blue-and-green manner and contains a great variety of slanting outcrops of a fantastic and excessive character. I do not know of any counterpart in painting to compare with the outcrop formation in the second Korean woodcut (Pl. 21, left edge). This formation certainly retains much of the bold, almost violent character of archaic designs. All the same, it exhibits a quality not apparent in them, a rational quality that is in tune with tenth-century tendencies, and which in this particular case may be recognized in the structurally convincing layering of the rock at an angle which agrees exactly with the tilt of the outcrop.

K 6. THE ARCHED GROTTO AND ROCK ARCHES (PLS. 26, 27). These motifs, which were briefly described above (p. 61), again appear to hark back to landscape styles as early as T'ang. A large picture attributed to Li Chao-tao in the Palace Museum collection, *The Ch'ü River*,[25] while not probably an original work by the master, may be accepted as a more or less exact copy of a T'ang composition; in it is displayed, at the foot of the main mountain, an arched grotto under whose vault there appears a pavilion-like building, reminiscent of the architectural elements seen through the grotto in the Korean woodcut. Small rock arches, similar to those in the escarpment of the plateau in front and to the left of the grotto in the Korean woodcut, appear in a ninth- or tenth-century Tun-huang painting in the Musée Guimet,[26] which shows *Shui-yüeh Kuan-yin* seated on a rock beneath which there are three small open arches through which water flows, exactly as in the woodcut.

K 7. ROCKS WITH HOLES (*Ling-lung*) (PLS. 19, 20). In itself of surpassing aesthetic interest, this motif is familiar from representations of garden rocks rather than from landscape paintings. It seems to go back to T'ang painting, and never afterward disappeared. The rocks in the examples listed below are all garden rocks.

An Empress Returning from a Journey, attributed to Chang Hsüan, first half eighth century.[27]

Eight Gentlemen on a Spring Outing, attributed to Chao Yen (d. 922).[28]

The Four Gray-Heads, attributed to Sun Wei, late ninth century.[29]

Flowers on New Year's Day, attributed to Chao Ch'ang, about A.D. 1000.[30]

K 8. THE DISTANT SLENDER CLIFF (PLS. 21, 22). The motif I have in mind is not simply a cliff or pinnacle but a cliff rising in the far distance, flat and without texture, as if enshrouded in haze, and often exceedingly slender.

Typically this cliff appears as a pale silhouette with an asymmetrically slanted apex. I am not aware of its occurrence in T'ang paintings.[31] By the tenth century, however, the motif seems to have been widely used. This date is suggested by the works listed below, though none of them offers a really safe *point d'appui* concerning the first appearance of the motif in question; what at best they permit us to conclude is that it appeared no later than the first half of the tenth century. It should be noted that, conversely, the presence of the motif in the Korean woodcut may now be adduced to support a date as early as the tenth century in the case of landscapes which hitherto, on account of this very motif, would have been dated much later, provided, of course, that other factors do not contradict so early a date. Examples:

The K'uang-Lu Mountain (Pl. 31), attributed to Ching Hao (about A.D. 900), in the Palace Museum collection,[32] where the motif appears in a form that does not strictly correspond to the definition given above; the form here seems more archaic than do typical examples of this motif.

Autumn Mountains (Pl. 34), anonymous. Tenth century. Palace Museum collection.[33]

The Yangtze Valley, handscroll, formerly attributed to Chü-jan (*fl. ca.* 975), in the Freer Gallery.[34] Unlikely to be earlier than the eleventh century.

Retreats in the Spring Hills, handscroll, by an anonymous artist, possibly of the tenth century. Crawford collection.[35]

Pine Wind Resounding in a Myriad Valleys, copy by Wang Hui (d. 1717) after Tung Yüan (d. 962).[36]

A Myriad of Trees and Strange Peaks, copy by Chang Tsung-ts'ang, dated 1732, after Tung Yüan.[37]

K 9. FOLIAGE IN THE FORM OF SHEETS OF SMALL RHOMBI (PLS. 25–27). This foliage pattern, noted in the fourth of the Nanzenji Korean woodcuts as a pattern distinct from any in the Chinese woodcuts, may be a Korean adaptation of a pattern which did occur in Chinese woodcuts now lost. The pattern is not matched in any painting I know.

K 10. BAMBOO WITH SHORT, SPIKY, RADIATE LEAVES (PLS. 18, 19). Though long a recognizable subject or motif, bamboo changes greatly in form over the centuries, as if the representation of the plant depended little on actuality and largely on the artist's conceptualization of it. The tall, thin rods with a few leaves pointing upward that we see in a Tun-huang mural of 538–39 in Cave 285 [38] have little in common with the feathery leaves of the bamboo as it appears in one of the panels of the seventh-century Tamamushi Shrine at Hōryūji.[39] This feathery, two-dimensional

design recurs in Wang Wei's *Wang-ch'uan-t'u* of the mid-eighth century.[40] But by the tenth century we find in representations of bamboo a rational concern for the third dimension, as may be seen in several drawings from Tun-huang in London and Paris, showing *Shui-yüeh Kuan-yin*, or Kuan-yin seated on a rock by the water.[41] One of the pictures in Paris is dated in accordance with A.D. 943,[42] but that which most closely approaches the design of the bamboo in the Nanzenji woodcut is a picture in the British Museum that is not dated.[43] Compared with these drawings, the woodcut rendition, diminutive in size, is of course greatly simplified; yet it seems clear that the woodcut bamboo does not agree with representations of either the T'ang or the Sung periods.

K 11. CHOPPY WATER FORMING WAVELETS (PLS. 18, 19). The representation of water must have been of great concern to the painters of late T'ang and the Five Dynasties periods if, as literary testimony has it, there were by then specialists in water painting as such.[44] It is very unlikely that the woodcuts reflect the sophistication in concept and the standards of design attained by such specialists. For, as we have seen, the treatment of the water in most of these woodcuts is, at best, pleasing and adequate, but certainly not exciting or inspired. But the small crested wavelets in the frontispiece of the Nanzenji print of Chapter XIII offer at least one instance of a comparatively differentiated design. What I consider the most significant feature of this design is that it is not a pattern. It is the absence of pattern that sets the design of these wavelets apart from T'ang and pre-T'ang traditions, traditions of which we to some extent become aware when perusing such examples as the *Lo Shen Scroll* in Peking,[45] the engravings of the Nelson Gallery Sarcophagus of about 540,[46] the River Landscape in Cave 172 (Pelliot's number 33) at Tun-huang,[47] the early T'ang scroll, *Spring Time Travelers*, attributed to Chan Tzu-ch'ien,[48] the *Travelers in the Spring Mountains*, attributed to Li Chao-tao (Pl. 28),[49] and the copies after Wang Wei's *Wang-ch'uan-t'u*.[50] All of these examples show certain patterns used to represent flowing water or the water of lakes and sea.

The painting attributed to Tung Yüan, *The River Bank* (Pl. 35),[51] shows, by contrast, diagonally receding crests of short waves suggesting the turbulence caused by a strong breeze. This rendering of an agitated surface, which agrees fairly well with the crested wavelets of the Korean woodcut, is not a mere pattern; it is an expressive and quite specific formulation that presupposes observation. It stands to reason that the designer of the woodcut knew, and to an extent had mastered, the relatively realistic idiom present in a painting such as *The River Bank*, that may date from the middle of the tenth century.

K 12. THE WATERFALL (PLS. 25, 26). None of the woodcuts gives prominence to the waterfall motif, though by the late T'ang period it had become an important requisite of landscape painting. In the fourth of the Korean woodcuts this motif is treated most unobtrusively. Lacking tone and color, woodcut design is, of course, dependent on linear means, here consisting of a bundle of straight strokes indicating the free plunge of the fall at the head of the gully (to the left of the grotto). Topographically this waterfall is related to its setting in a rational and convincing manner. This distinguishes it from older representations of waterfalls, where the water spurts forth from an overhang, as in a scene from the eighth-century *Ingakyō* or *Sūtra of Causes and Effects*,[52] or gushes down from a cliff top, as it does in the landscape on one of the lutes in the Shōsōin.[53] In these eighth-century designs the waterfall is treated as if it were an element almost independent and disengaged from its setting; it is treated with an archaic literalness inconceivable in the tenth century.

K 13. THE CASCADING STREAM (PLS. 26, 27). This motif occurs in the fourth of the Korean woodcuts; it was described (p. 61) as a stream cascading fitfully from the rocky face of the small plateau beneath the arched grotto. Its design consists of thin, slightly curved strokes running down from ledge to ledge in separate threads. The motif is frequently encountered in painting; I single out two examples for the exceptional clarity of formulation they offer:

First Snow over Rivers and Mountains (Pl. 32), anonymous work, one of several copies of a tenth-century composition. It was mentioned in the catalogue of motifs noted in the Sung woodcuts and in Section K 4 above.

The River Bank (Pl. 35), bearing the signature of Tung Yüan and dating, conceivably, from the middle of the tenth century.[54]

K 14. TEMPLE ROOFS BEYOND CLIFF TOPS (PL. 22). In the monumental roofs hovering amid formidable crags in the second of the Korean woodcuts, we are faced with an apparently very rarely employed motif, and one whose appearance is strange, not to say surrealistic. We cannot, however, suppose that it appeared so to the artist, and therefore should enquire into the reasons why it appears so to us. The strangeness of its effect may, I suspect, be the result of our misreading of the topography. For inasmuch as the startling effect of these roofs depends on the perspective and spatial relationships of the design, as in fact it does, we can be certain that it was not intended by the designer. Surely the designer did not knowingly manipulate or distort space; on the contrary, he struggled with the problem of spatial order. This is shown quite un-

mistakably by the tilt of the ground plane — if indeed one may speak here of a plane at all, since densely packed vertical shapes smother what little of a coherent plane can be inferred from the few pockets of open space. There is nothing here to suggest that the designer was acquainted with the effect of level recession first achieved by Li Ch'eng (d. 967).[55] In this archaic design the ground rises steeply toward the horizon; thus the seemingly tall cliffs which rise from the ground near the horizon are not so towering as our eye, accustomed to level recession, makes them out to be, nor so remote as their craggy character makes us feel they are. In short, a closer look at the design reveals that, owing to archaic conventions, there is a discrepancy here between the intended appearance and the unintended effect of these conventionalized crags. The temples whose roofs we see were meant to be read as distant but not as inaccessible.

The only fairly comparable example of this striking motif I know of is in the following painting:

Evening Blue in the Autumn Mountains, attributed to Kuan T'ung, first half tenth century. Palace Museum collection.[56] The relevant feature in this painting, which is hard to place but may well date from the tenth century, is the roof top of a pavilion appearing over the edge of the main cliff.

K 15. SIMPLE HUTS OR FARM HOUSES (PL. 20). This inconspicuous motif occurs in the frontispiece of the Korean print. Its absence in the majority of the woodcuts, Chinese and Korean, would seem attributable to the circumstance that it has no place in landscapes representing the mountain wilderness inhabited by mysterious saints, far from village and town. The motif offers no particular formal or stylistic interest and therefore need not occupy us further.

CHAPTER V / CONCLUSION

Having considered at length the landscape woodcuts contained in the fragmentary Chapter XIII of the *Pi-tsang-ch'üan*, one of the Sung Imperial commentaries written for the monumental printed edition of the Buddhist *Canon* in Chinese translation, I found myself convinced that these landscapes and the text they illuminate were printed from blocks of the late tenth century (between 984 and 991, to be precise) rather than from blocks of a later date, even as late as A.D. 1108, the year the printing was done. Fortunately a Korean version of the same text with the same kind of landscape woodcuts in the Nanzenji in Kyōto relieves us from the necessity to speculate; it is an edition printed in the eleventh century, faithfully copying the Sung edition and thus securing the date and authenticity of the hitherto entirely unknown prints.

Our investigation of the landscape woodcuts has shown that the tenth-century date of their design is supported also by the conventional motifs encountered in them. While some of these motifs can be traced back as far as the T'ang period, and others continue to occur in the eleventh century, the majority of them are found in paintings of tenth-century date as well as in copies after tenth-century masters. Taken collectively and in the specific form they possess in these woodcuts, these motifs or elements of design are, without question, symptomatic of the style of the woodcuts. They reflect, in greater or less degree, something of the pictorial structure in which they appear. The multitude of densely packed and precisely delineated forms displayed in the landscape woodcuts are a characteristic feature of style that recurs, *mutatis mutandis*, in each single rock or tree. It is, however, in the collective testimony of the elements of terrain formation that their stylistic import becomes most apparent. For we notice that most of the elements determining the physiognomy of the terrain were discarded in landscape painting contemporary with them or, at any rate, in the course of Northern Sung painting (pp. 51–52).

Nevertheless, the question of the stylistic position of these late tenth-century designs remains still to be answered. None of the paintings which were compared above in one detail or another would at all enable us to envisage their particular style. Their style is unfamiliar, almost

surprisingly so. It enlarges our knowledge of tenth-century art to an unforeseen degree.

That the essential linearity of the woodcut designs was not merely a matter of technique but was related to earlier tenth-century painting was noted above (p. 52), as was the puzzling fact that there appears to be no connection whatsoever between these prints and the painting of leading masters of landscape around the middle of the century, Tung Yüan and Li Ch'eng. The analogies with the work of these two painters which we observed are limited to details atypical of their mature styles. If, consequently, we tend to think of Kuan T'ung or the older Ching Hao as possible sources of the unfamiliar style of these woodcuts, assuming that the more pronounced linearity, complexity of design, and stronger patterning may be considered distinguishing features of theirs, we are doubtless logical. Yet we may feel uneasily that logic is a perilous faculty to rely on in historical matters. For one thing, the interval between the execution of the woodcut designs and the lifetimes of the two masters is very large indeed, so that we have to substitute "followers" in their stead, whose works we do not know. For the farther we move away from the great, the scantier do the records available to us become. Extant works, copies, and meaningful literary judgments are reserved to the great; if they are not understood, no lesser man will be. And this explains our dilemma when trying, as we must, to arrive at some understanding of the intriguing landscape woodcuts: no one has yet come forth with a convincing concept of the all but lost story of landscape painting in the tenth century.

Measured by what little we know of the late tenth century, the woodcut designs which I believe to date from the years between 984 and 991 (see pp. 29–33) were conservative or even somewhat archaizing works, by no means in tune with the achievements of the foremost landscapists of the time. As illuminations commissioned for one of the Imperial commentaries, the woodcuts must have been done in a style or manner acceptable to the Court and to the clergy. The feature which in this connection seems most noteworthy is the restraint exercised in the depiction of Buddhist subject matter. What the woodcuts display is landscape pure and simple; their allusions to Buddhism are restricted to the insertion of tiny, unobtrusive figures of priests and pious lay people and some mysterious hermits. The presence of these tiny figures deepens the spiritual tone of the landscapes without detracting from their visual impact as landscapes.

With their amazingly rich and tangled, yet ever precise design, these woodcuts reveal an intense mental effort on the part of the unknown artists who created them. Their effort was directed, it seems, toward compressing into a small format the grand form and lofty ethos that was the legacy of the early tenth century.

Notes / Lists of Chinese Characters / Bibliography / Index

NOTES

CHAPTER I / THE BEGINNINGS OF PRINTING
IN THE FAR EAST

1. *Chung-kuo pan-k'o t'u-lu*, pl. 1; text, Vol. I, p. 7.

2. For the *hyakuman-tō darani* or "dhāraṇī of the 1,000,000 wooden pagodas," cf. Carter, *The Invention of Printing in China*, pp. 33 ff.; *idem*, Second ed., pp. 46 ff.; Pelliot, *Les débuts*, pp. 28 ff.; Wang Kuo-wei, *Liang Che ku-k'an-pen k'ao*, shang, 17b; Tokushi, in *Bukkyō Kōkogaku Kōza*, Vol. III, 1936, pp. 13–17.

3. Cf. Takakusu, *A Record of the Buddhist Religion*, p. 150; Pelliot, *Les débuts*, pp. 14 ff.; Carter, Second ed., p. 38.

4. Pelliot, *Les débuts*, pp. 17 ff.

5. Cf. Tokushi, "Bukkyō hanga gaisetsu," p. 5. Wang Hsüan-ts'e, who went to India three times, 643–46, 647–48, and 658–60, is mentioned in *T'ang-shu*, ch. 198, *s.v.* Ni-po-lo (Nepal) and T'ien-chu (India); K'ai-ming ed., IV, 3611.4 and 3613.4. Cf. *Tōyō Rekishi Daijiten*, Vol. I, pp. 333 ff., with reference to S. Lévi, "Les missions de Wang Hiuen-ts'e dans l'Inde," in *J. As.* (1900), and *idem*, "Wang Hiuen-ts'e et Kaniṣka," in *T'oung Pao* (1912).

6. The *Sui-shu* passage is quoted in Pelliot's *Les débuts*, p. 17; my translation is modeled on Pelliot's.

7. Pelliot discusses these three instances in *Les débuts*, pp. 9–11.

8. L. C. Goodrich, in *JAOS*, Vol. 82 (1962), pp. 556–557, refuting a theory advanced by Robert Shafer, in *JAOS*, Vol. 80 (1960), pp. 328–329.

9. Tokushi, "Bukkyō hanga gaisetsu," p. 6.

10. Ono Gemmyō, "Insatsu-jutsu" (The art of printing), in *Tōyō Rekishi Daijiten*, Vol. IV, p. 62.2.

11. Pelliot, *Les débuts*, pp. 31–33. Carter, *The Invention of Printing in China*, Second ed., p. 65, n. 15. Wang Kuo-wei, *Liang Che ku-k'an-pen k'ao*, p. 1a, and Ono, "Insatsu-jutsu," p. 62.2, accept the tradition.

12. *T'ang-shu*, ch. 168; *Hsin T'ang-shu*, ch. 177; *Ts'e-fu yüan-kuei*, ch. 160. Pelliot, *Les débuts*, pp. 33 ff. Ono, "Insatsu-jutsu," p. 62.1. Carter, *The Invention*, Second ed., p. 59.

13. Carter, *ibid.*, p. 59.

14. *Teste* Tokushi, "Bukkyō hanga gaisetsu," p. 6.

15. *Kokka*, vol. 511. Matsumoto, *Tonkō-ga*, pl. 217. Carter, *The Invention*, pp. 39 ff.; Second ed., pp. 54 ff. L. Giles, *Descriptive Catalogue*, p. 279, No. 8083.

16. L. Giles, p. 280, No. 8099 and No. 8100.

17. Carter, *The Invention*, p. 44 and notes 12–16 on p. 210; *idem*, Second ed., p. 60 and notes 19–21 on p. 65. Pelliot, *Les débuts*, pp. 37–41, where the Chinese text of the passage is quoted. Instead of "*chiu kuan*, nine officials" read "*chiu kung*, nine palaces," as in the translation.

18. The *Ts'e-fu yüan-kuei* text translated is quoted in Wang Kuo-wei, *Wu-tai liang Sung Chien-pen k'ao*, shang, 1a. Cf. Carter, *The Invention*, Second ed., p. 70 and note 18, p. 77. Wang Kuo-wei also quotes the pertinent passages

in *Chiu Wu-tai-shih T'ang-shu* and *Chou-shu, ibid.*, 1a (cf. K'ai-ming ed., vol. V, pp. 4256.2 and 4359.1, respectively). Pelliot's discussion hinges mainly on Carter's assumption of Feng Tao's dependence on the achievements of the Shu country (*Les débuts*, pp. 50–54).

19. *Apud* Wang Kuo-wei, shang, 1 b.

20. T'ien Min's memorial of 953 is quoted by Wang Kuo-wei, shang, 2a, after *Ts'e-fu yüan-kuei*. The translation given by Carter, *The Invention*, p. 52 (Second ed., p. 72), supposedly of an account in *Wu-tai hui-yao*, actually corresponds to the passage as quoted in Wang Kuo-wei.

21. Carter, *The Invention*, pp. 47 ff. Cf. Pelliot, *Les débuts*, pp. 55–61.

22. For the dates of the Shu *Stone Classics*, see Pelliot, *ibid.*, and the article *"Sekkei"* (Stone Classics) by Watanabe, in *TRD*, Vol. V, pp. 190–192, the fourth section of which deals with the Shu *Stone Classics*. A recent contribution based on Sung rubbings in the Shanghai Library is an article, "On the Shu and Northern Sung Stone Tablets Engraved with the Confucian Classics," by Hsü Sen-yü, in *Wen Wu*, 1962, No. 1, pp. 9–11.

23. Wang Kuo-wei, *Chien-pen k'ao*, shang, 3 b ff. Pelliot, *Les débuts*, pp. 61–81.

24. Stein, *Serindia*, Vol. IV, pl. CIII. Matsumoto, *Tonkō-ga*, pl. CCXX a. Quotation translated in Giles, *Descriptive Catalogue*, p. 279, No. 8087.

25. Metropolitan Museum "Chinese print No. 5. Gift of Paul Pelliot through the Morgan Library, 1924."

26. Stein, *Serindia*, Vol. IV, pl. C. Matsumoto, *Tonkō-ga*, pl. CXX b. Giles, p. 280, No. 8093.

27. *Ibid.*, p. 279, No. 8084.

28. The bronze *stūpa* in the Yūrinkan is reproduced in *Yūrin Taikan*, Vol. I, 1929, pls. 23–24. A specimen of the printed scroll of A.D. 956 is in the collection of H.M. the King of Sweden.

29. Pelliot, *Les débuts*, pp. 49–50. Wang Kuo-wei, *Liang Che ku-k'an-pen k'ao*, shang, 18 a.

30. *Ibid. Chung-kuo pan-k'o t'u-lu*, pl. III.

31. Giles, in *JRAS*, 1925, pp. 513–515, and A. C. Moule, in *JRAS*, 1925, pp. 716–717.

32. *Sekai Bijutsu Zenshū*, Bekkan VIII: *Tōyō hanga-hen*, 1931, pl. 13, bottom. Tenri Central Library Photo Series, XIX, No. 9. *Yūrin Taikan*, Vol. I, pl. 25.

33. Yeh Kung-ch'o, *Hsia-an t'an-i-lu*, 7 b.

34. Laurence Binyon, *A Catalogue of Japanese and Chinese Woodcuts*, p. 580, No. 249. Matsumoto, *Tonkō-ga*, pl. CLVII b.

35. G. Henderson and L. Hurvitz, "The Buddha of Seiryōji," in *Artibus Asiae*, Vol. XIX, 1956, pp. 5–55. Shu Ying, "Pei Sung k'o-yin-ti i-fu mu-k'o-hua," in *Wen Wu*, 1962, No. 1, pp. 29–30. Carter, *The Invention*, Second ed., p. 74, indicates that the documents from the Shaka figure "include a Diamond Sūtra printed in 984 . . ."; actually the *sūtra* is dated in accordance with July 20, 985, while the Maitreya print bears the date corresponding to November 10, 984. *Kokuhō jiten*, p. 82.

36. Concerning Kao Wen-chin, see Soper, *Kuo Jo-hsü's Experiences in Painting*, p. 51. Sun Ta-kung, *Chung-kuo hua-chia jen-ming ta-tz'u-tien*, p. 330.2.

CHAPTER II / SUNG PRINTED EDITIONS
OF THE CHINESE TRIPIṬAKA

1. D. Tokiwa, *Daizōkyō chōin-kō*, in *Tetsugaku Zasshi*, XXVIII (1913).

2. *Fo-tsu t'ung-chi*, ch.43, as quoted in Tokiwa, pp. 382–383.

3. *Fo-tsu t'ung-tsai*, as quoted in Tokiwa, *ibid.*

4. *Shih-shih chi-ku-lüeh*, as quoted in Tokiwa, *ibid.*

5. Paul Demiéville, *Appendice*, 121 ff.

6. *Ibid.*, p. 122; Ogawa Kanichi, *Daizōkyō*, p. 32; Walter Fuchs, "Zur technischen Organisation der Übersetzungen . . .," *Asia Major*, Vol. VI, pp. 99–102.

7. An abbreviation of *K'ai-yüan shih-chiao-lu*, "Catalogue of [the books on] the teaching of Śākyamuni [compiled] in the K'ai-yüan era," "one of the best, if not the best, of Catalogues of the Chinese Translation of the Buddhist Tripiṭaka" in the words of B. Nanjio, *A Catalogue of the Chinese Translation of the Buddhist Tripiṭaka*, p. xx. Nanjio's No. 1485.

8. In Ogawa's account, *Daizōkyō*, p. 33, col. 3, the new translations received by Chōnen numbered no more than 40 scrolls. In Jōjin's *San Tendai Godaisan ki*, the figure of 286 scrolls is given; cf. Demiéville's translation of the letter which Jōjin received from the Chinese authorities in reply to his request of new translations; *Appendice*, p. 127, based on Takakusu's edition (5, 143 b-144 a) in *Dai Nihon Bukkyō Zensho*, vol. CXV. The same figure of 286 *chüan* appears in the more recent edition of Jōjin's book in Shimazu's *Jōjin ajari boshū* [and] *San-Tendai-Godaisan-ki no kenkyū* (1959), p. 590, col. 8.

9. The Chinese sources on Chōnen's visit mentioned by Demiéville, *Appendice*, p. 123, n. 4, are *Sung-shih*, ch. 491: 2b–4b; *Fo-tsu t'ung-chi*, ch. 43; and *Hsü Tzu-chih t'ung-chien* by Pi Yüan (1729–1797), ch. 12:23 b. The pictures of the *Hui-wen chi-sung*, of which a Korean print of the eleventh century is likely to exist at the Nanzenji monastery in Kyoto, have not been published so far.

10. Cf. *Nihon bijutsu-shi nempyō*, by Kobayashi and Fujita, under the years given above.

11. Ogawa, *Daizōkyō*, p. 33.

12. The relevant passages from Jōjin's *San-Tendai-Godaisan-ki* have been translated by Demiéville, *Appendice*, pp. 126–131.

13. Huai-chin's dates are given in Ch'en Yüan, *Shih-shih i-nien-lu*, 1964, p. 217, on the basis of an inscription composed by Huang T'ing-chien (1045–1105).

14. The text of the cartouche of 1071, mentioned by Pelliot, *Les débuts*, p. 89, was translated by Demiéville, *Appendice*, p. 125. Reproduced in Takakusu, *Hoppō ryūei*, pl. X A; Ogawa, *Daizōkyō*, p. 31, Fig. 12; Fukaura, *Bukkyō shōten gairon*, pl. 7.

15. Cf. Demiéville, *Appendice*, pp. 124 ff.

16. Cf. Ogawa, *Daizōkyō*, p. 36. Reproduced in Takakusu, *Hoppō ryūei*, pl. X B; Mochizuki, *Bukkyō Daijiten*, Vol. IV, p. 3312, Fig. 1018.

17. Yeh Kung-ch'o, "*Li-tai Tsang-ching k'ao-lüeh.*"

18. *Chung-kuo pan-k'o t'u-lu*, No. 220.

19. The dates have been established by Japanese scholars such as Tokiwa Daijō (1913), Ikeuchi Hiroshi (1923), and Fukaura Seibun (1927); see Bibliography. I have adopted the dates given by Ikeuchi.

20. *Kao-li-shih*, *s.v.* Sŏngjong, ninth year (A.D. 990). *Sung-shih*, ch. 487, *Kao-li lieh-chuan*, K'ai-ming ed., VII, p. 5710.3. *Fo-tsu t'ung-chi*, *s.v.* Shun-hua first year (990). *Kao-li ming-ch'en chuan*, *s.v.* Han On-gong. Excerpts in D. Tokiwa, "Daizōkyō chōin-kō" (1913), pp. 385–386. The Imperial prefaces are mentioned in both *Sung-shih* and *Kao-li ming-ch'en-chuan*.

21. *Kao-li-shih, s.v.* Sŏngjong, ninth and tenth years (990–991); Tokiwa, *op. cit.*

22. Cf. Ogawa, *Daizōkyō*, pp. 36 ff. The chief sources concerning the date of the Korean A edition are Prince Ŭich'ŏn's *Chu-tsung ching-tsang tiao-yin-su* and Ch'ae Ch'ung-sun's *Hyŏnhwasa pium-gi*. The former states that during the reign of Hyŏnjong (1010–1031) "5000 scrolls were printed," the latter, that in the king's eleventh year (1020) there had been completed the printing of four classes of *sūtras: Prajñāpāramitā, Avataṃsaka, Gold Splendor,* and *Lotus.* Cf. Fukaura, *Bukkyō shōten gairon*, p. 186.

23. A.D. 1083 or 1084 was taken to be the terminal date by Ono Gemmyō and Ogawa Kanichi.

24. Both H. Ikeuchi and S. Fukaura are inclined to accept the year 1087 as the terminal year of the first edition. Ikeuchi quotes *Kao-li-shih*, Sŏnjong, fourth year, second, third, and fourth months ("Kōrai-chō no Daizōkyō," in *Tōyō Gakuhō*, XIII/3, 1923, p. 330).

25. See Bibliography, *s.v.* Ŭich'ŏn.

26. Ikeuchi, p. 346.

27. *Ibid.*, pp. 346 ff.

28. *Ibid.*, p. 347.

29. Ikeuchi, "Kōrai-chō no Daizōkyō," in *Tōyō Gakuhō*, XIV/1, 1924, pp. 91–95. Ogawa, *Daizōkyō*, pp. 37 ff.

30. There are no discrepancies in the accounts given by Tokiwa (1913), Ikeuchi (1923), Fukaura (1927), Pelliot (1928/1953), Ono (1929/1937), and Ogawa (1964).

31. Ogawa, *Daizōkyō*, pp. 38–39. The computations of the numbers of works and scrolls vary; Paik, in his *"Tripiṭaka Koreana," Tr. Korea Branch R.A.S.*, XXXII (1951), for instance, speaks of 1511 works in 6805 scrolls.

32. The figure of 81,258 blocks is Paik's; Ogawa, *Daizōkyō*, p. 39, gives the far higher figure of 86,525 blocks. The estimate of the weight is based on Paik's account.

33. Y. Tokushi, *Kodai hanga-shū*, p. 43. When in 1964 through the kindness of Dr. Tokugawa Yoshihiro I was enabled to see the Korean prints of the Sung Imperial commentaries from the second Korean edition in the Library of the Imperial Palace in Tōkyō, I found that indeed they are without any illuminations.

34. Tokiwa, "Daizōkyō chōin-kō," in *Tetsugaku Zasshi*, Vol. XXVIII (1913), p. 387.

35. Ogawa, *Daizōkyō*, pp. 39–41.

36. Pelliot, *Les débuts*, p. 90

37. Ogawa, *Daizōkyō*, pp. 39–40.

38. *Ibid.*, p. 41.

39. Nogami, in *Tōyō Rekishi Daijiten*, Vol. IX, p. 18.

40. Cf. Ogawa, *Daizōkyō*, p. 41. For the Khitan edition, see also Ono, *Bussho Kaisetsu Daijiten*, Vol. XII, pp. 689 b ff.

41. Ogawa, *Daizōkyō*, pp. 42 ff.

42. Demiéville, *Appendice*, pp. 137 ff. Hu Chen-ch'i, in *Wen Wu*, 1962, No. 4–5, p. 92.

43. Tenri Central Library Photo Series, XIX, No. 18.

44. Hsiang Ta, in *Wen Wu*, 1962, p. 35, referring to Chiang Wei-hsin (1935).

45. Hsiang Ta, p. 35.

46. Ogawa, *Daizōkyō*, pp. 43–45.

47. *Ibid.*, pp. 45–46.

48. *Ibid.*, pp. 46–47. As for the year 1107, Ogawa's text is ambiguous insofar as it gives the date "Ta-kuan 7th year (1107)." Ta-kuan 7 would correspond to A.D. 1113, which is an impossible date because the era ended after four years in 1110. Obviously "7th year" is a mistake for "1st year," which corresponds to 1107.

49. Pelliot, *Les débuts*, p. 90.

50. Nakayama, *Sekai insatsu tsūshi*, Vol. II, *Shina insatsu-shi*, Chapter on "Sōdai no Bukkyō insatsu" (Buddhist *sūtra* prints of the Sung period), pp. 634 ff., *s.v.* Fu-chou editions (also Min-pen or Yüeh-pen).

51. Professor Mori Katsumi kindly accompanied me to, and introduced me at, the Kanazawa Bunko on November 7, 1964, enabling me to study samples of their holdings of Fu-chou A prints.

52. *Yasuda Bunko kogyō seikan*, Vol. III, pls. 282–283, 284–285.

53. *Chūsonji taikyō*, Vol. III, pl. 74.

54. Seen by the writer on November 18, 1964.

55. Seen by the writer on November 20, 1964. The beginning of the *sūtra* printed in 1085 is reproduced in *Ōtani Daigaku Toshokan zembon shūei*, 1961, p. 29.

56. Seen by the writer on November 26, 1964. Library No. I, 76, 247, referring to the *Catalogue of Rare Books of Tenri Library*.

57. Seen by the writer on September 24, 1964.

58. On November 25, 1964, the writer was shown all of the Imperial commentaries of the Tung-ch'an-ssu edition at Tōji.

59. The sample seen by the writer on November 23, 1964, is a wrapper of the *Ta-chih-tu-lun* or *Mahāprajñāpāramitā-śāstra* (wrapper symbol, *ming*, No. 211), dated in accordance with 1091.

60. Wu Lien-ch'eng, "Pei Sung Fu-chou Tung-ch'an Teng-chüeh-yüan k'an-pen Ta-tsang-ching," in *Wen Wu*, 1962, No. 4–5, p. 91.

61. Ogawa, *Daizōkyō*, pp. 47–48.

62. *Ibid.*, p. 49. Briefly mentioned by Pelliot, *Les débuts*, p. 90.

63. Ogawa, *Daizōkyō*, p. 50.

64. *Chūsonji taikyō*, Vol. III. pls. 75, 76, 77 a,b,c, 78 a,b. Nakayama, p. 637.

65. Ogawa, *Daizōkyō*, pp. 50 ff. Cf. Nakayama, p. 638.

66. Wang Kuo-wei, *Liang Che ku-k'an-pen k'ao*, hsia, 6 b.

67. According to Ch'en Yüan, *Shih-shih i-nien-lu*, p. 255.

68. This is mentioned by Ogawa, p. 50.

69. Wang Kuo-wei, hsia, 7 a.

70. Ogawa, *Daizōkyō*, pp 52–53.

71. Pelliot, *Les débuts*, p. 90, n. 1, notes that Lo Chen-yü distinguished two editions, one of 1132, and one of the mid-thirteenth century; Mori Katsumi, in a terse survey of the various editions of the *Canon* during the Sung period (Section 4 in Chapter 9 of his *Nichi-Sō bunka kōryū no sho-mondai*, esp. p. 212), seems to take the same view, which was held also by Naitō Torajirō ("Sōgen-han no hanashi," p. 123) and Ono Gemmyō (*Bussho Kaisetsu Daijiten, Sōron*, pp. 675b, 812a–815b, 830b–831b, according to Demiéville). Demiéville, *Appendice*, p. 133, rightly points out that the two names of the Ssu-ch'i *Canon* depend merely on the change of name of the same monastery, while Wang Kuo-wei, *Liang Che ku-k'an-pen k'ao*, hsia, 7b, concludes that the so-called *An-chi Tripiṭaka* represents not a separate edition but supplements to the *Ssu-ch'i Tripiṭaka*.

72. Ogawa, *Daizōkyō*, p. 54.

73. *Chūsonji taikyō*, Vol. III, pl. 78 c.

74. Ogawa, *Daizōkyō*, p. 51.

75. *Ibid.*, pp. 63–65. Pelliot, *Les débuts*, p. 90, speaks of this edition as having been undertaken at Su-chou, Kiangsu, in 1301; Demiéville, *Appendice*, pp. 133 ff., gives a more detailed and accurate account of this edition.

76. Pelliot, *Les débuts*, p. 91.

77. Ogawa, *Daizōkyō*, p. 66.

78. Demiéville, *Appendice*, p. 134.

79. *Ibid.*, p. 134; cf. Ogawa, *Daizōkyō*, p. 68. The title of the reprint in reduced size published in Shanghai, 1931–1936, runs *Ying-yin Sung Chi-sha Tsang-ching;* it is a set of 591 volumes.

80. Demiéville, *Appendice*, p. 134, n. 5.

81. Ogawa, *Daizōkyō*, p. 68.

82. *Ibid.*, p. 66, fig. 27.

83. Reproduction of a frontispiece with Tangut title: Ogawa, *Daizōkyō*, p. 67, fig. 28; text, pp. 66–68. Small, exquisitely printed fragments of Buddhist texts in Tangut script from Central Asia are in the possession of the Seikadō Foundation in Tōkyō; others, collected by Sven Hedin at Etsin-gol in Mongolia, are kept at Statens Etnografiska Museet in Stockholm. Two excellent reproductions of early Yüan prints of Buddhist texts in Hsi-Hsia script from Hang-chou are contained in *Chung-kuo pan-k'o t'u-lu*, Vol. IV, pls. 277, 278.

84. Ogawa, *Daizōkyō*, p. 66.

CHAPTER III / THE LANDSCAPE WOODCUTS
OF THE PI-TSANG-CH'ÜAN

1. Tung Yüan's style as it appears in one specific instance, namely, a painting entitled *The River Bank* (Chang Ta-ch'ien collection; *Taifūdō*, Vol. IV), which according to Hsieh Chih-liu, *T'ang Wu-tai Sung Yüan ming-chi*, pl. 2, bears the following signature: *Hou-yüan fu-shih ch'en Tung Yüan hua*, "Rear Park Assistant Commissioner, servitor Tung Yüan *pinxit*," and moreover is provided with the early Ming official seal reading Tien-li Chi-ch'a-ssu. Concerning this seal, see Max Loehr, "Chinese Paintings with Sung Dated Inscriptions" in *Ars Orientalis*, Vol. IV (1961), p. 224. *The River Bank* is reproduced in our Pl. 35.

2. This work may be a late T'ang replica of an earlier T'ang composition, of which there exist variant versions; compare Pls. 28 and 29, or the larger reproductions in *KK 300*, I, 4 and 35, the latter in color. A good detail, also in color, is shown in *Chinese Art Treasures*, No. 2. While there is no consensus of opinion regarding the date of *Ming-huang's Journey to Shu*, the ancientness of its design cannot be questioned. The widely differing versions just mentioned, and a third one, attributed to Chao Po-chü (*Chung-kuo ming-hua*, Vol. XXV, No. 3: *Plank-Road in the Clouds*), which derives from the left half of the composition, testify to the existence of a lost T'ang work of great importance. In Sirén's *Chinese Painting*, Vol. III, pls. 82 and 83, the two versions of our Pls. 28 and 29 appear side by side.

3. *KKSHC*, Vol. XLV.

4. Tokushi Yūshō, pl. 47; Ogawa Kanichi, *Daizōkyō*, p. 37, fig. 14; our Pl. 39 b.

5. Ono Gemmyō, *Bukkyō no bijutsu to rekishi*, pl. 29, fig. 99.

6. Cf. Note 1 above.

7. *T'u-hua chien-wen-chih*, ch. 2:13 a; Alexander Soper, *Kuo Jo-hsü's Experiences in Painting*, pp. 29ff. *Hsüan-ho hua-p'u*, ch. 10, ed. *Ts'ung-shu Chi-ch'eng*, Vol. 1652, p. 272.

8. Sirén, *Chinese Painting*, Vol. III, pls. 79–80.

9. *Ibid.*, pl. 91; Chu-tsing Li, *Autumn Colors*, pl. 3.

10. *KK*, Vol. XXVI; *KK 300*, I, 4; Sirén, *Chinese Painting*, Vol. III, pl. 82 (mistakenly referring to *KK*, vol. XXXVI). Cf. Note 2 above.

11. Sirén, *Chinese Painting*, III, 98; *KK 300*, I, 31, in color.

12. Sirén, *Chinese Painting*, III, 144; *KK 300*, I, 37.

13. Pelliot, *Les grottes de Touen-houang*, pls. 203 ff.; L. Bachhofer, "Die Raumdarstellung . . . ," in *Münchner Jahrbuch der bildenden Kunst*, Vol. VIII (1931), p. 241, fig. 22.

14. *KKSHC*, Vol XLV; mentioned above, Note 3. In *KKSHL*, chung, ch. 5:110 f., the painting is described as an anonymous Sung work in ink. Actually, however, it is colored in part; the low peaks in the distance show an opaque, greenish blue — quite unlike the transparent blue in typical Sung painting.

15. Notwithstanding the generally archaic character of the rock design, a Sung date of the execution of this particular version has been advocated on the basis of the linear technique of the rock design; cf. Li Lin-ts'an's article, listed in the Bibliography. The feature discussed by Dr. Li represents hardly more than a graphological idiosyncrasy, and it does not bear decisively on the question of style and of the date of the original composition.

16. Sir Aurel Stein, *The Thousand Buddhas*, pl. 34; Matsumoto, *Tonkō-ga no kenkyū*, pl. 95 a.

17. *KKSHL*, chung, ch. 5:104; unpublished. This painting, which is very large, has a strong T'ang flavor; it is done in rich but subdued color on dark brown, heavily damaged silk.

18. *Chung-kuo ming-hua*, Vol. V.

19. Sirén, *Chinese Painting*, Vol. III, pl. 145; *KKSHC*, Vol. VIII; *KK 300*, I, 38.

20. George Rowley, *Principles of Chinese Painting*, 1947, pl. 17.

21. Sirén, *Chinese Painting*, Vol. III, pl. 62 below; Fourcade, *La peinture murale de Touen Houang*, pl. 29.

22. J. D. Chen, *Chin-kuei ts'ang-hua-chi*, Vol. I (Hanging scrolls), pl. 2.

23. Sirén, *Chinese Painting*, Vol. III, pl. 151; Sickman and Soper, *The Art and Architecture of China*, 1956, pl. 86.

24. Sirén, *Chinese Painting*, Vol. III, pl. 160; *KK 300*, I, 42. The meaning and probable distortion of the title of this painting was recently discussed by L. S. Yang, in *Bulletin of the Institute of History and Philology*, Academia Sinica, Taipei (1960), Extra Vol. IV, pp. 53–56; the term *Lung-su chiao-min* ought to read *Lung-hsiu chiao-min*, and the current interpretation, "Dragon Boat Festival," ought to be replaced by "People of the Capital City."

25. *KKSHL*, chung, ch. 5:107 (unpublished); Freer Gallery of Art, Washington, No. 15.20 = Sirén, *Chinese Paintings in American Collections*, pl. 178; *Kwen Catalogue*, No. 12.

26. Sir Aurel Stein, *The Thousand Buddhas*, pl. 14; Matsumoto, *Tonkō-ga no kenkyū*, pl. 128.

27. Sirén, *Chinese Painting*, III, 24–28; Sickman and Soper, *The Art and Architecture of China*, 1956, pls. 52–53; M. Sullivan, *The Birth of Landscape Painting in China*, pls. 123–128.

28. Sirén, *Chinese Painting*, III, 154; James Cahill, *Chinese Painting*, p. 33, and an excellent detail, p. 31; *KK 300*, II, 64.

29. Sirén, *CP III*, 195: "Dwellers on the Mountain of the Sleeping Dragon."

30. *KKSHC*, Vol. XXV.

31. *Chung-kuo ming-hua*, Vol. VII.

32. Sirén, *CP III*, 124–125.

33. *Ibid.*, 143; Cahill, *Chinese Painting*, p. 68 (detail, in color).

34. *Chinese Calligraphy and Painting in the Collection of John M. Crawford, Jr.*, No. 5, pl. 2; Cahill, *Chinese Painting*, p. 41 (detail, in color).

35. Sirén, *CP III*, 66, and Add. pl. 66 B.

36. *KKSHC*, Vol. XII.

37. Sirén, *CP III*, 94; Gustav Ecke, *Chinese Painting in Hawaii*, Vol. I, p. 291; Vol. II, pl. XLI.

38. H. Munsterberg, *The Landscape Painting of China and Japan*, pl. 23, where a late tenth-century date is suggested, p. 42. In my opinion this work is far too archaic to fit in so late; a ninth-century date seems the latest possible.

39. *KKSHC*, Vol. III.

40. Sirén, *CP III*, 172–173; Sickman and Soper, *The Art and Architecture of China*, 1956, pl. 90 (section showing the slanting tree).

41. Sherman Lee and Wen Fong, *Streams and Mountains Without End*, pl. 1; Sherman Lee, *Chinese Landscape Painting*, p. 25, top, center of fig. 16.

42. Sirén, *CP III*, 81 (lower right-hand corner and, halfway up, on the cliff near the right edge).

43. *Shi Ō Go Un* (*Ssu Wang Wu Yün*), pl. 13 (halfway up, near the right edge and in the center).

44. Museum of Fine Arts, Boston, No. 57.194. The same composition recurs in a painting attributed to Liu Tao-shih; see J. D. Chen, *Chin-kuei ts'ang-hua-chi*, Vol. I, pl. 4.

45. Sirén, *CP III*, 153; *KKSHC*, Vol. IV; *KK 300*, II, 67.

46. The numbers refer to *Tu Fu's Gedichte*, übersetzt von Erwin von Zach. Harvard-Yenching Institute Studies, VIII.

47. Sirén, *Chinese Paintings in American Collections*, pl. 143; Bachhofer, *A Short History of Chinese Art*, 1946, fig. 98.

48. Sirén *CP III*, 171; *KK 300*, II, 71.

49. The works omitted in the chart are these: Chan Tzu-ch'ien (1). T'ang *Snowscape*, Ku Kung (1, 12). *Buddha on the Vulture Peak*, embroidery from Tun-huang (2). *Mountain Landscape*, Princeton (4). *Buddhist Temple Amid Clearing Mountain Peaks* (5, 15). *First Snow over Rivers and Mountains* (6). Sun Wei (10). *Deer Among Red-Leafed Maples* (10). *Landscape*, by a follower of Ching Hao (11). *Mountain Landscape*, ninth century (?), Kansas City (12). *Autumn Mountains*, Ku Kung (12). *Streams and Mountains Without End* (12). *The Ch'ü River*, Ku Kung (13). *Drinking and Singing at the Foot of a Precipitous Mountain* (15). *Sitting Alone by the Mountain Stream* (15). *Winter Mountains*, Freer Gallery (16).

50. Wang Ming-ch'ing, *Hui-chu ch'ien-lu*, ch. 3, near the end.

51. *T'u-hua chien-wen-chih*, ch. 3:7. Soper's translation differs.

52. Chang Keng, *T'u-hua ching-i-chih* (1762) as quoted by Chu Chu-yü and Li Shih-sun, *T'ang Sung hua-chia jen-ming tz'u-tien*, p. 99.2.

53. *Hsüan-ho hua-p'u*, ch. 11, ed. *Ts'ung-shu Chi-ch'eng*, Vol. 1653, p. 284.

54. Soper, *Kuo Jo-hsü's Experiences in Painting*, p. 19.

55. K. Tomita, *Portfolio of Chinese Paintings*, 1938, pl. 32; Sirén, *CP III*, 152.

56. *KKSHC*, Vol. XIX.

57. In anticipation of the description of the Korean woodcuts in Chapter IV below, I wish to mention that the motif will be listed as "rhombic cliff tops" (No. 8, under the second Korean picture; section K 2, p. 63).

CHAPTER IV / AN ELEVENTH-CENTURY KOREAN COPY
OF THE PI-TSANG-CH'ÜAN

1. Nanjio, *A Catalogue of the Chinese Translation of the Buddhist Tripiṭaka*, 1883, Introduction, p. xxv.

2. Ono Gemmyō, *Bukkyō no bijutsu to rekishi*, Part IX, pp. 945–1034, especially Chapter 6, pp. 993–1014, which deals with the copy of the Nanzenji.

3. The Korean B or, in Ono's terminology, New Edition (of 1236–1251) referred to by him is the copy at the Zōjōji, Tōkyō; the copy I was able to see is that of the Imperial Palace Library in Tōkyō (Chapter II, Note 33 above).

4. Ono, p. 991.

5. *Ibid.*, p. 1012.

6. *Ibid.*, p. 1010.

7. *Ibid.*, pp. 991 and 1009; for the date corresponding to A.D. 1201, see pl. 31, fig. 110.

8. *Ibid.*, p. 1010. Cf. Chapter II, p. 16 above.

9. *Ibid.*, p. 991.

10. *Ibid.*, p. 995.

11. *Ibid.*, p. 1013.

12. *Ibid.*, pl. 29, fig. 99.

13. Tokushi, *Bukkyō hanga gaisetsu*, in *Sekai Bijutsu Zenshū, bekkan* VIII, p. 8.

14. Tokushi, *Kodai hanga-shū*, pl. 47; Ogawa Kanichi, *Daizōkyō*, p. 37, fig. 14.

15. The main reason for the imperfection of my photographs was the lack of such facilities as adequate light and a tripod; even so I am most grateful to the librarian, Mr. Sakurai, for his permission to study and photograph the prints in question, given when I visited the monastery on November 23, 1964.

16. Shen Kua, *Meng-ch'i pi-t'an*, ch. 17, ed. Hu Tao-ching, Vol. I, p. 565.

17. *KKSHC*, Vol. XIX.

18. Sirén, *CP III*, 98; *KK 300*, I, 31.

19. *KKSHC*, Vol. III.

20. *Chung-kuo ming-hua*, Vol. XXIII.

21. *KKSHL*, chung, ch. 5:107 (unpublished); Freer Gallery of Art, Washington, No. 15.20 = Sirén, *Chinese Paintings in American Collections*, pl. 178; *Kwen Catalogue*, No. 12.

22. *KKSHC*, Vol. XXVI.

23. Sirén, *CP III*, 48–49; Yonezawa, *Chūgoku kaigashi kenkyū*, color pl. 1; pls. 2, 3; text fig. 9.

24. Ise, *Shina sanzui-gashi*, pls. II, 1–13.

25. Sirén, *CP III*, pl. 81; *KK*, Vol. XVII.

26. Matsumoto, *Tonkō-ga no kenkyū*, pl. 97 a.

27. Sirén, *CP III*, 107.

28. Cahill, *Chinese Painting*, p. 56; *KK 300*, II, 53; *Chinese Art Treasures*, No. 11.

29. Shanghai Museum; *CP III*, 124.

30. Sirén, *CP III*, 141; *KK*, Vol. XXI; *KK 300*, II, 55.

31. A landscape in the Palace Museum collection, *Horsemen by the Lakeside*, which is attributed to the T'ang period, does exhibit this motif quite distinctly; see *KK 300*, I, 32. It appears to be an archaistic exercise of a later period and therefore is excluded. The motif appears also in the remarkable painting by Wang Hui (d. 1717), *Remote Monastery in Snowy Mountains* (our Pl. 37), alleged to be a copy after Wang Wei; in my opinion the original is not earlier than late T'ang or Five Dynasties.

32. Sirén, *CP III*, 144; *KK 300*, I, 37.

33. *KKSHC*, Vol. III.

34. *Kokka*, Vol. 252; Otto Fischer, *Chinesische Landschaftsmalerei*, 1923, pl. 9; third ed., 1943, pl. 48.

35. *Chinese Calligraphy and Painting in the Collection of John M. Crawford, Jr.*, No. 3.

36. *Shi Ō Go Un (Ssu Wang Wu Yün)*, pl. 13. The painting was mentioned in the catalogue of motifs in the Sung woodcuts in sections 13 and 16.

37. *Shin-chō shogafu*, Ōsaka, 1922, pl. 59; Sirén, *CP VII*, List, p. 292. A painting of this title purporting to be a work of Tung Yüan is listed in *Mo-yüan hui-kuan*, the catalogue of An Ch'i's collection, completed in 1743, ch. 4; ed. *Ts'ung-shu Chi-ch'eng*, Vol. 1579, p. 205. An Ch'i denies Tung Yüan's authorship of that painting, which may have been the original copied by Chang Tsung-ts'ang.

38. Sirén, *CP III*, 36.

39. Paine and Soper, *The Art and Architecture of Japan*, pl. 6 A; Noma, *The Arts of Japan, Ancient and Medieval*, tr. by John Rosenfield, p. 47, fig. 33.

40. Sirén, *CP III*, 91; Chu-tsing Li, *Autumn Colors*, pl. 3.

41. Drawings representing Shui-yüeh Kuan-yin: Matsumoto, *Tonkō-ga no kenkyū*, pls. 97 a, b, and 98 a, b.

42. *Ibid.*, pl. 168, and a detail, pl. 98 b.

43. *Ibid.*, pl. 97 b.

44. Sun Wei's water pictures were praised by Su Tung-p'o in his short essay on the development of water painting. Kuo Jo-hsü, *T'u-hua chien-wen-chih*, names four water specialists: Ts'ao Jen-hsi, Ch'i Wen-hsiu, P'u Yung-sheng, and Tung Yü, see Alexander Soper, *Kuo Jo-hsü's Experiences in Painting*, pp. 69, 70, 71, 96 ("Tung Yü's Water"), and 186, n. 580. A part of Su Tung-p'o's essay was translated by Sirén, *History of Early Chinese Painting*, Vol. II, p. 35.

45. Sirén, *CP III*, Add. pl. 9 B.

46. *Ibid*, pl. 26; cf. Chapter III, Note 27, for other reproductions.

47. *Ibid.*, pl. 62; Fourcade, *La Peinture murale de Touen Houang*, pl. 29.

48. Sirén, *CP III*, pl. 80.

49. *Ibid.*, pl. 82; *KK*, Vol. XXVI; *KK 300*, I, 4.

50. Sirén, *CP III*, 91; Chu-tsing Li, *Autumn Colors*, pl. 3.

51. Hsieh Chih-liu, *T'ang Wu-tai Sung Yüan ming-chi*, pl. 2.

52. Shimomise, *Shina kaigashi kenkyū*, fig. 70.

53. Sirén, *CP III*, pl. 48; Yonezawa, *Chūgoku kaigashi kenkyū*, color pl. 1; Munsterberg, *The Landscape Painting of China and Japan*, pl. 73.

54. See Note 51 above.

55. *T'u-hua chien-wen-chih*, ch. 1:17 a; Soper, *Kuo Jo-hsü's Experiences in Painting*, p. 19.

56. *KK 300*, I, pl. 40.

CHINESE CHARACTERS FOR CHINESE, JAPANESE, AND KOREAN WORDS

A-p'i-ta-mo fa-chih-lun
阿毗達磨發智論

Ai-jih-chai ts'ung-ch'ao
愛日齋叢抄

Aichi 愛知

An Ch'i 安岐

An-chi 安吉

An-chi-chou Ssu-ch'i Fa-pao Tzu-fu
Ch'an-ssu hsin-tiao Ta-tsang-ching
mu-lu 安吉州思溪法寶資福
禪寺新雕大藏經目錄

Bekkan 別卷

Benridō 便利堂

Bukkyō Daijiten 佛教大辭典

Bukkyō hanga gaisetsu 佛教版
画概説

Bukkyō Kōkogaku Kōza 佛教
考古學講座

Bukkyō no bijutsu to rekishi
佛教の美術と歴史

Bukkyō shōten gairon
佛教聖典概論

Bussho Kaisetsu Daijiten
佛書解説大辭典

Butsu-fu 佛賦

Ch'ae Ch'ung-sun (Chin., Ts'ai
Chung-shun) 蔡忠順

Chan Tzu-ch'ien 展子虔

Ch'an 禪

chang (Jap., chō) 張

chang (Jap., jō) 丈

Chang Chü-sheng hsien-sheng ch'i-
shih sheng-jih chi-nien lun-wen-chi
張菊生先生七十生日記
念論文集

Chang Hsüan 張萱

Chang Keng 張庚

Chinese Characters

Chang Ta-ch'ien　張大千

Chang Tsung-ts'ang　張宗蒼

Chang Ts'ung-hsin　張從信

Chang Yüan　張爰

Ch'ang-a-han-ching　長阿含經

Ch'ang-an　長安

Chao-ch'eng　趙城

Chao An-kuo　趙安國

Chao Ch'ang　趙昌

Chao K'uang-yin　趙匡胤

Chao Po-chü　趙伯駒

Chao Yen　趙巖

Che-pen　浙本

che-pen (Jap., orihon)　折本

Che-tsung　哲宗

Chen, J. D., see Ch'en Jen-t'ao

Chen-tsung　真宗

Ch'en Hsüan　陳宣

Ch'en Jen-t'ao　陳仁濤

Ch'en *Lake*　陳湖

Ch'en Shu　陳恕

Ch'en Yüan　陳垣

Cheng-i-t'ang　証義堂

Cheng-lung　正隆

Ch'eng-tu　成都

Ch'eng-tu Fu　成都府

Chi-sha　磧砂

Ch'i Wen-hsiu　戚文秀

Ch'i-tan (Khitan)　契丹

chia (No. 518)　駕

Chia-hsi　嘉熙

Chia-hsün　家訓

Chia-t'ai　嘉泰

Chiang-hua (Kor., Kanghwa)　江華

Chiang-nan (Kiangnan)　江南

Chiang Ts'an　江參

Chiang Wei-hsin　蔣唯心

Chieh-chou　解州

chieh-tu-shih　節度使

Ch'ien Hung-shu　錢弘俶

Ch'ien Shu　錢俶

Ch'ien-tao　乾道

Ch'ien-tzu-wen　千字文

Ch'ien-yu　乾祐

Ch'ien Yüan-kuan　錢元瓘

chih (Jap., chitsu)　帙褒

Chih-chih　至治

Chih-p'an　志磐

Chih-yüan　至元

Chin　金

86

Chin-kuei ts'ang-hua-chi
金匱藏畫集

Chin Tsang tiao-yin shih-mo k'ao
金藏雕印始末考

ching (sūtra) 經

Ching Hao 荊浩

Ch'ing-ning 清寧

Chionin 知恩院

chiu kuan 九官

Chiu kung 九宮

Chiu Wu-tai-shih T'ang-shu
舊五代史唐書

Chiu-ching tzu-yang 九經字樣

Chiu-k'u Kuan-yin 救苦觀音

ch'o 辵

Chōji 長治

Chōnen 奝然

Chŏngjong (Chin., Ching-tsung)
靖宗

Chōrōji 長瀧寺

Chou-li 周禮

Chou-shu 周書

chu (Jap., chiku) 軸

Chu Chu-yü 朱鑄禹

Chu Wen-ch'ing 朱文清

Chu-tsung ching-tsang tiao-yin-su
諸宗經藏雕印疏

Chü-jan 巨然

Ch'uan-fa-yüan 傳法院

chüan (Jap., kan) 卷

Chüeh-an 覺岸

Chūgoku kaigashi kenkyū 中国
絵畫史研究

Chung-ho 中和

Chung-kuo hua-chia jen-ming ta-
tz'u-tien 中國畫家人名大
辭典

Chung-kuo ming-hua 中國名畫

Chung-kuo pan-k'o t'u-lu 中国版
刻圖録

Chung-lun 中論

chung-shu she-jen 中書舍人

chung-tzu (Jap., shuji) 種子

Ch'ung-ning-ssu 崇寧寺

Ch'ung-ning wan-shou ta-tsang
崇寧萬壽大藏

Ch'ung-shan-ssu 崇善寺

Chūsonji 中尊寺

Chūsonji Taikyō 中尊寺大鏡

Dai Nihon Bukkyō Zensho 大日本佛教全書

Dai Nihon Bukkyō Zensho Hakkō-sho 大日本佛教全書發行所

Dai Nihon kōtei Daizōkyō 大日本校訂大藏經

Daigoji 醍醐寺

Daitō Shuppansha 大東出版社

Daiyūkaku 大雄閣

Daizōkyō 大藏經

Daizōkyō chōin-kō 大藏經雕印考

Daizōkyō gaisetsu 大藏經概説

Daizōkyō, seiritsu to hensen 大藏經成立と變遷

Daizō Shuppan Kabushiki Kaisha 大藏出版株式會社

Enjōji, Jirō 圓城寺次郎
Enshiki 緣識

Fa-chen 法珍

Fa-pao Tzu-fu Ch'an-ssu 法寶資福禪寺

Fa-yüan chu-lin 法苑珠林

Fan K'uan 范寬

Feng Su 馮宿

Feng Tao 馮道

Fo-fu (Jap., Butsu-fu) 佛賦

Fo-pen-hsing-chi-ching 佛本行集經

Fo-tsu li-tai t'ung-tsai 佛祖歷代通載

Fo-tsu t'ung-chi 佛祖統紀

Fo-tsu t'ung-tsai 佛祖通載

Fo-yin 佛印

fu (Jap., fuku) 幅

Fu-chou 福州

Fujii Shuichi 藤井守一

Fujii Zennosuke 藤井善助

Fujita Tsuneyo 藤田經世

Fujiwara Michinaga 藤原道長

Fukaura Seibun 深浦正文

Fusanbō 富山房

Gifu　岐阜

Gozan　五山

Gyosei　御製

Gyosei emon geju　御製廻文
偈頌

Gyosei Hizōsen　御製秘藏詮

Haeinsa (Chin., Hai-yin-ssu)
海印寺

Hakubundō　博文堂

han　函

Han Ŏn-gong, (Chin., Han Yen-
kung)　韓彦恭

Hang-chou　杭州

Hankyō　版經

Hasedera　長谷寺

Heian-kyō　平安京

Heibonsha　平凡社

Hieizan　比叡山

Hiraizumi　平泉

Hizōsen, *see* Gyosei Hizōsen

Ho-kan Chi　紇干泉

Hōjōji　法成寺

Hoppō ryūei (or Hōbō ryūei)
法寶留影

Hou-yüan fu-shih ch'en Tung
Yüan hua　後苑副使臣董
源畫

Hsi-an　西安

Hsi-Hsia　西夏

Hsi-kuan　西關

Hsi-ning　西寧

Hsia-an t'an-i-lu　遐庵談藝錄

Hsia-hsien　夏縣

Hsiang Ta　向达

hsiao-hsüeh　小學

Hsiao-yao-yung　逍遙詠

Hsieh Chih-liu　謝稚柳

Hsien-sheng-ssu　顯聖寺

Hsien-te　顯德

Hsin T'ang-shu　新唐書

Hsin-chi tsang-ching yin-i sui-han-
lu　新集藏經音義隨函錄

Hsin-pien chu-tsung chiao-tsang
tsung-lu　新編諸宗教藏揔錄

Hsin-tiao Ta-tsang chiao-cheng
pieh-lu　新雕大藏校正別錄

Hsü K'ai-yüan-lu　續開元錄

Hsü Sen-yü　徐森玉

Hsü Tzu-chih t'ung-chien　續資
　治通鑑

Hsüan-chuang　玄奘

Hsüan-ho hua-p'u　宣和画譜

Hsüan-hua-ssu　pei-yin-chi　(Kor.,
　Hyŏn-hwasa piŭm-gi)　玄化寺
　碑陰記

Hsüan-tsang, see Hsüan-chuang

Hu Chen-ch'i　胡振祺

Hu Tao-ching　胡道靜

Hu-chou　湖州

Hu-chou pan　湖州版

Hu-chou　Ssu-ch'i　Yüan-chüeh
Ch'an-yüan　hsin-tiao　Ta-tsang
ching lü lun teng mu-lu　湖州思
　溪圓覺禪院新雕大藏經
　律論等目錄

Hua-t'ing　華亭

Hua-yen-ching　(Jap.,　Kegon-kyō)
　華嚴經

Hua-yüan　華原

Huai-chin　懷謹

Huai-shen　懷深

Huang T'ing-chien　黃庭堅

Hui-chu (ch'ien, hou, san) lu
　揮麈 (前, 後, 三) 錄

Hui-lin Ch'an-yüan　慧林禪院

Hui-tsung　徽宗

Hui-wen chi-sung (Jap., Emon geju)
　迴文偈頌

Hung-fa-ssu　弘法寺

Hŭngjong (Chin., Hsing-tsung)
　興宗

Hung-yin　弘胤

Hyakkaen　百華苑

Hyakuman-tō darani　百萬塔
　陀羅尼

Hyōgo　兵庫

Hyŏnhwasa pium-gi (Chin., Hsüan-
hua-ssu pei-yin-chi)　玄化寺碑
　陰記

Hyŏnjong (Chin., Hsien-tsung)
　顯宗

I-ch'ieh　ju-lai-hsin　pi-mi　ch'üan-
shen she-li pao-chieh-yin t'o-lo-ni
ching　一切如來心祕密全身
　舍利寶篋印陀羅尼經

I-ching　義靜

I-ching-t'ang　譯經堂

I-ching-yüan　譯經院

I-chou 益州

I-li 儀禮

I-su-li 易俗里

I-tsing, *see* I-ching

Ikeuchi Hiroshi 池内宏

Ingakyō 因果經

Insatsu-jutsu 印刷術

Ise Senichirō 伊勢專一郎

Ishida Mosaku 石田茂作

Ishiyamadera 石山寺

Issaikyō 一切經

Iwate (ken) 岩手 (縣)

Iwayadera 岩屋寺

Jōjin 成尋

Jōjin ajari boshū. San-Tendai-Godaisan-ki no kenkyū 成尋阿闍梨母集. 參天台五臺山記の研究

Jun-wen-t'ang 潤文堂

Jurchen 女真

KK 故宮

KK 300 故宮名画三百種

KKSHC 故宮書畫集

KKSHL 故宮書畫録

Kaesong (Chin., K'ai-ch'eng) 開城

K'ai-pao 開寶

K'ai-pao-ssu 開寶寺

K'ai-pao-tsang 開寶藏

k'ai-shu 楷書

K'ai-yüan Ch'an-ssu 開元禪寺

K'ai-yüan-lu 開元録

K'ai-yüan shih-chiao-lu 開元釋教録

K'ai-yüan-ssu 開元寺

K'ai-yün 開運

Kanazawa Bunko 金澤文庫

Kangakuin 勸學院

Kao Wen-chin 高文進

Kao-li (Kor., Koryŏ) 高麗

Kao-li Lieh-chuan 高麗列傳

Kao-li ming-ch'en-chuan 高麗名臣傳

Kao-li-shih 高麗史

Kao-seng-chuan 高僧傳

Khitan, see Ch'i-tan

Kita-in 喜多院

k'o 顆

K'o-hung 可洪

Kōan 弘安

Kobayashi Takeshi 小林剛

Kōbundō Shobō 弘文堂書房

Kodai hanga-shū 古代版画集

Kōdansha 講談社

Kojong (Chin., Kao-tsung) 高宗

Kokka 國華

Kokuhō jiten 国宝事典

Kompon Chūdō 根本中堂

Koraichō no Daizōkyō 高麗朝
の大藏經

Kōyasan 髙野山

Ku-liang Chuan 穀梁傳

Ku-tien Wen-hsüeh Ch'u-pan-she
古典文學出版社

Kuan Fu-ch'u 菅復初

Kuan T'ung 關仝

Kuan-ch'a-shih 觀察使

Kuan-chu-pa 管主八

Kuang-sheng-ssu 廣勝寺

Kuang-shun 廣順

Kuang-yün 廣韻

Kuei-chi 會稽

Kuei-i (chün) 歸義(軍)

kung 弓

Kung-yang Chuan 公羊傳

K'ung P'ing-chung 孔平仲

Kuo Chung-shu 郭忠恕

Kuo Hsi 郭熙

Kuo Jo-hsü 郭若虛

Kuo Tzu-ch'eng 國子丞

Kuo-tzu-chien 國子監

Kwen, F. S., *see* Kuan Fu-ch'u

Lai-yüan *Company* 来遠公司

Lei Yen-mei 雷延美

Lei-feng-t'a 雷峰塔

Li Chao-tao 李昭道

Li Ch'eng 李成

Li Chih-shun 李知順

Li hou-chu 李後主

Li Kung-lin 李公麟

Li Lin-ts'an 李霖燦

Li O 李鶚

Li Shih-sun 李石孫

Li Yü 李愚

Li-tai tsang-ching k'ao-lüeh 歷代藏經考略

Liang Che ku k'an-pen k'ao 兩浙古刊本考

Liao 遼

Lien-hua-hsin lun 蓮華心輪

Lin-an Fu 臨安府

Lin-chi 臨濟

ling (No. 296) 令

ling-lung 玲瓏

Liu Hsi-ku 劉熙古

Liu Hung 劉宏

Liu P'ien 柳玭

lo (No. 525) 勒

Lo Chen-yü 羅振玉

Lu Yung 陸永

Lu-chou 潞州

Lü (Vinaya) 律

Lun (Abhidharma) 論

Lung-hsing-ssu 龍興寺

Lung-hsiu chiao-min 龍袖嬌民

Lung-su chiao min 龍宿郊民

Lung-su chiao min chieh 龍宿郊民解

Makimono 卷物

Makita Tairyō 牧田諦亮

Matsumoto Eiichi 松本榮一

Meng 孟

Meng Ch'ang 孟昶

Meng-ch'i pi-t'an 夢溪筆談

Meng-ch'i pi-t'an chiao-cheng 夢溪筆談校證

Mi Fei (or Fu) 米芾

Mi-chou 密州

Min-hsien 閩縣

Min-pen 閩本

ming (No. 211) 名

Ming-tsung 明宗

Mochizuki Shinkō 望月信亨

Mori Katsumi 森克己

Mo-yüan hui-kuan 墨緣彙觀

Munjong (Chin., Wen-tsung) 文宗

Nagoya 名古屋

Naitō Torajirō 內藤虎次郎

Nakamura Fusetsu 中村不折

Nakayama Kyūshirō　中山久
四郎

Nan-hai chi-kuei nei-fa-chuan
南海寄歸内法傳

Nanjio Bunyiu (Nanjō Bunyū)
南條文雄

Nanking　南京

Nanzenji　南禪寺

Nara　奈良

nengō　年號

Ni-po-lo　泥婆羅

Nichi-Sō bunka kōryū no sho-
mondai 日宋文化交流の諸
問題

Nieh-p'an-ching　涅槃經

Nien-ch'ang　念常

Nihon bijutsushi nempyō　日本
美術史年表

Nihon Kaigai Shōji Kabushiki
Kaisha 日本海外商事株式
會社

Nikkō　日光

Ning-po　寧波

Nogami Shunsei　野上俊靜

Noma Seiroku　野間清六

Ōei　應永

Ogawa Kanichi　小川貫弌

Ōmi　近江

Ono Gemmyō　小野玄妙

orihon　折本

Ōsaka　大阪

Ōtani University　大谷大學

Ōtani Daigaku Toshokan zembon
shūei　大谷大學圖書館善本
聚英

Ōtsuka Kōgeisha　大塚巧藝社

P'ang Lai-ch'en (Yüan-chi) 龐萊臣
（元濟）
Pao-li　寶歷

Pei Sung Fu-chou Tung-ch'an
Teng-chüeh-yüan k'an-pen Ta-
tsang-ching 北宋福州東禪等
覺院刊本大藏經

Pei Sung k'o-yin-ti i-fu mu-k'o-hua
北宋刻印的一幅木刻画

Pi Yüan　畢沅

Pi-tsang-ch'üan　祕藏詮

Pien-ching　汴京

Pien-liang　汴梁

P'ing-chiang Fu　平江府

Po Chü-i　白居易

pu　部

P'u Yung-sheng　蒲永昇

Puinsa (Chin., Fu-jen-ssu)
　符仁寺

Rinnōji　輪王寺

Rinzai　臨濟

Ryūkoku University
　龍谷大學

Saga　嵯峨

Sakurai Kageo　櫻井景雄

Saitama　埼玉

San-Tendai-Godaisan-ki
　参天台五臺山記

Sanzuiga-ron　山水画論

Sasagawa Kisaburō　笹川喜三郎

Sasaguchi Rei　笹口玲

Sawamura Kakushin　澤村覺眞

Seiryōji　清涼寺

Sekai Bijutsu Zenshū　世界美術
　全集

Sekai insatsu tsūshi　世界印刷通史

Sekkei　石經

Shaka　釋迦

Shakadō　釋迦堂

Shanghai Ch'u-pan Kung-ssu　上海
　出版公司

Shansi-sheng Po-wu-kuan so-ts'ang
Chao-ch'eng Tsang　山西省博物
　館所藏趙城藏

Shao Ming yin　邵明印

Shao-hsing　紹興

She-li-t'a (Jap., sharitō)　舍利塔

Shen Kua　沈括

Shen-chou Kuo-kuang-she　神州國
　光社

Sheng-shou Ch'an-yüan　聖壽禪院

Shi Ō Go Un, *see* Ssu Wang Wu
Yün

Shih-shih chi-ku-lüeh　釋氏稽古略

Shih-shih i-nien-lu　釋氏疑年錄

Shih-sung-ni-lü　十誦尼律

Shimazu Kusako　島津草子

Shimomise Shizuichi　下店靜市

Shina insatsu-jutsu 支那印刷術

Shina kaigashi kenkyū 支那繪畫史研究

Shina sanzuiga-shi 支那山水画史

Shin-chō shogafu 清朝書画譜

Shinpukuji 真福寺

Shōsōin 正倉院

Shou-ch'ang 壽昌

Shōyōei 逍遙詠

Shu 蜀

Shu Ying 叔英

Shui-yüeh Kuan-yin 水月觀音

Shun-hsi 淳熙

Shun-hua 淳化

Shun-yu 淳祐

Sōdai no Bukkyō insatsu 宋代の佛教印刷

Sōgen-han no hanashi 宋元版の話

Sōgensha 創元社

Sŏngjong (Chin., Ch'eng-tsung) 成宗

Sŏnjong (Chin., Hsüan-tsung) 宣宗

Sōron 總論

Sōtō, *see* Ts'ao-tung

Ssu Wang Wu Yün 四王吳惲

Ssu-ch'i 思溪

Ssu-ch'i Tsang 思溪藏

Ssu-fen-lü 四分律

Su Tung-p'o 蘇東坡

Su-chou 蘇州

Sugi (Chin., Shou-ch'i) 守其

Sui-shu 隋書

Sun Ch'ing 孫清

Sun-Ta-kung 孫鑑公

Sun Wei 孫位

Sung-chiang (Prefecture) 松江

Sung-kuang-ssu 松廣寺

Sung-shih 宋史

Ta T'ang Hsi-yü-chi 大唐西域記

Ta Tsang 大藏

Ta Tsang Ching 大藏經

Ta-an 大安

Ta-chih-tu-lun 大智度論

Ta-hua-yen-ssu 大華嚴寺

Ta-kuan 大觀

Ta-p'u-ning-ssu 大普寧寺

Ta-sui-ch'iu t'o-lo-ni 大隨求陀
羅尼

Ta-te 大德

Ta-t'ung 大同

Ta-yeh 大業

t'a-pen (Jap., takuhon) 拓本

Taehŭngwangsa (Chin., Ta-hsing-
wang-ssu) 大興王寺

tai-chao Kao Wen-chin hua 待詔
高文進畫

Taifūdō meiseki 大風堂名迹

Taishō Daizōkyō 大正大藏經

T'ai-chou 台州

T'ai-ho 泰和

t'ai-hsüeh po-shih 太學博士

T'ai-miao *Front Avenue* 太廟前
大街

T'ai-p'ing Hsing-kuo 太平興國

T'ai-p'ing-hsing-kuo-ssu 太平興
國寺

t'ai-tien 苔点

T'ai-ting 泰定

T'ai-tsu 太祖

T'ai-tsung 太宗

T'ai-yüan 太原

Takakusu Junjirō 高楠順次郎

Tamamushi *Shrine* 玉蟲厨子

T'ang Ming-huang 唐明皇

T'ang Sung hua-chia jen-ming tz'u-
tien 唐宋画家人名辭典

T'ang Wu-tai Sung Yüan ming-chi
唐五代宋元名迹

T'ang-shu 唐書

Tao-tsung 道宗

Tenri University 天理大學

Tetsugaku Zasshi 哲學雜誌

ti-tzu Chang-i-chün chieh-tu-shih
Ch'ien Hsin ching she 弟子彰
義軍節度使錢信敬捨

Tien-li Chi-ch'a-ssu 典禮紀察司

T'ien Min 田敏

T'ien-chu 天竺

T'ien-fu 天福

T'ien-hsia ping-ma ta-yüan-shuai
天下兵馬大元帥

T'ien-hsia tu-yüan-shuai 天下
都元帥

T'ien-mu Chung-feng kuang-lu
天目中峰廣録

T'ien-ning-ssu 天寧寺

T'ien-sheng 天聖

T'ien-t'ai (Tendai) 天台

tobira-e 扉絵

Tōdaiji 東大寺

Tōhō Bunka Gakuin, Kyōtō
Kenkyūjo Kenkyū Hōkoku
東方文化學院京都研
究所研究報告

Tōhō Bunka Gakuin, Tōkyo
Kenkyūjo 東方文化學院
東京研究所

Tōji (or Kyōōgokokuji) 東寺
（敎王護國寺）

Tokiwa Daijō 常盤大定

Tŏkchong (Chin., Te-tsung) 德宗

Tokugawa Yoshihiro 德川義寬

Tokushi Yūshō 禿氏祐祥

Tonkō-ga no kenkyū
敦煌画の研究

Tōshōdaiji 唐招提寺

Toshoryō 圖書寮

Tōyō Bunkashi Kenkyū
東洋文化史研究

Tōyō Gakuhō 東洋學報

Tōyō hanga-hen 東洋版
画篇

Tōyō Rekishi Daijiten
東洋歷史大辭典

ts'an-chih-cheng-shih 參知
政事
Tsang-yüan 藏院──

Ts'ao Jen-hsi 曹仁熙

Ts'ao Yüan-chung 曹元忠

Ts'ao-tung (Jap., Sōtō) 曹洞

ts'e 冊

Ts'e-fu yüan-kuei 冊府元龜

tso (No. 533) 佐

ts'un 皴

Ts'ung-shu Chi-ch'eng 叢書
集成

Tu Fu 杜甫

T'u-hua chien-wen-chih 圖画
見聞誌

T'u-hua ching-i-chih 圖画精
意識

Tun-huang 敦煌

Tung Yü 董羽

Tung Yüan 董源

Tung-ch'an-ssu 東禪寺

Tung-ch'an Teng-chüeh-yüan
東禪等覺院

Tung-ch'uan 東川

Ŭich'ŏn (Chin., I-t'ien) 義天

Wang Chieh 王玠

Wang Chien 王建

Wang Ch'in-jo 王欽若

Wang Chung-k'o-kung i-shu
王忠愨公遺書

Wang Hsüan-ts'e 王玄策

Wang Hui 王翬

Wang Kuo-wei 王國維

Wang Ming-ch'ing 王明清

Wang Wei 王維

Wang Wen-chao 王文沼

Wang Yung-ts'ung 王永從

Watanabe Kōzō 渡邊幸三

Wen Wu 文物

Wen-ti 文帝

Wen-tsung 文宗

Wo-lung-ssu 臥龍寺

Wu 吳

Wu Chao-i 毋昭裔

Wu Lien-ch'eng 吳連城

Wu-ching wen-tzu 五經文字

Wu-hsing 吳興

Wu-hsing *Gazetteer* 吳興志

Wu-hsing Hsien 吳興縣

Wu-tai Chien-pen k'ao 五代監
本考

Wu-tai hui-yao 五代會要

Wu-tai liang Sung Chien-pen k'ao
五代兩宋監本考

Wu-t'ai-shan 五臺山

Wu-Yüeh 吳越

Yamato 大和

Yang 楊

Yang, L. S. (Lien-sheng) 楊聯陞

Yasuda Bunko 安田文庫

Yasuda Bunko kogyō seikan
　安田文庫古經清鑒

yeh (*leaf, folio*) 葉

Yeh Chih 葉宣

Yeh Kung-ch'o 葉恭綽

Yen Wen-kuei 燕文貴

Yen-ching 燕京

Yen-sheng Ch'an-yüan 延聖禪院

Yen-sheng-ssu 延聖寺

Yi Kyu-bo (Chin., Li K'uei-pao)
　李奎報

yin 印

Yin *family* 尹家

Yin-ching-fang 印經坊

Yin-ching-yüan 印經院

ying-huang-chih 硬黃紙

Yokohama 橫浜

Yonezawa Yoshiho 米澤嘉圃

Yu-cheng Book Company
　有正書局

Yü Chi 虞集

Yü-chih Fo-fu 御製佛賦

Yü-chih Hsiao-yao-yung
　御製逍遙詠

Yü-chih Hui-wen chi-sung
　御製迴文偈頌

Yü-chih Pi-tsang-ch'üan
　御製秘藏詮

Yü-chih yüan-shih 御製
　緣識

Yü-p'ien 玉篇

Yüan Chen 元稹

Yüan Chiang 元絳

Yüan-chüeh Ch'an-yüan
　圓覺禪院

Yüeh-chou seng Chih-li tiao
　越州僧知禮雕

Yüeh-pen 越本

Yün, *or* wen 蘊

Yūrinkan 有鄰館

Yūrin taikan 有鄰大觀

Zenshōji 禅昌寺

Zōjōji 增上寺

CHINESE TITLES OF PAINTINGS

MENTIONED IN CHAPTERS III AND IV

A Myriad of Trees and Strange Peaks 萬木奇峰

An Empress Returning from a Journey 唐后行從

Autumn Mountains 秋山

Buddhist Temple Amid Clearing Mountain Peaks 霽山蕭寺

Ch'ü River, The 曲江圖

Clearing After a Snowfall 雪霽圖卷

Clearing Autumn Skies over Mountains and
Valleys 谿山秋霽

Deer Among Red-Leafed Maples 丹楓呦鹿

Drinking and Singing at the Foot of a
Precipitous Mountain 崖曲醉吟

Dwellers on the Mountain of the Sleeping Dragon 龍眠山居

Eight Gentlemen on a Spring Outing 八達春遊

Evening Blue in the Autumn Mountains 秋山晚翠

Fairy Dwellings on a Pine Cliff 松巖仙館

First Snow over Rivers and Mountains 溪山初雪

Fishing in Seclusion on a Clear Stream 清江漁隱

Flowers on New Year's Day 歲朝圖

Four Gray-Heads, The 四皓圖卷

Horsemen by the Lakeside 湖亭遊騎

Chinese Characters

K'uang-Lu Mountain, The 匡盧圖

Landscape 山水

Landscape with Rocky Cliffs 山水石巖

Lo Shen Scroll 洛神圖卷

Lu-shan 盧山

Lung-hsiu chiao-min t'u 龍袖嬌民圖

Lung-su chiao-min t'u 龍宿郊民圖

Ming-huang's Journey to Shu 明皇幸蜀

Mountain Peaks After a Snowfall 羣峯霽雪

Pine Wind on the T'ai-shan 泰山松風

Pine Wind Resounding in a Myriad Valleys 萬壑松響風

Plank Road in the Clouds 雲棧道

Remote Monastery in Snowy Mountains 雪山蕭寺

Retreats in the Spring Hills 春山別苑

River Bank, The

Sitting Alone by the Mountain Stream 臨流獨坐

Snowy Landscape 雪景圖

Spring Time Travelers 遊春圖

Streams and Hills Under Fresh Snow 溪山雪意

Streams and Mountains Without End 溪山無盡

Temples Among Streams and Mountains 溪山樓觀

Travelers Among Snowy Hills 雪山行旅

Travelers Among Streams and Mountains 溪山行旅

Travelers in the Spring Mountains 春山行旅

Travelers in the Autumn Mountains　秋山行旅

Waiting for the Ferry　山谿待渡

Wang-ch'uan Scroll　輞川圖卷

Wu-t'ai-shan Panorama　五臺山景

Yangtze Valley, The　長江萬里圖

BIBLIOGRAPHY

(This list does not include the Chinese dynastic histories, ancient sources without specific interest, standard reference works, or the titles of Buddhist scripture mentioned.)

Bachhofer, Ludwig, *A Short History of Chinese Art*. New York: Pantheon, 1946.
———, "Die Raumdarstellung in der Chinesischen Malerei des ersten Jahrtausends n. Chr." *Münchner Jahrbuch der bildenden Kunst*, N.F. VIII (1931), 193–242.
Binyon, Laurence, *A Catalogue of Japanese and Chinese Woodcuts in the British Museum*. London, 1916.
Cahill, James, *Chinese Painting*. Geneva and New York: Skira, 1960.
Carter, Thomas Francis, *The Invention of Printing in China and Its Spread Westward*. New York: Columbia University Press, 1925.
———, *The Invention of Printing in China and Its Spread Westward*. Second edition, revised by L. Carrington Goodrich. New York: Ronald Press, 1955.
Chen, J. D. (Ch'en Jen-t'ao), *Chin-kuei ts'ang-hua-chi*. 2 vols. Kyōto: Benridō, 1956.
Ch'en Yüan, *Shih-shih i-nien-lu*. Peking: Chung-hua Shu-chü, 1964.
Chiang Wei-hsin, *Chin Tsang tiao-yin shih-mo k'ao*. 1935.
Chinese Art Treasures, exhibited in the United States by the Government of the Republic of China, 1961–1962. Geneva: Skira, 1961.
Chinese Calligraphy and Painting in the Collection of John M. Crawford, Jr. Edited by Laurence Sickman. New York: The Pierpont Morgan Library, 1962.
Chung-kuo ming-hua ("Famous Chinese Paintings"). 40 vols. Shanghai: Yu-cheng Book Company, *s.a.*
Chung-kuo pan-k'o t'u-lu, 8 vols. Compiled by the Peking T'u-shu-kuan. Peking: Wen Wu Press, 1961.
Chūsonji taikyō, by Ishida Mosaku. 3 vols. Tōkyō: Ōtsuka Kōgeisha, 1941.
Dai-Nihon Bukkyō Zensho, 151 vols.; Supplement, 10 vols. Tōkyō: Dai-Nihon Bukkyō Zensho Hakkōsho, 1913–1922.
Demiéville, Paul, *Appendice* [to Pelliot, *Les débuts de l'imprimerie en Chine*]: Notes additionelles sur les éditions imprimées du canon bouddhique. Paris, 1953.
Ecke, Gustav, *Chinese Painting in Hawaii*. 3 vols. Honolulu: Honolulu Academy of Art, 1965.
Fischer, Otto, *Chinesische Landschaftsmalerei*. München: Kurt Wolff, 1923.
———, *Chinesische Landschaftsmalerei*, Third edition. Berlin/Wien: Paul Neff, 1943.
Fo-tsu t'ung-chi, by the T'ien-t'ai (Tendai) priest Chih-p'an, A.D. 1269. 54 ch. Ed. *Taishō Daizōkyō*, Vol. 49, No. 2035.
Fo-tsu t'ung-tsai (*Fo-tsu li-tai t'ung-tsai*), by Nien-ch'ang, A.D. 1341. 22 ch. Preface by Yü Chi. Ed. *Taishō Daizōkyō*, Vol. 49, No. 2036.

Fourcade, François, *La peinture murale de Touen Houang*. Paris: Editions Cercle d'Art, 1962.

Fuchs, Walter, "Zur technischen Organisation der Übersetzungen buddhistischer Schriften ins Chinesische." *Asia Major*, VI (1930), 84-103.

Fukaura Seibun, *Bukkyō shōten gairon*. Tōkyō, 1927.

Giles, Lionel, *Descriptive Catalogue of the Chinese Manuscripts from Tun-huang in the British Museum*. London, 1957.

———, "Chinese Printing in the Tenth Century." *Journal of the Royal Asiatic Society*, 1925, pp. 513-515.

Goodrich, L. Carrington: see also Carter, *The Invention of Printing*, 2nd ed.

———, "Earliest Printed Editions of the Tripiṭaka." *Visvabharati Quarterly*, XIX (1953-54), 215-220.

———, "The Origin of Printing." *Journal of the American Oriental Society*, vol. 82 (1962), pp. 556-557.

Henderson, Gregory, and Leon Hurvitz, "The Buddha of Seiryōji." *Artibus Asiae*, XIX (1956), 5-55.

Hsiang Ta, "Notes on some extant versions of Hsüan-chuang's *Ta T'ang Hsi Yü Chi*." *Wen Wu*, No. 135 (1962/1), pp. 31-36.

Hsieh Chih-liu, *T'ang Wu-tai Sung Yüan ming-chi*. Shanghai: Ku-tien Wen-hsüeh Ch'u-pan-she, 1957.

Hsü Sen-yü, "On the Shu and Northern Sung Stone Tablets Engraved with the Confucian Classics." *Wen Wu*, No. 135 (1962/1), pp. 9-11.

Hsüan-ho hua-p'u, 20 ch. Preface dated 1120. Ed. *Ts'ung-shu Chi-ch'eng*, Vols. 1652, 1653. Shanghai: Commercial Press, 1936.

Hu Chen-ch'i, "Shansi-sheng Po-wu-kuan so-ts'ang Chao-ch'eng Tsang." *Wen Wu*, No. 138-139 (1962), p. 92.

Ikeuchi Hiroshi, "Kōrai-chō no Daizōkyō." *Tōyō Gakuhō*, XIII/3 (December 1923), 302-362; XIV/1 (July 1924), 91-130; XIV/4 (December 1924), 546-558.

Ise Senichirō, *Shina sanzui-gashi*. Kyōto: Tōhō Bunka Gakuin, Kyōto Kenkyūjo, *Kenkyū Hōkoku*, V, 1934.

KK (Ku Kung, Vols. I-XLV). Peking: Palace Museum, 1929 ff.

KK 300 (Ku Kung ming-hua san-pai chung, "Three Hundred Masterpieces of Chinese Painting in the Palace Museum"). 6 vols. Taichung, 1959.

KKSHC (Ku Kung Shu-hua-chi, Vols. I-XLV). Peking: Palace Museum, 1930 ff.

KKSHL (Ku Kung Shu-hua-lu). 3 vols. Taipei, Taiwan, 1956.

Kokka. Tokyo, 1889 ff.

Kokuhō jiten. Compiled by the Commission for the Protection of Cultural Properties. Tōkyō and Kyōto: Benridō, 1961.

Kwen Catalogue (A Descriptive Catalogue of Ancient and Genuine Paintings). By F. S. Kwen (Kuan Fu-ch'u). Shanghai: Lai-yüan Company, 1916.

Lee, Sherman E., *Chinese Landscape Painting*, second edition. Cleveland: The Cleveland Museum of Art, 1962.

———, and Wen Fong, *Streams and Mountains Without End*. Ascona (*Artibus Asiae Supplement*, XIV), 1955.

Lévi, Sylvain, "Les missions de Wang Hiuen-ts'e dans l'Inde." *Journal Asiatique*, XV (1900), 279-341, 401-468.

———, "Wang Hiuen-ts'e et Kaniṣka." *T'oung Pao*, XIII (1912), 307-309.

Li Chu-tsing, *The Autumn Colors on the Ch'iao and Hua Mountains*. Ascona (Artibus Asiae Supplement, XXI), 1965.

Li Lin-ts'an, "A Study of the Masterpiece, T'ang Ming-huang's Journey to Shu." *Ars Orientalis*, IV (1961), 315-321.

Loehr, Max, "Chinese Paintings with Sung Dated Inscriptions." *Ars Orientalis*,
IV (1961), 219–284.

Matsumoto Eiichi, *Tonkō-ga no kenkyū*. 2 vols. Tōkyō: Tōhō Bunka Gakuin,
Tōkyō Kenkyūjo, 1937.

Mochizuki Shinkō, *Bukkyō Daijiten*. 6 vols. Tōkyō: Bukkyō Daijiten Hakkōjo,
1932–36.

Mori Katsumi, *Nichi-Sō bunka kōryū no sho-mondai*. Tōkyō: Tōkō Shoin, 1950.

Moule, A. C., "The Lei-feng-t'a." *Journal of the Royal Asiatic Society*, 1925,
pp. 285–288.

———, "Chinese Printing of the Tenth Century." *Journal of the Royal Asi-
atic Society*, 1925, pp. 716–717.

Mo-yüan hui-kuan, 4 ch. By An Ch'i, 1743. Ed. *Ts'ung-shu Chi-ch'eng*, Vols.
1577–1579. Shanghai: Commercial Press, 1937.

Munsterberg, Hugo, *The Landscape Painting of China and Japan*, second
edition. Rutland, Vt., and Tōkyō: Charles E. Tuttle, 1956.

Naitō Torajirō, *Tōyō bunka-shi kenkyū*. Fifth edition. Tōkyō: Kōbundō Shobō,
1940. The chapter of particular interest is "Sōgen-han no hanashi," pp.
113–123.

Nakayama Kyūshirō, *Sekai insatsu tsūshi*, 2 vols. Tōkyō, 1930.

Nanjio Bunyiu (Nanjō Bunyū), *A Catalogue of the Chinese Translation of the
Buddhist Tripiṭaka, The Sacred Canon of the Buddhists in China and Japan*.
Oxford: Clarendon Press, 1883.

Nihon bijutsu-shi nempyō, by Kobayashi Takeshi and Fujita Tsuneyo. Tōkyō:
Sōgensha, 1952.

Noma Seiroku, *The Arts of Japan, Ancient and Medieval*. Translated and
adapted by John Rosenfield. Tōkyō: Kodansha International Ltd., 1966.

Ogawa Kanichi, *Daizōkyō, seiritsu to hensen*. Kyōto: Hyakkaen, 1964.

Ono Gemmyō, *Bukkyō no bijutsu to rekishi*. Tōkyō: Daizō Shuppan Kabushiki
Kaisha, 1937.

———, *Bussho Kaisetsu Daijiten*. 12 vols. Tōkyō: Daitō Shuppansha,
1932.

———, "Shina — insatsu-jutsu." *Tōyō Rekishi Daijiten*, IV, 62 A ff.

Ōtani Daigaku Toshokan zembon shūei. Compiled by the Ōtani University
Library. Kyōto: Ōtani Daigaku Toshokan, 1961.

Paik, Nak Choon (George Paik), "Tripiṭaka Koreana. Library of Wood-
blocks of Buddhist Classics at Haein-Sa, Korea." *Transactions Korea
Branch of the Royal Asiatic Society*, XXXII (1951), 62–78.

Paine, Robert Treat, and Alexander C. Soper, *The Art and Architecture of
Japan*. Second edition. Baltimore: Penguin Books, 1960.

Pelliot, Paul, *Les débuts de l'imprimerie en Chine*. Oeuvres posthumes de Paul
Pelliot, IV. Paris: Adrien-Maisonneuve, 1953.

———, *Les grottes de Touen-houang*. 6 vols. Paris: Paul Geuthner, 1920–1924.

Rowley, George, *Principles of Chinese Painting*. Princeton Monographs in
Art and Archaeology, XXIV, 1947; 2nd ed., 1959.

Shafer, Robert, "Words for 'Printing Block' and the Origin of Printing."
Journal of the American Oriental Society, Vol. 80 (1960), pp. 328–329.

Shen Kua, *Meng-ch'i pi-t'an*, 26 ch., *pu*, 3 ch.; late 11th c. Ed. by Hu Tao-ching,
Meng-ch'i pi-t'an chiao-cheng, 2 vols. Shanghai: Shanghai Ch'u-pan Kung-
ssu, 1956.

Shi Ō Go Un (Chinese, *Ssu Wang Wu Yün*, i.e., The Four Wang, Wu Li, and
Yün Shou-p'ing). Osaka: Hakubundō, 1919.

Shih-shih chi-ku-lüeh, 4 ch. By the priest Chüeh-an, about 1341. Edition of the
year Kuang-hsü 12 (1886).

Shimazu Kusako, *Jōjin ajari boshū* [and] *San-Tendai-Godaisan-ki no kenkyū*. Tōkyō: Daizō Shuppan Kabushiki Kaisha, 1959.

Shimomise Shizuichi, *Shina kaigashi kenkyū*. Second edition. Tōkyō: Fusanbō, 1944.

Shin-chō shogafu. Ōsaka: Hakubundō, 1922.

Shu Ying, "Pei Sung k'o-yin-ti i-fu mu-k'o-hua." *Wen Wu*, No. 135 (1962, No. 1), pp. 29-30.

Sickman, Laurence, and Alexander C. Soper, *The Art and Architecture of China*. Baltimore: Penguin Books, 1956.

Sirén, Osvald, *Chinese Painting: Leading Masters and Principles*. 7 vols. London and New York, 1956-1958. (Abbreviated, *CP*.)

———, *History of Early Chinese Painting*. 2 vols. London: The Medici Society, 1933.

———, *Chinese Paintings in American Collections*. 2 vols. Annales du Musée Guimet, Bibliothèque d'art, Nouvelle Série, II. Paris and Brussels: van Oest, 1928.

Soper, Alexander C., tr., *Kuo Jo-hsü's Experiences in Painting (T'u-hua chien-wen-chih)*. Washington: American Council of Learned Societies, 1951.

Stein, Sir Aurel, *Serindia*. 5 vols. Oxford: Clarendon Press, 1921.

———, *The Thousand Buddhas: Ancient Buddhist Paintings from the Cave-Temples of Tun-huang on the Western Frontier of China*. 3 vols. London: Quaritch, 1921.

———, *Innermost Asia*. Oxford, 1928.

Sullivan, Michael, *The Birth of Landscape Painting in China*. Berkeley and Los Angeles: University of California Press, 1962.

Sun Ta-kung, *Chung-kuo hua-chia jen-ming ta-tz'u-tien*. Second edition. Shanghai: Shen-chou Kuo-kuang-she, 1940.

Taifūdō meiseki (Chinese, Ta-feng-t'ang ming-chi) [Collection of Chang Yüan = Chang Ta-ch'ien]. 4 vols. Kyōto: Benridō, 1955-1956.

Takakusu Junjirō, tr., *A Record of the Buddhist Religion as Practised in India and the Malay Archipelago* (A.D. *671-95*) *by I-tsing*. Oxford, 1896.

———, *Hoppō ryūei* (Hōbō ryūei). Tōkyō: Daiyūkaku, 1925.

T'ang Sung hua-chia jen-ming tz'u-tien. By Chu Chu-yü and Li Shih-sun. Peking, 1958.

Tenri Central Library Photo Series, XIX: *Sung Editions (Sōhan)*. Tenri: Tenri University Press, s.a.

Tokiwa Daijō, "Daizōkyō chōin-kō." *Tetsugaku Zasshi*, XXVIII (1913) and XXIX (1914).

———, "Daizōkyō gaisetsu." *Bukkyō Kōkogaku Kōza*, I (1936), 1-63.

Tokushi Yūshō, *Kodai hanga-shū*, Kyōto, 1923.

———, "Bukkyō hanga gaisetsu." *Sekai Bijutsu Zenshū, bekkan* VIII: *Tōyō hanga-hen*. Tōkyō: Heibonsha, 1931.

———, "Hankyō." *Bukkyō Kōkogaku Kōza*, III (1936), 1-44.

Tomita, Kōjirō, *Portfolio of Chinese Paintings in the Museum* [of Fine Arts, Boston] (*Han to Sung Periods*). Cambridge, Massachusetts: Harvard University Press, 1938.

Tōyō Rekishi Daijiten. Second edition. 9 vols. Tōkyō: Heibonsha, 1940.

Ts'e-fu yüan-kuei, 1000 ch. By Wang Ch'in-jo *et al.*, 1005-1013.

Tu Fu's Gedichte, übersetzt von Erwin von Zach. Edited with an Introduction by James Robert Hightower. 2 vols. Harvard-Yenching Institute Studies, VIII. Cambridge, Massachusetts: Harvard University Press, 1952.

T'u-hua chien-wen-chih, 6 ch. By Kuo Jo-hsü, about 1080. Ed. *Ts'ung-shu*

Chi-ch'eng, Vol. 1648. Shanghai: Commercial Press, 1937. Translated by Alexander C. Soper, *q.v.*

T'u-hua ching-i-chih, 1 ch. By Chang Keng. First published in 1762.

Wang Kuo-wei, *Liang Che ku-k'an-pen k'ao*, 2 ch. In *Wang Chung-k'o-kung i-shu*, Pt. II, ts'e 24. 1927.

———, *Wu-tai liang Sung Chien-pen k'ao*, 3 ch. In *Wang Chung-k'o-kung i-shu*, Pt. II, ts'e 23. 1927.

Wang Ming-ch'ing, *Hui-chu-lu*. (*Hui-chu ch'ien-lu*, 4 ch., 1166; *hou-lu*, 11 ch., 1194; *san-lu*, 3 ch., about 1195.)

Watanabe Kōzō, "Sekkei." In *Tōyō Rekishi Daijiten*, V, 190–192.

Wu Lien-ch'eng, "Pei Sung Fu-chou Tung-ch'an Teng-chüeh-yüan k'an-pen Ta-tsang-ching." *Wen Wu* (1962), No. 4–5, p. 91.

Yang Lien-sheng, "Lung-su chiao-min chieh — An Explanation of the Term 'Lung Su Chiao Min.'" *Bulletin, Institute of History and Philology*, Extra Volume No. 4. Taipei, Taiwan: Academia Sinica, 1960, 53–56.

Yasuda Bunko kogyō seikan. 3 vols. Edited by Ishida Mosaku. Tōkyō: Nihon Kaigai Shōji Kabushiki Kaisha, 1952.

Yeh Kung-ch'o, "Li-tai Tsang-ching k'ao-lüeh." In *Chang Chü-sheng hsien-sheng ch'i-shih sheng-jih chi-nien lun-wen-chi*. Shanghai: Commercial Press, 1937.

———, *Hsia-an t'an-i-lu*. N. p., n. d.

Yonezawa Yoshiho, *Chūgoku kaigashi kenkyū. Sanzuiga-ron*. Tōkyo: Heibonsha, 1962.

Yūrin Taikan. 3 vols. Edited by Fujii Zennosuke. I, II (1929), III (1942). Kyōtō, Yūrinkan.

INDEX

Abhidharma, 15, 28
Abhidharma-jñānaprasthāna-śāstra, 23
Academy (N. Sung), 11
Ai-jih-chai ts'ung-ch'ao, 4
Aichi, 26, 27
An-chi, Chekiang, 27
Annam, 16
Aśoka, 8
Avataṃsakasūtra, Hua-yen-ching, 20

Bibliothèque Nationale, Paris, 8
Bīja syllables, 10
Bodhisattva: Avalokiteśvara, 7, 10; Maitreya, 11; Mañjuśrī, 11; Samantabhadra, 11; Shui-yüeh Kuan-yin, 65, 67; six-armed, 1; ten-armed, 10–11
Boston, 49, 54
British Museum, 4, 7, 9, 25, 26, 43, 67
Buddha: images of, 11; Śākyamuni, 11. *See also* Siddhārtha
Buddhacarita, 16, 17, 56
Buddhism: favored by Sung Dynasty founders, 13; opponent of, 16; persecution of, 14

Calligraphy, 3, 5, 14
Calligraphy Museum, *see* Shodō Hakubutsukan
Canton, 10
Carter, Thomas Francis, 4, 6
Cartouche: of 1071, 16, 18, 32, 33, 76n14; of 1108, 17, 18, 32, 33
Central Asian Antiquities Museum, New Delhi, 46
Chan Tzu-ch'ien, 46, 67
Ch'an (sect), 25
Chang Hsüan, 65
Chang-i-chün, 10
Chang Tsung-ts'ang, 66
Chang Ts'ung-hsin, 13
Ch'ang-an, 5. *See also* Hsi-an
Chao An-kuo, 28
Chao Ch'ang, 65
Chao-ch'eng, Shansi, 22
Chao K'uang-yin, Sung T'ai-tsu, 9, 13
Chao-tsung (889–904), 4
Chao Yen, 65

Charms, spells, 1, 2, 10
Che pen, *see* Ssu-ch'i (edition)
Che-tsung (1086–1100), 17, 19
Chekiang, 3, 7, 8, 11, 15, 26, 28
Chen, J. D., Ch'en Jen-t'ao, 44
Chen-tsung (998–1022), 17
Ch'en Shu, 17
Ch'en Yüan (printer), 31
Cheng-i-t'ang, 15
Ch'eng-tu, I-chou, 1, 4, 6, 7, 13, 14, 30
Chi-sha (edition), 28
Chiang-nan, 14
Chiang Ts'an, 47
Chien-luan, 32
Ch'ien Hsin, 10
Ch'ien Hung-shu, *see* Ch'ien Shu
Ch'ien Shu, 8, 10
Ch'ien Yüan-kuan, 10
Chih-li (priest), 11
Chih-p'an, 13
Chin (edition), 22–23, 30
Chin, Jurchen (Tatars), 17, 21, 33
Ching Hao, 34, 42, 43, 44, 47, 48, 53, 64, 66, 71
Chionin, 24, 25
Chiu-ching tzu-yang, 6
Chōnen, 11, 12, 15, 16, 30
Chŏngjong (1035–1047), 19
Chōrōji, Gifu, 27
Chou-li, 6
Chu Wen-ch'ing, 28
Chü-jan, 41, 44, 45, 47, 48, 53, 63, 66
Chüeh-an, 14
Chung-feng, 29
Ch'ung-ning-ssu, 24. *See also* Tung-ch'an-ssu
Ch'ung-ning wan-shou Ta-Tsang, 24
Ch'ung-shan-ssu, T'ai-yüan, 17, 28
Chūsonji, Iwate, 24, 26, 27
Clay stamps, 1, 2
Cleveland Museum of Art, 48
Colophons, 18, 23, 24, 26, 27, 28, 33
Confucian: books, 14; historiographers, 13
Contributions, donations, 23, 24, 26, 28
Copying of scripture, 10
Crawford, John M., Jr., 47, 66

PLATES

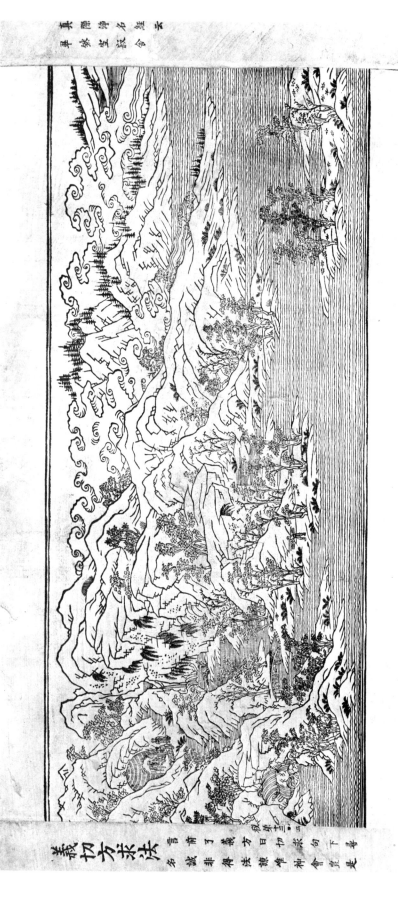

1 First woodcut in the *Pi-tsang-ch'üan*, Chapter XIII. Fogg Art Museum, Harvard University.

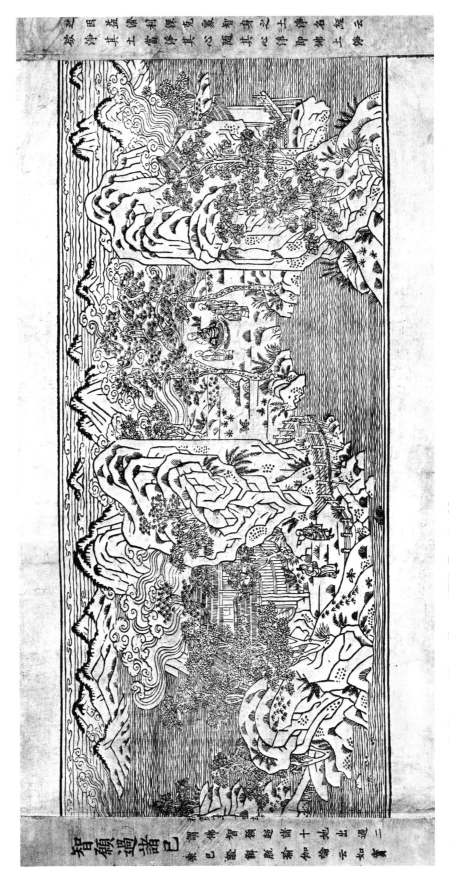

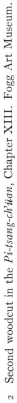

2　Second woodcut in the *Pi-tsang-ch'üan*, Chapter XIII. Fogg Art Museum.

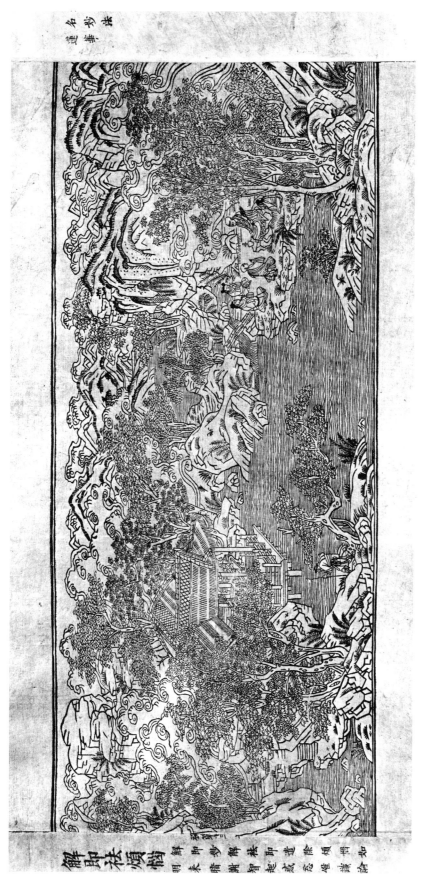

3　Third woodcut in the *Pi-tsang-ch'üan*, Chapter XIII. Fogg Art Museum.

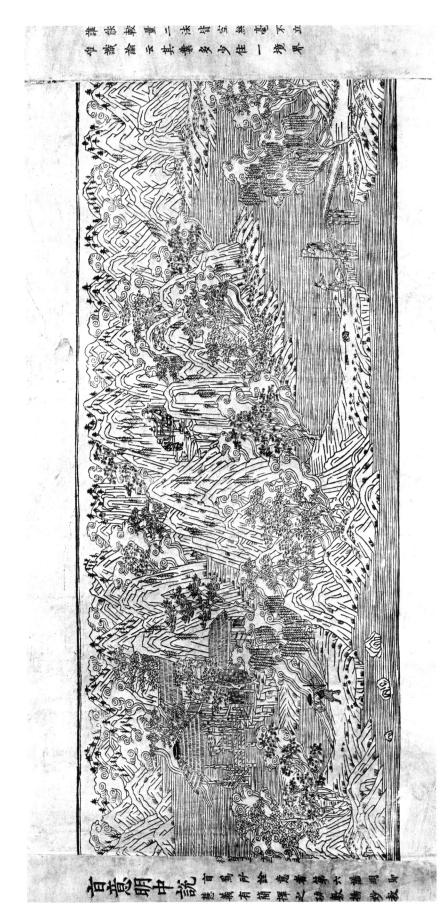

4 Fourth woodcut in the *Pi-tsang-ch'üan*, Chapter XIII. Fogg Art Museum.

法身無有盡　十方用周三界鑒嚴經云
是佛之境界　果德因行體圓鑒
炳然齊現皆無自體同一法性　難一念備
楞伽經云我了諸法唯心所現　坦然三界內
無彼無此絕幻忘憂雖居三界之中不礙隨
緣之理恒時自在故是坦然密嚴經云出世
而安住其心轉清淨　運轉暫無時　悲及含識拯拔
無時暫息莊嚴經云雖於一切塵現運用方　四生運用方
為明智者而在密嚴中寂然無動轉

御製秘藏詮卷第十三

邵明印

蓋聞施經妙善獲三乘之惠因讚誦真詮超五趣之業果然願普賓窮法界心廣
及無邊水陸群生同登覺岸時皇宋大觀二年歲次戊子十月　日畢
　莊主僧　福滋　管居養院僧　福海　庫頭僧　福深
供養主僧　福住　都化緣報�た住持沙門　鑒戀

5　End of the text, title, and cartouche of A.D. 1108 in the *Pi-tsang-ch'üan*, Chapter XIII.
Fogg Art Museum.

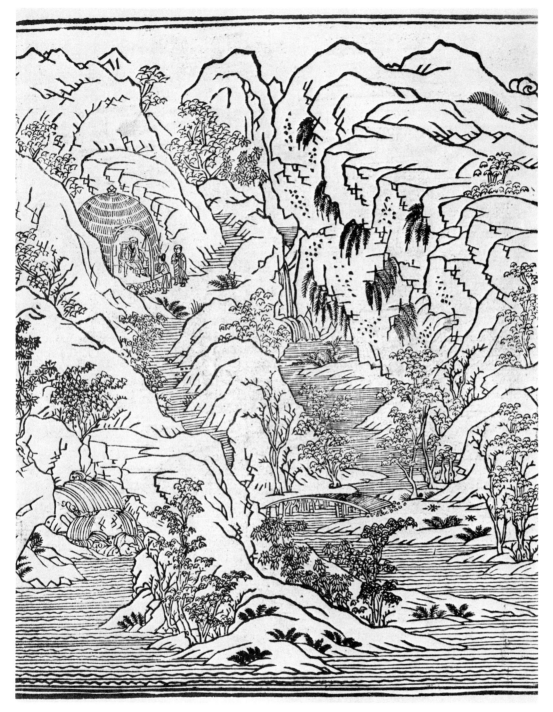

6 First woodcut, left third, slightly reduced.

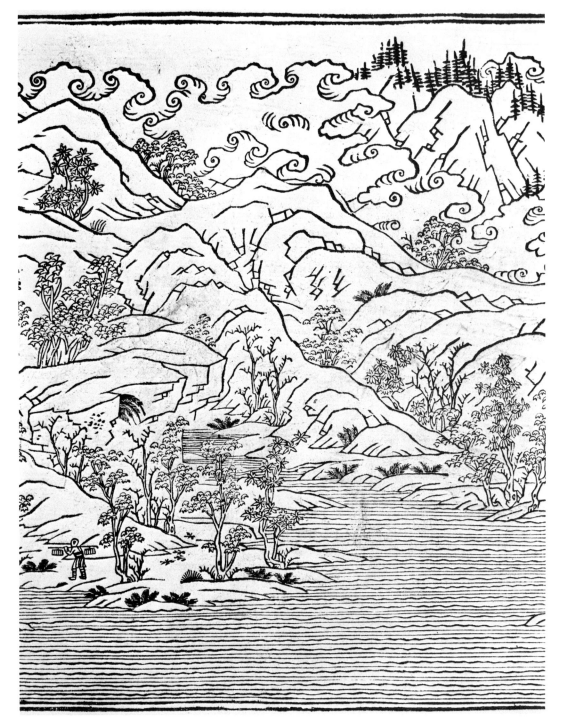

7 First woodcut, middle third, slightly reduced.

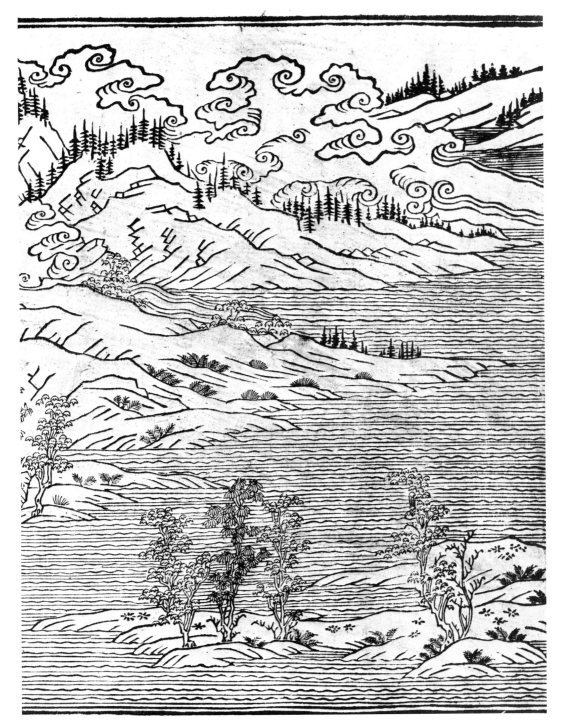

8 First woodcut, right third, slightly reduced.

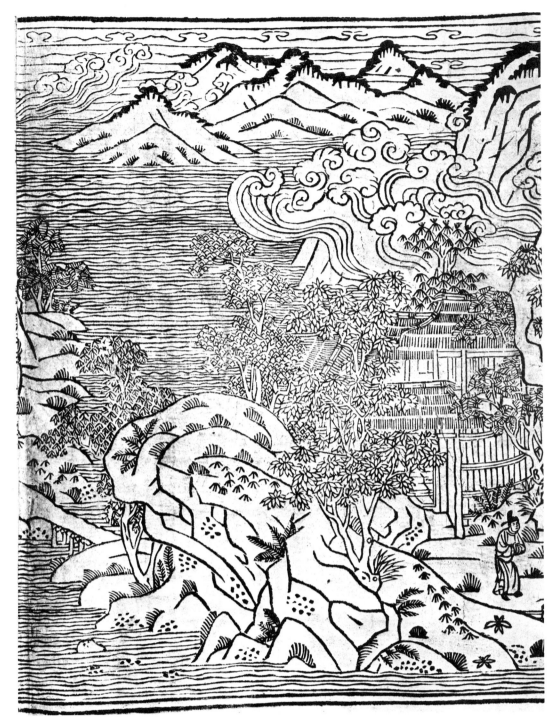

9 Second woodcut, left third, slightly reduced.

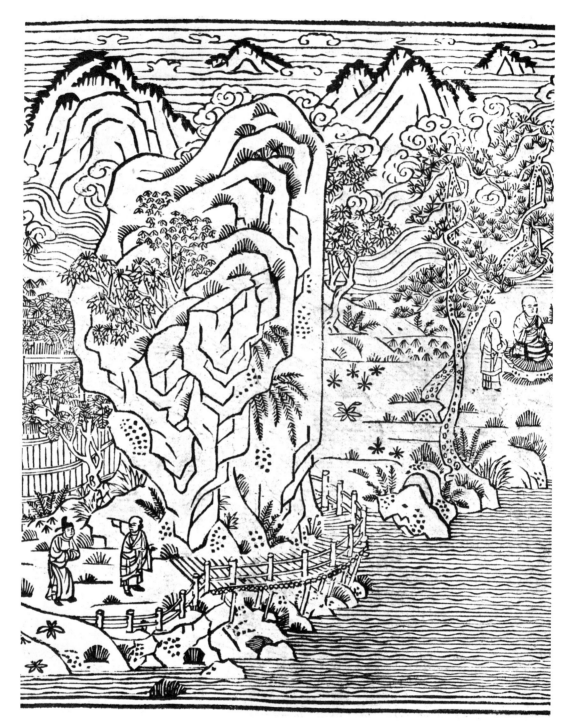

10　Second woodcut, middle third, slightly reduced.

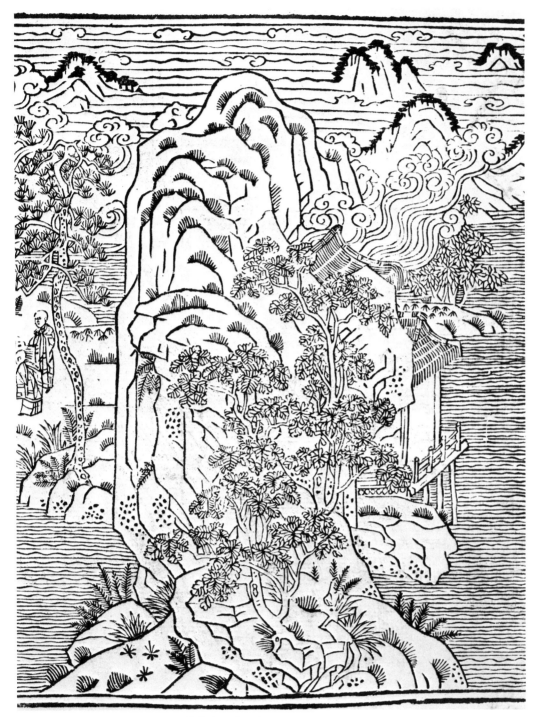

11 Second woodcut, right third, slightly reduced.

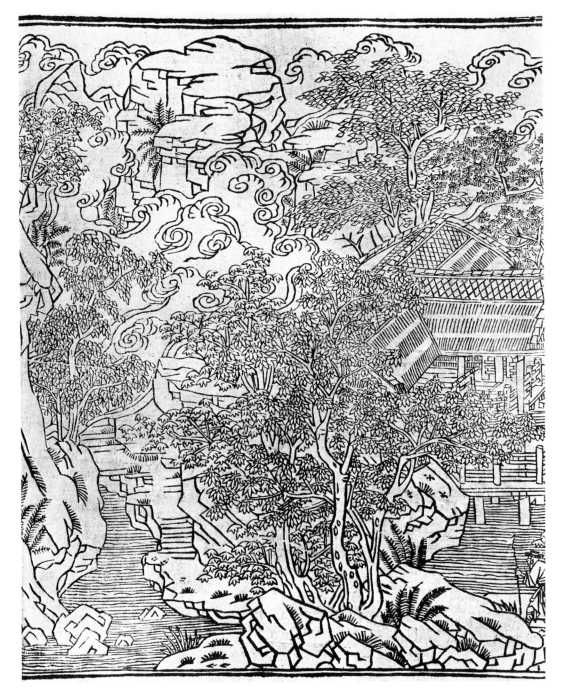

12 Third woodcut, left third, slightly reduced.

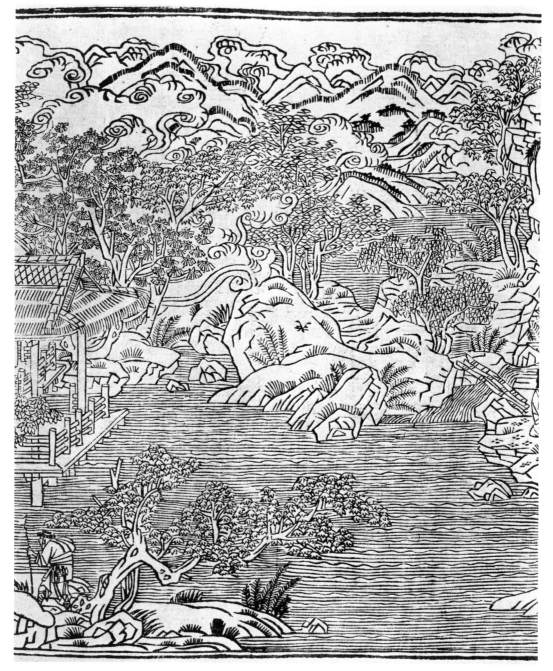

13 Third woodcut, middle third, slightly reduced.

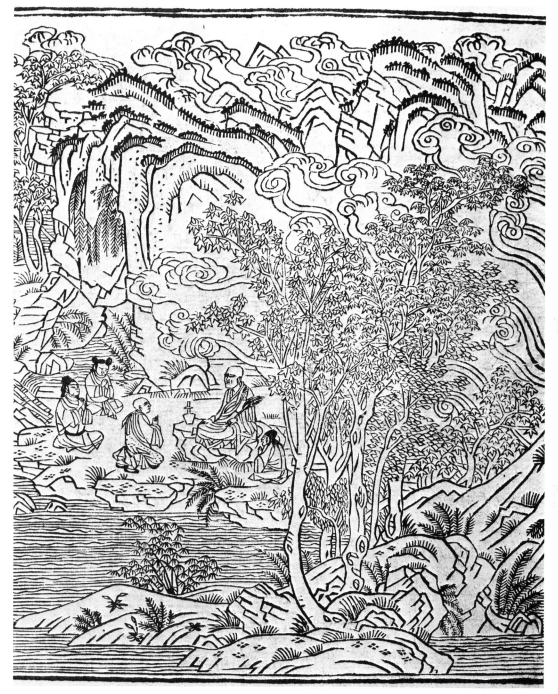

14 Third woodcut, right third, slightly reduced.

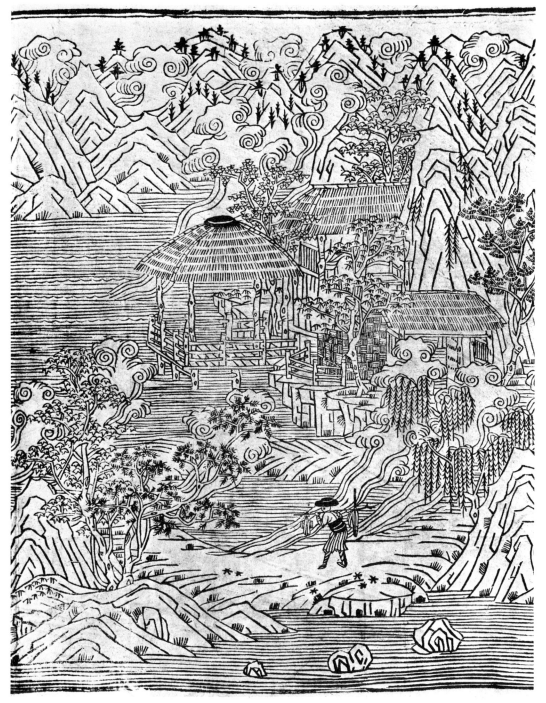

15 Fourth woodcut, left third, slightly reduced.

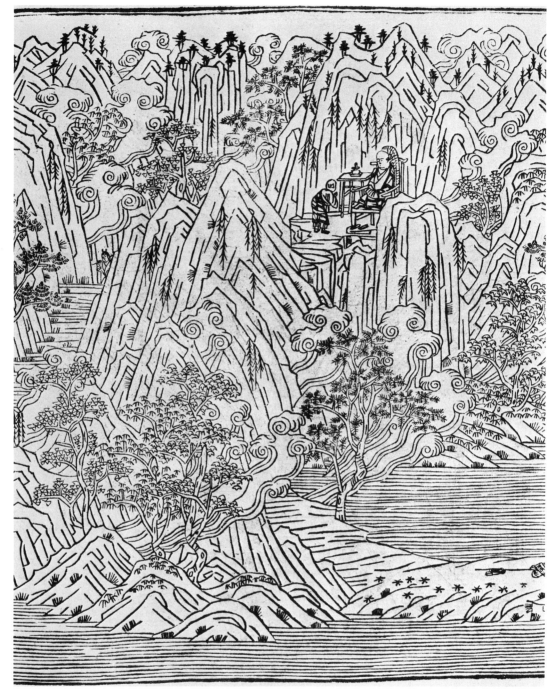

16 Fourth woodcut, middle third, slightly reduced.

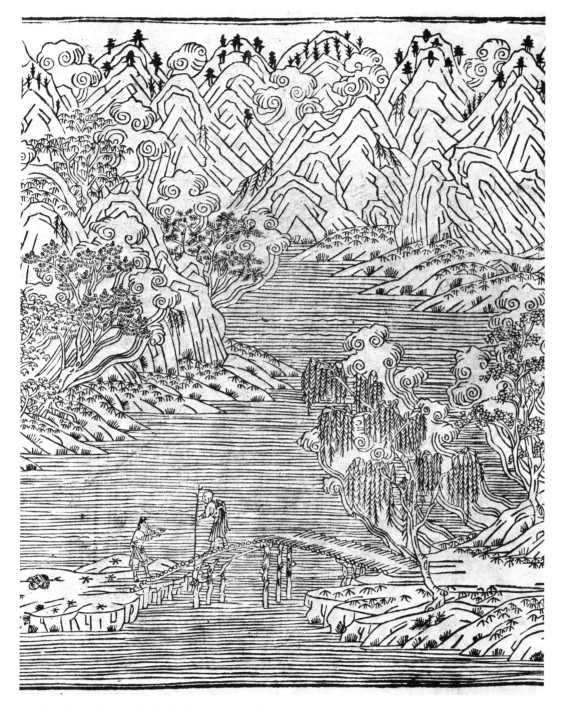

17 Fourth woodcut, right third, slightly reduced.

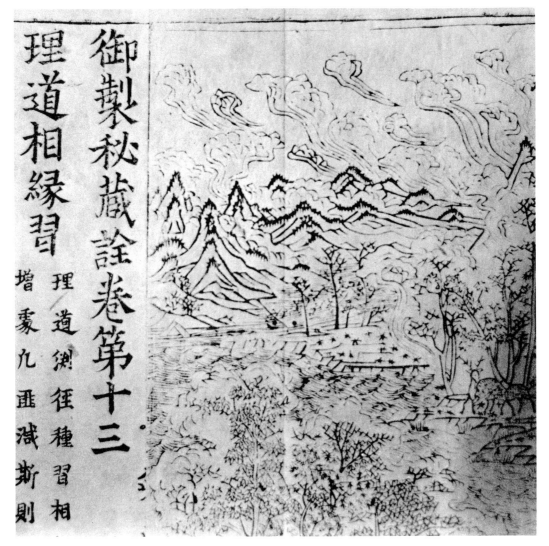

御製秘藏詮卷第十三

理道相縁習

御製秘藏詮卷第十三

理道測徑種習相
增豪九亞減斯則

18 Frontispiece of the Korean print of the *Pi-tsang-ch'üan*, Chapter XIII. Detail. Nanzenji, Kyōto.

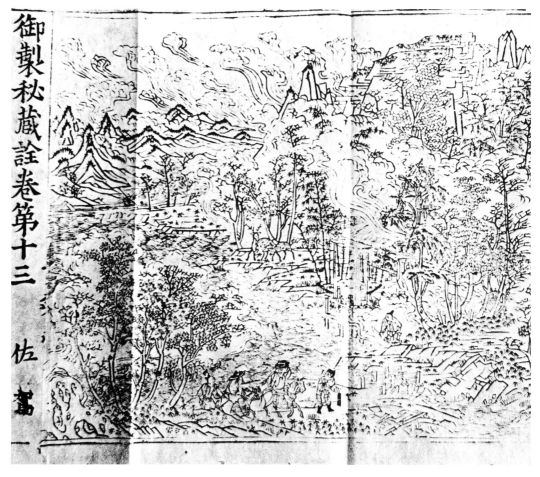

19 Frontispiece of the Korean print of the *Pi-tsang-ch'üan*, Chapter XIII. Left half. Nanzenji,
 Kyōto.

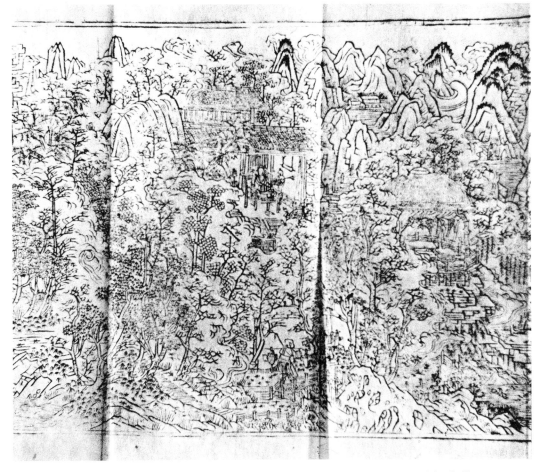

20 Frontispiece of the Korean print of the *Pi-tsang-ch'üan*, Chapter XIII. Right half.
Nanzenji, Kyōto.

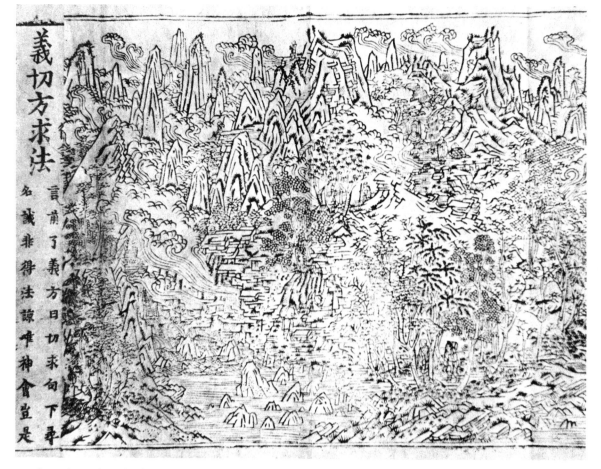

義切方求法

名義非得法諒年神會豈是

言前了義方日切求句下平

21 Second woodcut in the Korean print of the *Pi-tsang-ch'üan*, Chapter XIII. Left half.
Nanzenji, Kyōto.

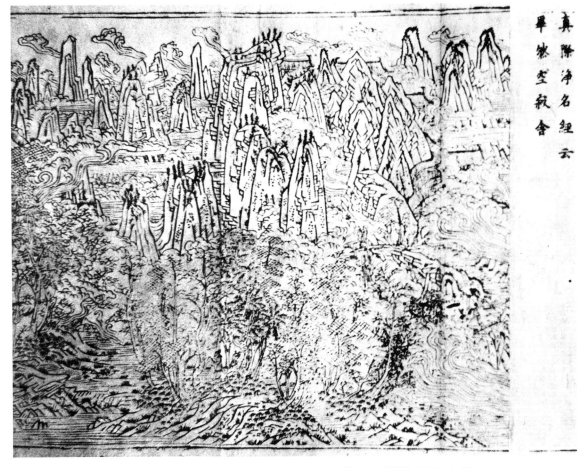

真際淨名經云
畢竟空寂舍

22 Second woodcut in the Korean print of the *Pi-tsang-ch'üan*, Chapter XIII. Right half.
Nanzenji, Kyōto.

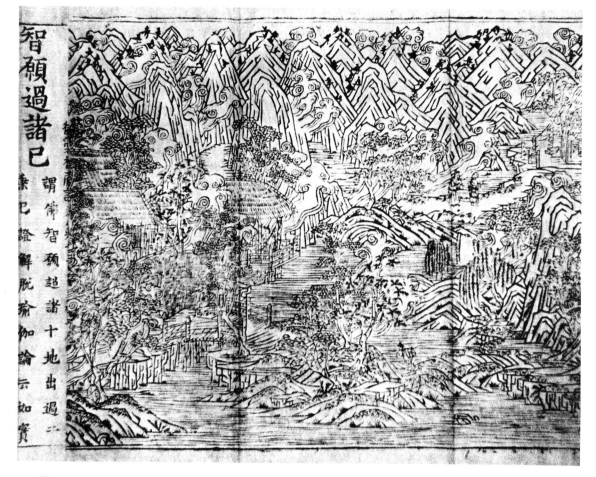

智顗過諸已

謂佛智顗超諸十地出過二

廉已證解脱瑜伽論云如實

23 Third woodcut in the Korean print of the *Pi-tsang-ch'üan*, Chapter XIII. Left half.
Nanzenji, Kyōto.

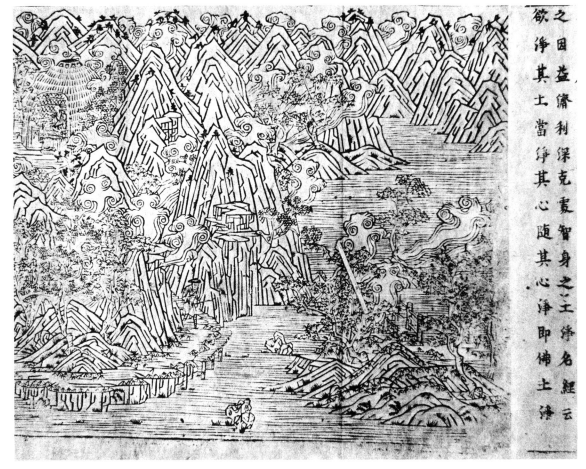

之國益儁利深克麥智身之工淨名經云
欲淨其土當淨其心隨其心淨即佛土淨
欲淨其土當淨其心

24 Third woodcut in the Korean print of the *Pi-tsang-ch'üan*, Chapter XIII. Right half.
Nanzenji, Kyōto.

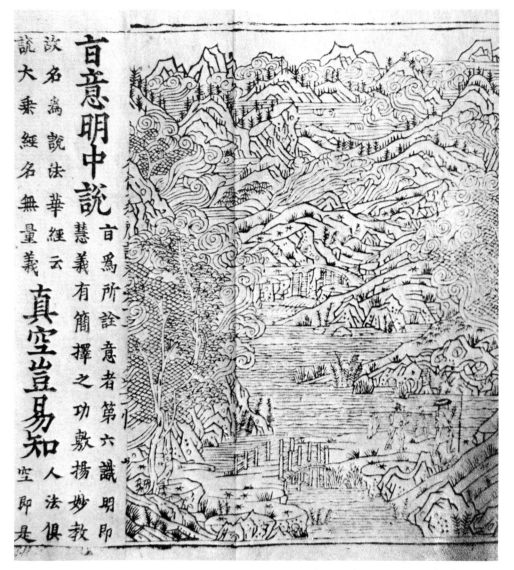

說大乘經名無量義　真空豈易知　空即是
故名為說法華經云
盲意明中說　慧義有簡擇之功敷揚妙教人法俱
盲為所詮意者第六識明即

25 Fourth woodcut in the Korean print of the *Pi-tsang-ch'üan*, Chapter XIII. Left third.
Nanzenji, Kyōto.

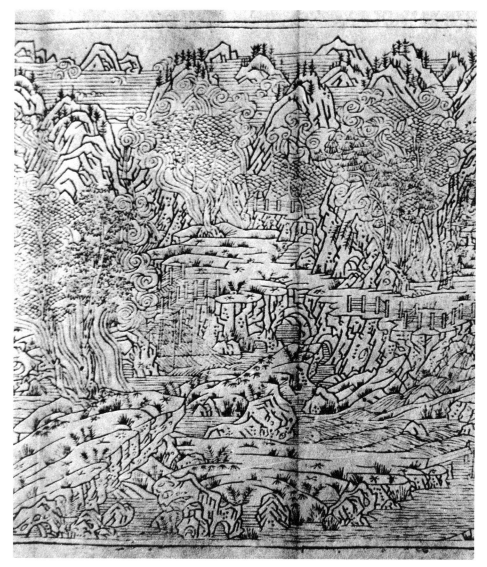

26 Fourth woodcut in the Korean print of the *Pi-tsang-ch'üan*, Chapter XIII. Middle third. Nanzenji, Kyōto.

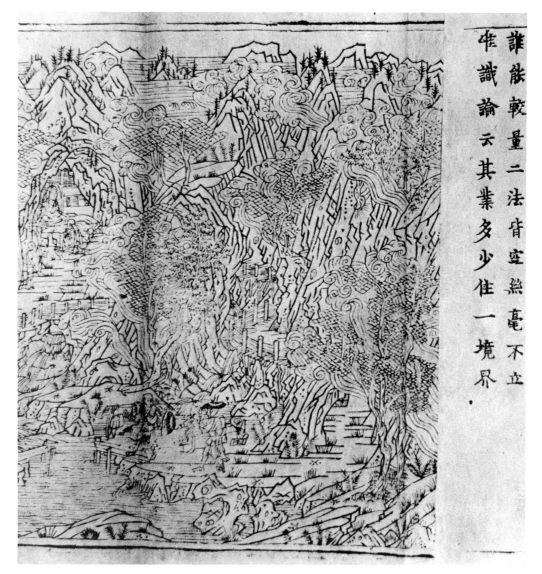

誰能較量二法皆空纖毫不立
唯識論云其業多少住一境界。

27　Fourth woodcut in the Korean print of the *Pi-tsang-ch'üan*, Chapter XIII. Right third. Nanzenji, Kyōto.

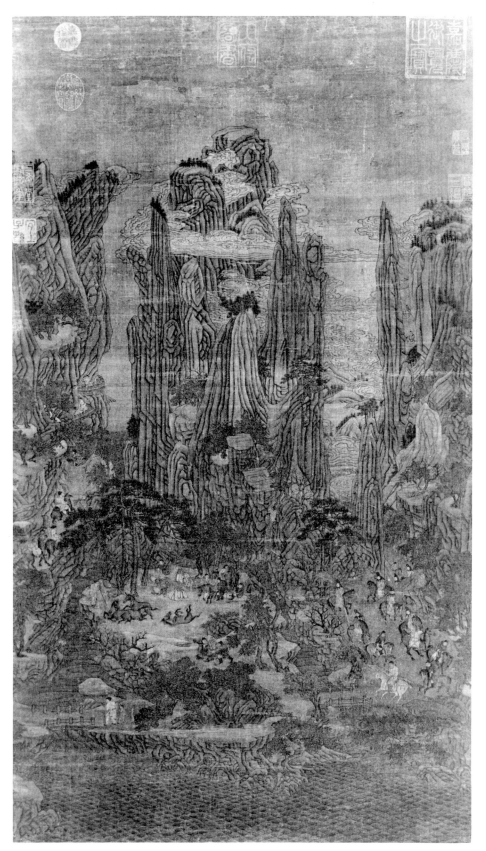

28 Travelers in the Spring Mountains. Attributed to Li Chao-tao. Northern Sung copy (?)
Palace Museum Collection, Taipei.

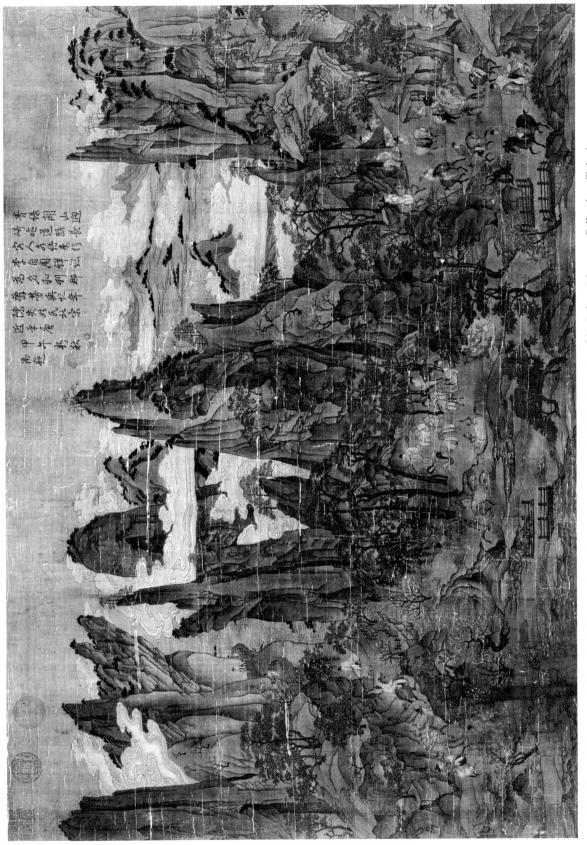

29 Ming-huang's Journey to Shu. Late T'ang replica of an anonymous work of about A.D. 800 (?). Palace Museum Collection, Taipei.

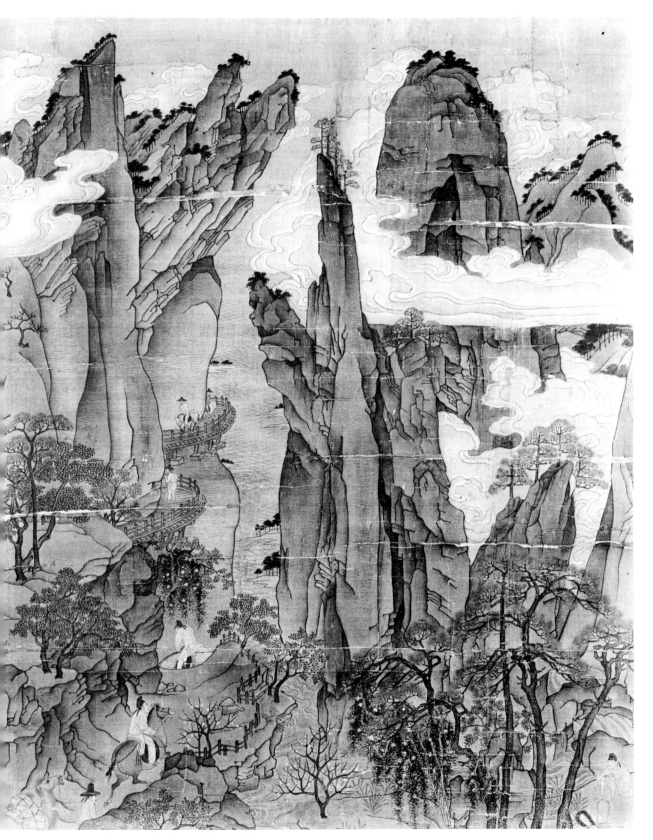

30 Detail of Ming-huang's Journey to Shu.

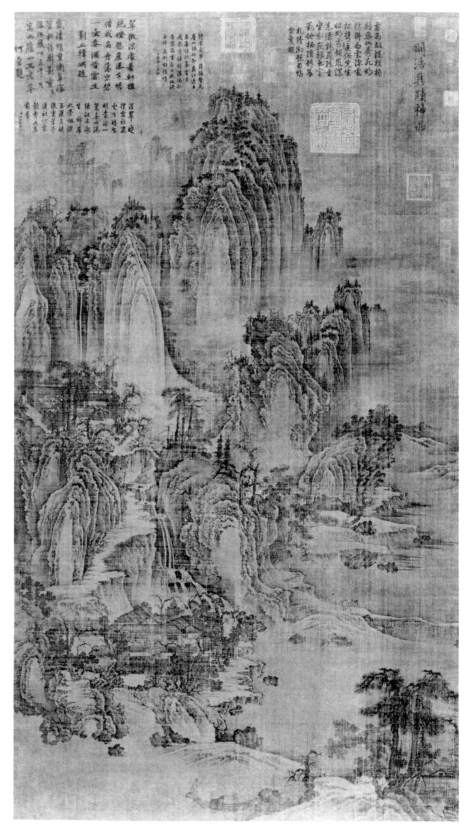

31　The K'uang-Lu Mountain. Attributed to Ching Hao, about A.D. 900. Palace Museum Collection, Taipei.

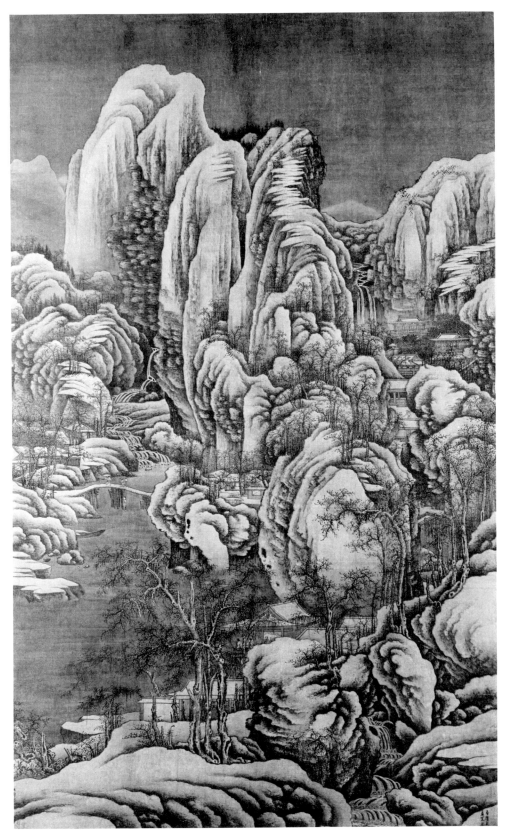

32 Winter Landscape ("First Snow over Rivers and Mountains"). Copy after a tenth-century work. Freer Gallery, Washington.

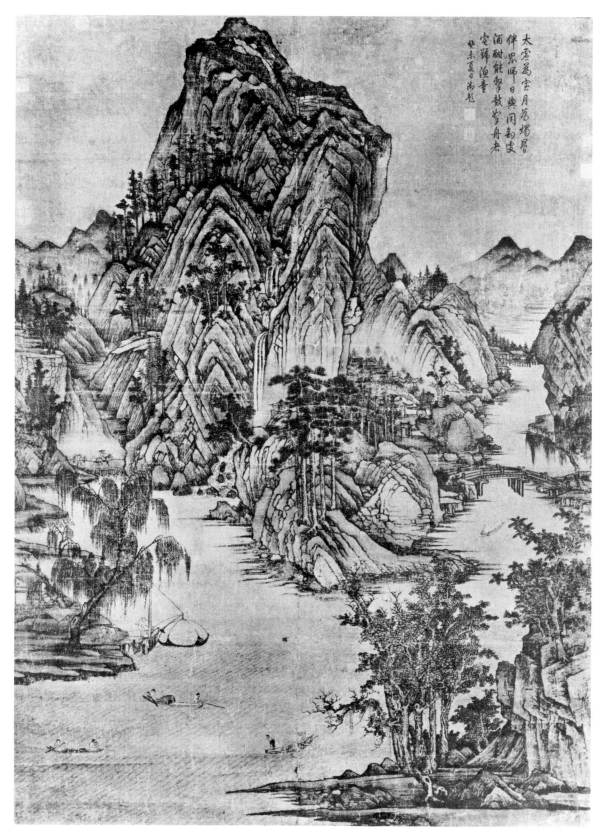

太
雲
為
宅
月
為
燭
昏
伴
界
師
日
與
同
為
友
酒
酬
能
擊
敲
學
舟
秋
宅
辭
漁
童
姚
來
夏
日
尚
題

33 Fishing in Seclusion on a Clear Stream. Anonymous work of the tenth century (?). Palace Museum Collection, Taipei.

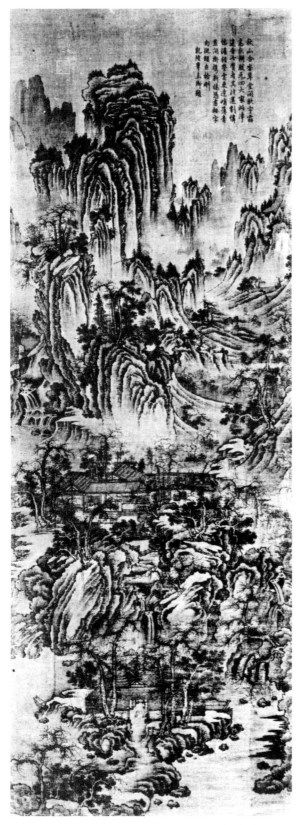

秋山含翠章詞款寄蒼
蒼秋梢黛元四大家山澤
逸會少暗岩泉遂劃情
怡藻經繁密竟思違峻隱書
孟洞樂逍新德逸峯秘字
句況頹自燦晰
乾隆辛丑御題

34 Autumn Mountains. Anonymous work of the tenth
century(?). Palace Museum Collection, Taipei.

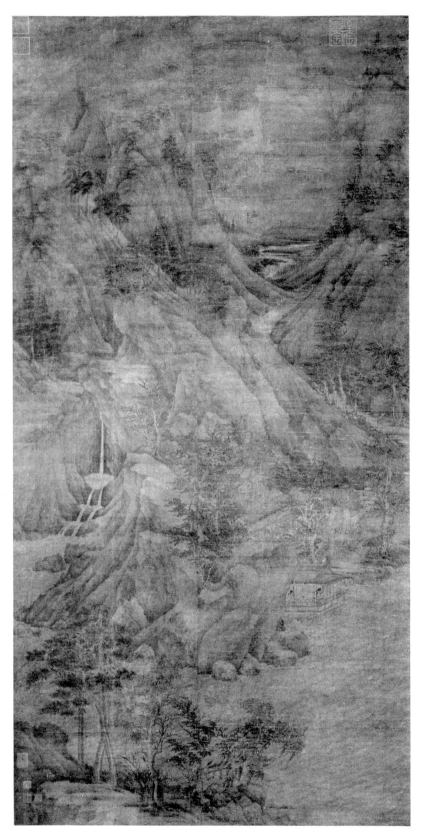

35 The River Bank. Signature of Tung Yüan. Chang Ta-ch'ien collection.

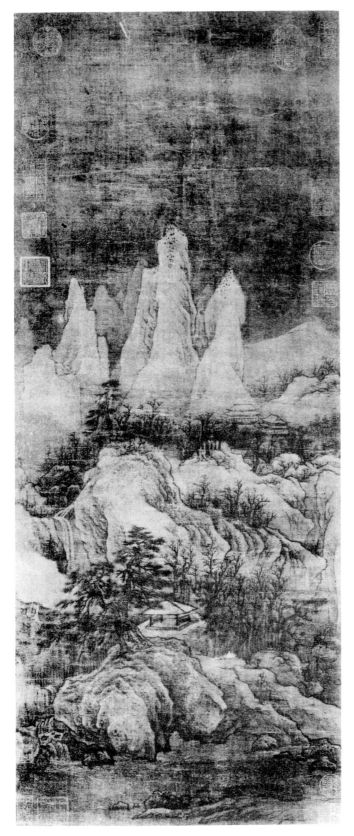

36 Mountain Peaks After a Snowfall. Attributed to Li Ch'eng.
Tenth century. Palace Museum Collection, Taipei.

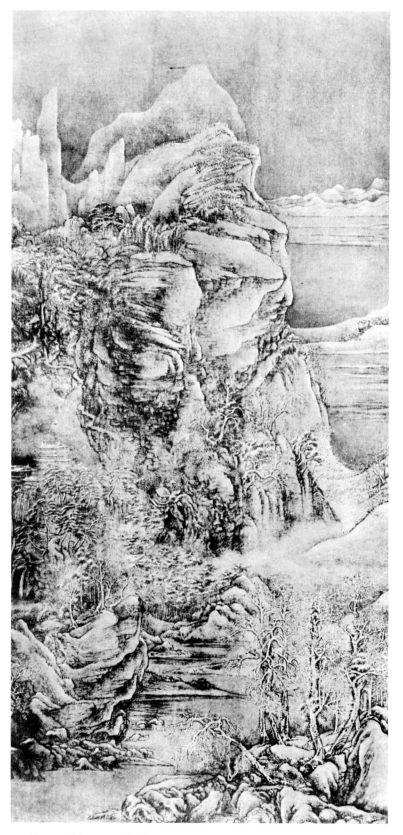

37 Remote Monastery in Snowy Mountains. Copy by Wang Hui, allegedly
after Wang Wei. After *Chung-kuo ming-hua*, V. Whereabouts unknown.
Formerly P'ing-teng-ko collection.

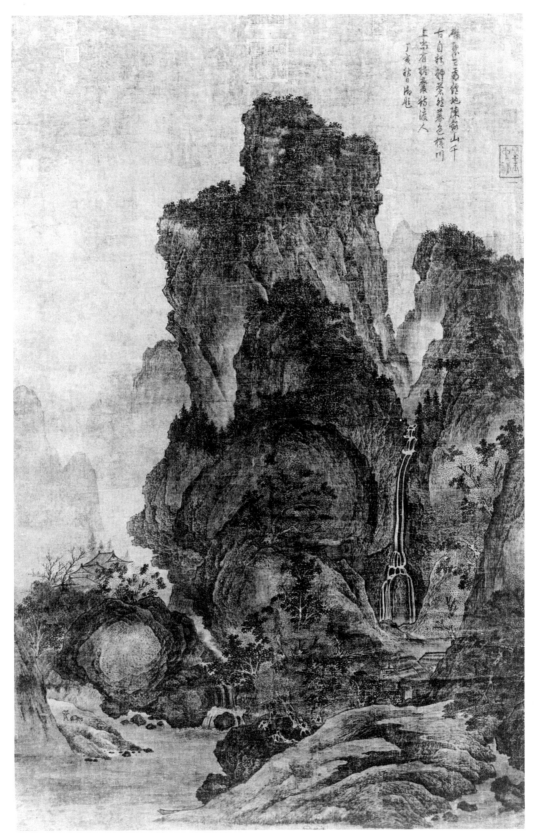

38　Waiting for the Ferry. Attributed to Kuan T'ung. Mid-tenth century (?). Palace Museum Collection, Taipei.

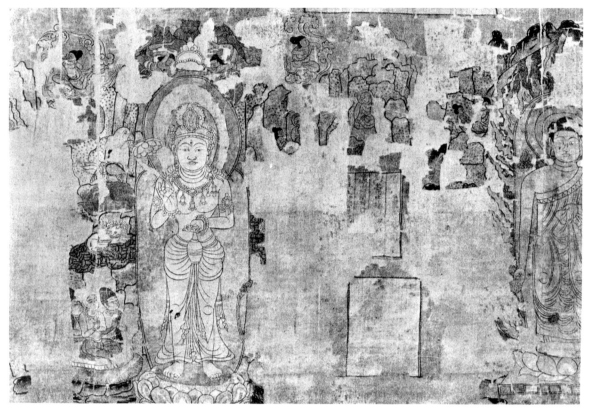

39A Iconographic Study of Buddha Images in Western Countries, from Tun-huang. Detail.
Ninth century (?). Stein collection, British Museum. After Sir Aurel Stein, *The Thousand
Buddhas*, pl. XIV.

39B Frontispiece of the Korean print of the *Fo-fu* (*Pi-tsang-ch'üan*, Chapter XXI) represent-
ing the Palace of Kapilavastu and the birth of the Buddha. After Tokushi, *Kodai
hanga-shū*. Nanzenji, Kyōto.

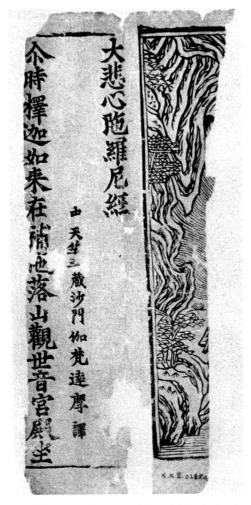

大悲心陀羅尼經

尒時釋迦如来在補陁落山觀世音宮殿坐

由天竺三藏沙門伽梵達摩譯

K.K.II.0195.a

40　Fragment of a *sūtra* (*Ta-pei-hsin t'o-lo-ni-ching*) with landscape frontispiece found by Sir Aurel Stein at Kara-Khoto. New Delhi, Museum of Central Asian Antiquities.